THE VIDEOTAPE BOOK

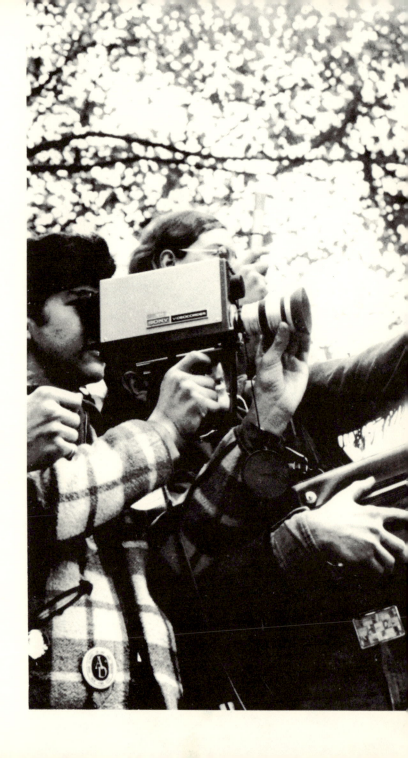

THE VIDEOTAPE BOOK

A BASIC GUIDE TO PORTABLE TV PRODUCTION

Michael Murray

Taplinger Publishing Company ‖ New York

This edition published in 1975 by
TAPLINGER PUBLISHING CO., INC.
New York, New York

ACKNOWLEDGMENTS
Excerpts from *The Use of Videotape in Private Practice* by Milton M. Berger, M.D.
 Copyright © 1970 by Milton M. Berger. Reprinted by permission of Brunner/Mazel, Inc.
Excerpts from *Filmmakers Newsletter*. Copyright © 1972 by Suni Mallow. Reprinted by
 permission.
Excerpts from *Guerrilla Television* by Michael Shamberg and Raindance Corporation.
 Reprinted by permission of Holt, Rinehart and Winston, Inc.
Excerpts from *Film Library Quarterly*. Copyright © 1972 by Film Library Information
 Council. Reprinted by permission.
"Fifth Graders Make a Video Tape," by Janice I. Wilkison. Reprinted from *Instructor*.
 Copyright © 1970 by The Instructor Publications, Inc. Reprinted by permission.
Excerpts from *Expanded Cinema* by Gene Youngblood. Copyright © 1970 by Gene
 Youngblood. Published by E. P. Dutton & Co., Inc., and reprinted by permission.
"A New Approach to Security," by Leonard Cohen. Reprinted from the December 1972
 issue of *Educational & Industrial Television*. Copyright © 1972 by C.S. Tepfer
 Publishing Company, Inc., and reprinted by permission.
"Dan Graham's TV Camera/Monitor Performance" was first published in *The Drama
 Review*, Vol. 16, No. 2 (T-54), June 1972. Copyright © 1972 by *The Drama Review*,
 and reprinted by permission.
Excerpts from the brochure of Hydrex Termite and Pest Control. Copyright © 1970 by
 Hydrex Pest Control Co., Inc. Reprinted by permission.

Published simultaneously in the Dominion of Canada by
Burns & MacEachern, Ltd., Toronto

Published by arrangement with Bantam Books, Inc.

Library of Congress Catalog Card Number: 75-8413

ISBN 0-8008-8020-X

Acknowledgments

Special thanks to Sam Adwar of Adwar Video and Sal Spiezia of Video Onion in New York who have tried to keep my technical errors to a minimum. My thanks also to the many people who taught me about video: Paul Wilson, Bill Stephens, John Reilly and Ray Sundlin among others.

The Children's Aid Society of New York has pioneered in using video in the social work field and I am grateful to this organization for sponsoring many of my own video experiments.

Finally, I am indebted to all who wrote or spoke to me about their video experiences. Many of their stories are now in the book, and many others have helped to shape my own thinking. These concrete examples are what may give the reader a real taste of what video is all about.

The book is dedicated to Jane, Caitlin and Nathanael.

Photo Credits

Contents

Wednesday Afternoon

The crew moves out of the community center into
101st Street, Maximo with the microphone, Curtis
with the camera, and some little kid wearing the
headphones although the recorder isn't turned on. It
is a hot day and everybody is out: the old ladies
on the stoops, the men drinking beer and playing
dominoes in the shade of the tenement wall, hundreds
of kids chalking pictures and games on the street,
bicycling around, or playing a stunted baseball game
in the narrow corner lot.

We are doing this week's segment of "The 101st
Street News." The three boys and I stop to look
around and decide who we will talk to today. Does
Maximo know the lady with the cane? He knows
her a little but she speaks no English; he is always
nervous about his Spanish with the older people.
We give it a try. When Curtis clicks on the camera,
she is full of information about her sister who has
been taken to the hospital. It was some kind of

stomach pain, and she's not sure what the doctors think but she expects her home on Friday. Maximo seems to get through to her with no trouble, and afterwards he gives us an easy translation. We move on.

Down the block some workmen are carrying huge baskets of plaster out of a house and throwing it into a truck. Curtis shoots this activity from a nearby stoop as Maximo stops one of the workmen. What's going on? The workman is friendly but he doesn't know what's going on. They told him to knock down some walls, so that's what he's doing. Who's going to be moving in? The workman is no help. He goes on with his job. Curtis shoots the exterior of the building, old lumber jutting through the windows, as Maximo does a commentary, explaining where we are and everything we know about the situation, which isn't much.

Next stop is Tony who sells ices—this interview in a combination of Spanish and English. He continues to do business as he talks (great for the camera), scraping the block of ice in his cart, shaping the ice in a paper cone, lifting one of the colored bottles and

slurping the liquid over the shaved ice. He's been coming to the block for ten years, he says, and yes, it's changed, it's more friendly now because of the community center. But then it was always friendly.

Anyway, the ice business is better than ever. A customer says he has tried all the ices in East Harlem, and Tony's are best.

We keep going, with Curtis taking a turn at the interviews and Maximo at the camera. We hear about Lorraine's birthday; we investigate a social club around the corner; we find out about up-coming center activities; and more. When we are finished, we take the tape inside the center and hook it up to the TV set. We invite four or five people from the street to look at it with us and decide what should be used on the "news" tomorrow night. Total agreement that a five-minute stretch without sound (unplugged microphone) should come out. Debate about whether one interview was too long and boring. Intense debate about a segment describing the activities of another community action group around the corner. One point of view: why give them publicity? Another point of view: people should know what this group is doing so that both groups might work together.

Thursday Evening

Out on the street twenty or thirty people are watching "The 101st Street News" on the center's battered TV set which is on top of two tables; the sound is amplified through a loudspeaker. We are

doing the second showing and people pass by
and watch as much as they want. Many people wander
into the middle of a showing and then hang around
to see the beginning of the next. There is a lot of
talk, mostly about the news, mostly in Spanish. What
about the old lady's sister? What about the gutted
house? A lot of joking about Tony's ices and the young
men in the social club. Total silence in response to
the story about the rival community group. At the end,
after we've shown it three times, they go away
talking—some intently, some laughing and drinking.
But everybody's talking.

Fritzi, a thirty-two-year-old, smilingly ingratiating
mother of two children, who separated recently from
her husband, a biochemist provoked by her into
great rages, remarked quietly, after experiencing a
playback of herself during a group session, "I could
see how I come through phony, as if I'm reciting,
which is what I do when I'm talking to Jack. I also
picked up that I come through as not telling the whole

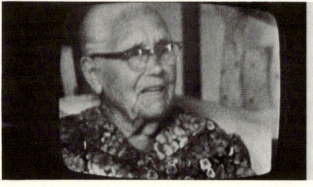

story. I'm so used to hiding my true feelings I'm
afraid to be open. But I didn't think it showed. . . ."
Another member of the same group, Mike, said
sadly with surprised recognition, "What I see is

that what I hate so much in my brother and nephews is in me too. And I finally can acknowledge the bitterness you've told me I come through with. . . ."

Jimmy, a hardcore passive-aggressive character neurotic, still plagued with deep anger toward himself and others, commented, "I see I need to go to another therapist—to take elocution lessons. I could hear my Brooklyn accent. But at least I did sound sincere, direct, and warm and felt I came through more with the group. I'm feeling more a part of the group these days and I'm feeling more involved with my family at home too. . . ."

Another group member, Mark, insisted that his outer physical appearance is not important. He insisted that the fact that he is unshaved, unkempt, wearing sloppy, dirty, unpressed clothes should not affect his relationships and that only what he is underneath should count. He was helped to understand the tremendous neurotic claim he was making on others, "Love me, love my smell!"

Milton M. Berger, M.D.
"The Use of Videotape in Private Practice"

The Appalachian Videotape Project

The educational discipline that motivates the tapes I've been producing is the folk school concept of

5

education, which means essentially that: People learn best in terms of their own situation and their own life; they learn best in a group that is familiar and natural to them; they learn through confronting a problem and sharing that struggle with other groups with similar problems; and, however inefficiently, they learn by being responsible themselves for the solution and by participating in that solution, however ill equipped they may be by professional standards.

Viewing education as problem solving among individuals and groups, portable video is a beautiful medium—and in that sense I view a portapak as a total system, with cable TV being a major outlet for that system, but secondary to it. You bring the portapak to the problem and only those people involved in it. Appalachians in the coal fields can communicate with others in the coal fields and with agencies and professions having direct impact on the coal fields. A. T. Collins listens to Tillman Cadle talk about his work with the early unions, and A. T. Collins, in his own home, on his front porch, responds by sharing his experiences in the mines and in the Hyden mine explosion. Other miners hear

A. T. and talk about their problems, recording some on tape. A. T. and others view those tapes, etc., etc. . . .

Rather than "talking" a lot of tapes, what I've been trying to encourage is a mutual dialogue. I almost never tape any situation unless the people involved first learn about the machinery, fool with it themselves, and then listen to a tape made by someone else in the mountains who shares their experience. The techniques are not media oriented, but oriented to education and conversation. For instance, I almost never view someone I'm taping through the camera, but always, if possible, set up a monitor so that I can be face to face with the people I'm talking with—only glancing at the monitor occasionally to check my camerawork. I accept a discipline of being part of what is taped instead of separating myself with the camera as a "tapemaker."

Ted Carpenter
Catalog
Alternate Media Center

1. Portapaks to the People

■ like to watch for reactions
when I am hooking up my videotape deck to an
ordinary television set. Whatever people have heard
about it, they are often astonished to see that a
picture can travel from the reels on the deck to the TV
screen by means of a small wire attached to the
antenna leads. If we think about it, of course, it might
be even more astonishing that a picture can bounce
off a satellite from Tokyo to New York City,
pretty much *without* wires. But normal television
comes to life whenever we push the button, and we
have stopped thinking about it. We know that the
manufacturers of our TV sets and the manufacturers of
the programs will, between them, keep the thing
working.

But videotape is something else. One reason for
this is that the industry has developed in a quirky way,
not always following the predictions and prescriptions
of the manufacturers and publicists; people are
surprised at what it does because they haven't been
warned. In addition, people often get an immediate

sense of the startling potential of video—it doesn't take long to see that its development may literally change our world. Many educators believe that the video study carrel will be the classroom of the future; many political idealists believe that video will unite communities and help to break down unresponsive social structures; many businessmen, lured by the prospect of huge future revenues, are positioning themselves for the great chase for video profits; and, most important, many individuals are learning that television is not just something to watch but, because of videotape, a means of communication available for their personal use.

History

When it was developed, during the 1950's, video-tape was only for broadcasters. By the end of the decade there had been considerable fanfare about the fact that moving pictures could be recorded by an electronic process on magnetic tape, not unlike sound tape, rather than on light-sensitive film, like photographs. This offered huge practical advantages to the TV producer. Unlike film, tape could be played back immediately, avoiding the delay and expense of film processing. Just as important at the time was the fact that finished tape had the look of live TV, as kinescopes (films of the TV picture) definitely did not. The immediacy of TV was one of the exciting things about the medium; it was important to the viewer to know that he was watching "Your Show of Shows" or "Studio One" as they were actually happening. (I was briefly a floor manager at a local station before tape was in common use, and we sometimes did *live* commercials for the late movie, on and on into the night.)

Videotape in broadcasting made the TV experience seem immediate even when it wasn't, and at the same time the technical blunders, blown lines, dirty words, and other embarrassments of live TV could

be taken care of in the privacy of the studio.
There was also the attractive feature that all concerned
in the production could be doing something else
when the program was aired, and so time could be
organized more efficiently. The idea of videotape for
the home was talked about then, but mainly as
a miracle for the future and entirely as a consumer
convenience—some day the viewer would be able to
record his favorite program while he was out for
a drive, so that he could see it when he came home.

Today, broadcast videotape has improved in quality
and flexibility. The two-inch tape and the complex
studio equipment used in broadcasting are still not
portable enough to be much help in late-breaking
news or in location shooting, where film is more
prevalent, but certainly live TV is a thing of the past
except for those predictable real-life occasions that
happen reasonably on schedule, such as sports events,
political conventions, or Senate hearings.

Instant Replay

Actually it is sports that has made videotape famous
because of the conspicuous use of one of the key
properties of tape—instant replay. Most broad-
casters have now switched to a disk system for this,
but it is still best known as a videotape feature.
After the touchdown is scored, someone in the control
booth pushes a button to rewind the tape (or
disk)—which may have been recording from a
separate "isolated" camera not seen on the air—
and within seconds we can see again what we have
just seen. This is exactly what the mind wants to do
after any surprising or important moment: to go
back again and again, to make sure it understands,
and to fix the event in memory. It is enormously
satisfying to have the assistance of a machine for the
job—with no trips to the lab, no waits for processing,
no need to drag out the projector and unfurl the
screen. Before the teams on the field have even

regrouped, we have studied the play from several angles, backwards, forwards, and in slow motion, and we have been able to make our own judgments about it.

The average person appreciates the instant replay of the touchdown pass, but he is only beginning to understand the implications of instant replay of his business conference, his daughter's birthday party, his psychotherapy session, or his golf swing. Schools, libraries, hospitals, community centers, and businesses are just beginning to understand how a replay of what happened in one room (the principal's or vice-president's office, the operating room, the local police station) can be usefully shown in another room (the parents' meeting, the sales conference, the class or club meeting) if not instantly, at least very quickly. The value expands geometrically when those in the second room can make their own tape in response, so that small networks are set up, when and where they are needed.

The Personal Medium

Part of the value of videotape derives from the way we think of television itself. There is no need to establish that television has profoundly influenced modern life. Many people have eloquently described how their habits, their values, and perhaps their postures were formed on long afternoons after school, sitting in front of "Howdy Doody" and "The Lone Ranger"—or "Sesame Street" and "The Flintstones."

Marshall McLuhan's ideas from the early sixties concerning the impact of television are still being discussed and extended. His basic notion, very briefly, is that TV is the medium of our times because it is supremely "cool," i.e., it involves the viewer. Since the screen is small and the depth of the picture is limited, the image has relatively low definition. According to McLuhan, the viewer's mind must

actively participate in the TV experience in order to fill in the gaps, so to speak, and we are ultimately affected more deeply by anything we participate in.

Yet it is obvious that in a different sense we do not really participate in TV at all. Many would argue that the ugly parade of game shows, talk shows, situation comedies, and polite news packages has turned us into a nation of passive zombies. Is network television really a communications network, or is it rather a sales medium, programmed to stifle real communication and to hide or ignore the real needs of people by appealing to bland common denominators?

The virtue of videotape is that it requires participation in TV in the most complete sense. It uses television to beat television. Its communication is direct and personal; it converts the passive TV watcher into the active TV maker.

For better or for worse, TV is now the source of most of our information. People are at home with it; they have grown up with it, and they aren't intimidated by it. Although broadcast TV is removed and impersonal in many ways, there is ironically an intimacy to it because what is on the screen is, at its best, casual, spontaneous, and offhand and because there is such a close physical relationship between the viewer and the screen. (As the fashion in screens gets smaller and smaller, the relationship becomes more and more intimate.) We trust our TV set in some instinctive way—the medium itself, the box. It has shared a great deal with us—walks on the moon, state funerals, soap operas, Super Bowls.

This is why it is overwhelming to see our own street on the TV set, our own friends and family, the corner store, the neighbor's dog and, most incredibly, ourselves. The friendly impersonality of TV becomes vividly personal. This is the videotape experience.

There is a technique sometimes used in psychotherapy in which a person is asked to sit facing a television set while a camera, positioned just above

the set, takes his picture, feeding a closed-circuit close-up of his face to the TV. He is confronted with his own image, not as in a mirror where everything is reversed, but straight on, as others see him. It is also unlike a mirror in that he is in fact on television—in the same place and framed by the same plastic as David Brinkley and therefore automatically to be measured by some of the same criteria as David Brinkley. The therapist will ask questions. (Who is that person? What do you like about him? What do you dislike?) This is not necessarily as unnerving as one might think. A recent study of psychiatric inpatients who had undergone the experience, and who might be expected to be most uneasy about it, showed that although 77 percent suffered initial anxiety, 68 percent ultimately responded favorably. Other data has confirmed that, with the exception of psychotic individuals, most people approve of themselves on TV. Of course, at first we check out the sensitive areas—hairline, double chin, whatever—but we are also basking a bit in being *on TV*, in looking quite normal and the way people on TV look.

I have used videotape for various purposes with groups of all ages and levels of sophistication, and there is nearly always some degree of pandemonium as they look at themselves the first time, either live on a monitor or in playback. Youngsters will shriek, make faces, or quite often go immediately into some role that seems appropriate to them for TV—particularly if there is a good prop around like a microphone or a cap pistol. When things have settled down, they are likely to admit, as one girl did to me, "I didn't know I looked that good." Adults go through the same process without showing it so much.

Even if we agree philosophically with McLuhan that TV requires our participation, the idea that television is something that we can *really* participate in and use—right now, and for any purpose—is hard to take in.

Even professional videotape makers, although very accustomed to the medium, often remain absorbed with the videotape phenomenon as a thing in itself. I have known professional groups to work hard all day shooting a tape for a hospital or a school and then sit around in the evening watching TV—not "Cannon" or "Columbo," but the picture from a live camera monitoring their own activities. John O'Connor of the *New York Times* described an interview with members of a video group, in the presence of their portapak and monitor:

> . . . back at the loft, the three members of the group trained a video camera on their visitor [the writer] to demonstrate the unsettling effects of the closed-circuit image as a sort of "time-machine."
> For one thing, there is another defined presence in the room. For another, that presence is not simultaneous but delayed by one-thirtieth of a second.
> The self-conscious interviewer, then, found himself glancing at himself, not into a mirror but at the flip-flop image that he rarely sees but everyone else always sees. To complicate matters, the three being interviewed would sometimes talk directly to the visitor, sometimes to the imperceptibly delayed "surrogate image" on the screen.

The powerful TV image can be turned into something homey and private—people eating dinner, people sitting around, even people watching TV, people talking about their own concerns in terms that may be undecipherable to more than a very small community. The smallest concern plays on the same stage with the so-called large concerns—wars, depressions, world series, and the rest.

Bypassing the Networks

Indeed, at times the small concern can seem to literally force the networks off the air. The signal from a videotape recorder normally flows through a cable

to a special monitor, a TV set specially wired to receive it. The signal can, however, be adapted to work on radio frequencies as all broadcast television does, by the insertion of a small device in the playback deck. The homemade tape can compete directly with ABC, NBC, and the others (on an unused channel) when the deck is connected to anyone's home TV set through the antenna leads.

I saw the effect of this with a group of thirteen-year-old boys I had been working with in East Harlem. Over a period of months the boys had put together a TV action drama, complete with automobile chases, rooftop pursuits, and a final shoot-out. In the editing process they included titles, credits, and a pounding background score taken from a record. What to do with it? They wanted families and friends to see the tape under the best circumstances, and they decided to take it into each boy's home so that everyone could be comfortable in his own living room, watching his own friendly TV set.

During several days and nights we trooped from one building to another, the whole group moving along to each new location. The parents at first were no more than tolerant. Their attitude usually changed, however, as they watched their sons in action on the living room screen, sounding and moving very much like the characters in the show that had just been turned off on that very TV. Younger brothers and sisters were gleeful; aunts, uncles, and grandmothers were incredulous. Partly because their TV set itself meant so much to these families, the boys were instant celebrities.

As later chapters will show, the power of TV is now being stolen away from the networks and is being put to active use by many people for many reasons. In every field, people are discovering that television can be harnessed for very specific and immediate uses. Some videotape users in large organizations have equipment nearly as extensive and sophisticated as that of a network studio. Most

pioneering tapemakers, however, are dealing with half-inch tape and with *portapaks,* the generic name for the lightweight, battery-driven camera and recording deck that is the most flexible system on the market. The portapak has transformed television making into an everyday possibility for thousands of people.

At the same time, videotape is coming to the public's attention in many other shapes and guises. Cassettes and cartridges of various kinds are being vigorously hustled to those who need the wide distribution that cassettes can make possible. Pepsi-Cola, for example, sends out a series of cassettes on production and sales training to its bottlers. The Ford Motor Company has a similar program with its dealers. Many producers are putting together cassettes for the home, from old movies to courses in speed-reading or how to take care of a baby, in the hope that sooner or later people will be buying playback machines for the living room. Video disks will soon be competing for this market.

Most of these are attempts to borrow from and to extend the television experience *exactly as it is now*— a big broadcast, by one means or another, to a passive mass audience. But it is the person or group who are making their *own* tapes who are the focus of this book. The distribution of the tape may be no wider than a playback for the tapemaker himself, or a closed-circuit image to the next room, or a broadcast on the local cable television channel where the message can be sent out to the whole neighborhood. In any case, the individual has stopped just sitting in front of his TV set and instead has gotten up and started to use the medium for his own purposes. Compared to the awesome future developments in video that are now being dreamed about, when it may be as universal and as personally useful as the telephone, today's technology is still rudimentary and haphazard. Today's portapak user is still fumbling with basic techniques; the sense of what

video is all about, what it means for society, is just emerging. But the first steps have been made, and without doubt the video revolution is under way.

How do you reach low-income people with information that has a direct bearing on their future well-being? On Saturday, I made myself and low-cost portable TV equipment available to all the candidates who wished to represent the poor on the Community Action Board. Each candidate was interviewed and asked to state what he hoped to do for the low-income people if elected.

Monday morning, I took my videotape recorder and a large TV set to Surplus Foods where low-income people must sit and wait to receive their monthly allocations. The TV program was played over and over again. This process made the people there aware that an election was in process that could affect their future. They also were able to meet their potential representatives. Outside of Surplus Foods was a mobile voting truck where they could vote upon leaving while the information was fresh in their minds.

Since over 50 percent of the entire county votes came from Surplus Foods on Monday, one could conclude that this new closed-circuit TV approach to information distribution was a success.

The results of this experiment have implications for the future in terms of getting needed information to the economically disenfranchised. One reason the antipoverty programs have not been more successful is lack of getting out the information on resources available to the poor and how to take advantage of them. For a very low cost, TV programs in say ten- to fifteen-minute packages could be shown in places where the poor were forced to sit in limbo for extended periods of time. I'm thinking of such places as Social Welfare, Surplus Foods, Unemployment, and medical clinics. The medium of TV is much better suited for information exchange with the poor, as in many cases they are kept disenfranchised due to lack of literacy. Information packages would relay information on retraining, tenants' rights, food and child care services, or even how to organize to solve their own problems. . . .

H. Allan Fredericksen
Community Access Video

[Shirley] Clarke [the artist-filmmaker] is intrigued by the way an image on a VT monitor can be doubled, tripled, and quadrupled. She calls this process of feeding material back and forth by focusing the camera on the monitor, "enfolding." "Videotape asks us to see more than we are normally aware of and requires that we retrain our perceptions." The portability of half-inch tape is another important factor. I counted seven monitors in her garret-studio, but there were numerous others placed throughout her two-tiered apartment. Several were "videoballs," small spherical containers for monitors with chain handles which can be carried easily by one hand. . . .

At John Lennon and Yoko Ono's recent art show in Syracuse, N.Y., Clarke carried one of the videoballs throughout the gallery, feeding participants images of themselves. When Jackie Cassen, another video

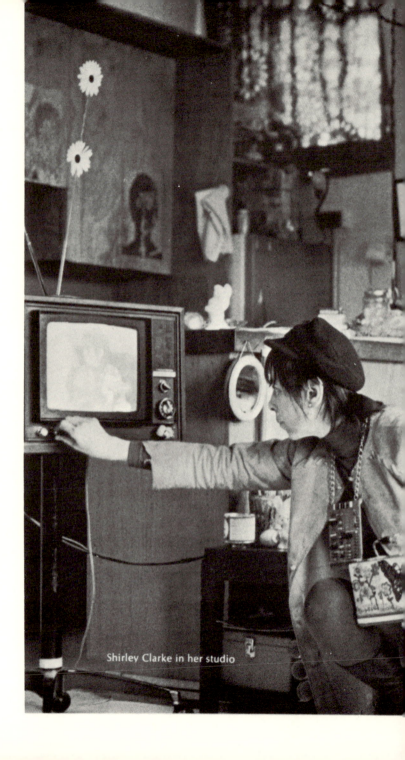
Shirley Clarke in her studio

artist, came to visit Clarke in her studio she was met with a camera and monitor so that she and Clarke could respond to one another via the tape medium. Shirley Clarke sees this aspect of VT as "the ability to play and enjoy playing which we have lost as a life-style in America. Things are either foolish or serious. Lots of videotape is game-playing in a nice, healthy way."

Filmmakers Newsletter

Video Crime-Busting

The Accident Investigation Squad of the New York City Police Department has received special grants to use portapaks to help nail drunken drivers. The suspect is brought into a room where the video recorder tapes his behavior as he walks the traditional straight line down the middle of the room. Such tapes have been used as evidence in court, but often the suspect, confronted with an instant replay of his wobbling, crumbles and pleads guilty.

In Chicago, the Police Department Crime Laboratory takes a portapak on criminal investigation assignments. One technician tapes the scene, recording all standard types of evidence as well as special material requested by the detective in charge, while his partner dictates into the system's microphone a verbal description of what the camera is viewing. The tape becomes a permanent and immediately accessible record of conditions at the scene of the crime. Also in Chicago, police have used video to help identify suspects. In one criminal assault case, the injured victim was in the hospital when the suspect was located. Since she couldn't leave her bed, the graphic arts department videotaped the lineup in the precinct station and then played it back for the victim in her hospital room, where she was able to pick out her assailant.

The Connecticut State Police are using video to

deal with highway violations. With both a camera and a monitor in a patrol car, the troopers can follow a car suspected of being stolen or behaving erratically or illegally, and they can make an indisputable record of what they see. After following the car and recording its actions on tape, the trooper picks a safe stretch of highway to pull the offending driver off the road. He then asks that the driver accompany him to the patrol car where he replays the videotape image of the violation. "The psychological effect of the visual image, accompanied by the factual commentary of the trooper, is tremendous," reports a spokesman.

II. Video and Film

To understand television and to use videotape effectively, it is helpful to realize first that it is not film. Many tapes have been transferred to film and obviously many films have ended up on TV, but there are significant aesthetic and functional differences between the two. Many video practitioners have never been involved in film, and those who may have had film experience soon learn that the principles and techniques of that medium are not always applicable in making tapes.

On a basic technical level, a motion picture is a series of still photographs, and a videotape is a series of electronic messages stored on a magnetic tape. A piece of exposed film will show the actual pictures that, when projected at twenty-four frames per second, give the impression of a moving scene. A piece of videotape, however, reveals nothing to the naked eye. As we shall see, it must be scanned electronically and its signal translated into shades of light and dark on the TV screen.

Informal vs. Formal

From the standpoint of the viewer, film is very formal and important compared to television. Even the most casual moviegoing takes place in a general atmosphere of purpose and decision: a specific film must be chosen, given all the pros and cons of critical opinion, showing time, price, etc.; a trip to the theater must be planned, involving baby-sitters and dinner arrangements. Once at the theater, the spectator is in a dark room, confronted with nothing but the film, and the value of the experience depends almost entirely on that.

TV, on the other hand, is seldom important. People may watch TV for hours at a stretch, but they don't consider that they are making any great commitment to it. The lights are on, so the screen does not necessarily dominate the environment. The viewer wanders back and forth, eats, talks, perhaps even reads. In most cases he does not make any serious decision to watch in the first place, and he feels he can leave when he wants, without sacrificing any investment on his part.

This casual approach to television might be only a normal reaction to less than compelling programming, but it also suggests the kind of ease with which we treat even those TV programs we are eager to watch. Television has been integrated into the routines of life, and the instrument is taken for granted, like a telephone. It is on a human scale.

Thus the TV image gives the impression of being more an open window on reality than something consciously constructed and shaped. The meandering conversations of sports announcers during a game would seem silly in a movie theater, where we are used to structure. At home, we don't mind, just as we are content with TV talk shows that are *occasionally* interesting or amusing. Our minds go elsewhere, or just rest, during the boring parts— exactly as they do in life. Television, like life, is a

process; it is going on all the time, and if we miss something at one moment, we'll pick it up later.

Differences in Image

We almost never *see* television very well, in comparison to film. The quality of the picture, for all kinds of reasons, is just not as good. Ironically, this very fact gives TV a sense of reality and immediacy; it has a built-in roughness around the edges, like life—no machine has polished it up or honed it down. The movies have sometimes chosen to work at the *illusion* of this kind of immediacy, with grainy film, hand-held cameras and harsh light, but TV can scarcely avoid it.

Thus, certain guidelines have been dictated for TV and video producing. Because the picture is small and relatively empty of detail, television makes heavy use of close-ups, so that we will know what we are looking at. When the camera pulls back for a panoramic scene (a crowd at a rally or half time at the game), the viewer is usually left with a vague blur, even in those relatively rare cases where the TV set is getting good reception and is properly tuned in. Famous film long shots like the pullback at the end of *Bridge over the River Kwai,* or the opening of *Shane*—where the horse and rider are first picked out as a dot on the horizon and then approach the camera very slowly over a period of minutes, building suspense all the way—are simply lost on television.

In addition, the TV image seems much more two-dimensional than the film image. The various and subtle gradations of light and shadow are what create the illusion of three dimensions, and normal TV transmission is not capable of that much detail with light. (There is the additional factor that the little knobs on the receiver can control the brightness and contrast of a picture, so no one can ever be sure that the light coming in is what was intended.) But if the TV camera cannot capture an abundance of

visual detail, it can, because of its own properties, transmit an image that seems more alive, more real, and directly in the rough and tumble of life. The telling small detail in a film—the glance that expresses an important emotion, the dropped key that may be the foundation of a whole plot line—is not for television. But the interview with someone in the news, where the person's face is the predominant image and the news is hot, has an impact which is not possible to film.

Differences in Sound

The interview is a recurring TV form—it is perhaps the predominant TV form—for yet another reason. Interviews depend more than 50 percent on *sound*. Once again, because of the relatively poor quality of even the best TV picture, sound plays a much different role than it does in film. A successful screenwriter, describing the differences between a screenplay and a television script, said that TV is really "illustrated radio." There is some truth to the observation.

Films thrive on silence today almost as much as they did in Chaplin's day. Our visual concentration in a movie theater is so intense that sound must be very carefully used, so as not to be a distraction, and most laymen would be surprised to realize how little actual dialogue the average film contains. TV, on the other hand, is jabbering constantly. For one thing, the advertisers want to make sure their message is getting across whether the viewer is actually watching or not; but words are necessary for many other reasons. If a dropped key is important to the plot, a TV character must also say, "I've dropped my key," or we might miss it. Likewise, many have complained that the TV "commentator"—the voice in the background while some event is being shown— is a useless holdover from the days of radio. Actually he or she is there to help us interpret the

vaguely fuzzy pictures we are watching. There may be a better way to do this, but the garrulous sportscaster can be helpful, simply because, on the small screen, it is not always easy to tell a base hit from a foul ball.

An old saw from television applies as well to videotape: a good picture with poor sound is frustrating or boring to watch, but good sound can often save a poor picture.

Relative Pros and Cons

The relative advantages of film and videotape could be described in the following way:

On the side of film:

1. *The film picture is better.* The very size of the projected picture, for one thing, makes it easier to watch. Also, although television technology is improving every day, it is unlikely that videotape in the smaller widths (such as half inch or one inch) will ever have the picture quality of equivalent film gauges (Super 8 and 16 millimeter). The film image is also more stable and not subject to the unpredictable rolls, slides, jumps, and glitches that are still familiar on TV. Color, too, is better in film, and at this point cheaper and easier to achieve.

2. *Film distribution is easier.* The facts here too are changing dramatically with every passing month, because of the growth of cassettes and cable broadcasting, but it is temporarily true that there are more 16-millimeter and 8-millimeter film projectors around than playback decks for videotape.

3. *Film is more capable of a professional finished product.* Sixteen-millimeter film can be edited very precisely and with a wide range of special effects— dissolves, wipes, sound mixes, etc. Tape is edited in an entirely different manner, but at the present time an edited half-inch tape cannot be as professionally *finished* as an edited film. One-inch tape has the capacity to be just as good as film in this regard, but

it is used only with certain large studio recording decks and not with any portable systems.

On the side of videotape:

1. *Video is cheaper to operate.* The purchase of a fairly extensive videotape system—portapak, editing deck, monitor, and various accessories—might cost more than the equivalent in 16-millimeter equipment (both between $3,000 and $3,500) but the cost of half-inch tape runs approximately $35 an hour whereas the cost of that much film, processed, would be well over $100. In addition, tape is erasable and reusable.

2. *Video has instant replay.* The same machine that records the picture can instantly play it back on a monitor or on the camera viewfinder. This obviously saves time as well as the cost of processing, and it allows the tapemaker to see how he is doing at any time. This property alone makes videotape useful in many areas where film would not be of any value.

3. *Video is easy to operate.* One person can handle a portapak as long as the built-in microphone is providing the sound. In the most popular model, the camera and deck together weigh approximately twenty-four pounds.

4. *Video can record in comparatively low light.* Unlike film, which needs special light for almost any indoor job (and some outdoors), videotape can record using relatively normal light. The strong fluorescent light often found in schools or offices, for example, provides adequate illumination for tapes.

5. *Video has automatic synchronized sound.* In most cases, film presents problems in synchronizing sound with lip movements and other elements of the picture. Although some new film cameras have a sound tape directly attached to the film itself, the typical sound track is recorded on a separate machine and is usually not matched up with the film until the editing stage. In videotape, the sound signal is always recorded on the same tape as the video signal; synchronization is built in. The videotape unit

also records in relative silence; there is no whirring sound and no need for camera insulation, as in film.

6. *Video permits more continuous recording time.* A portapak has the capability of thirty minutes of continuous recording, and a larger half-inch table deck will record for an hour. A four-hundred-foot magazine of 16-millimeter film will run for only eleven minutes.

7. *Video can be used as closed-circuit TV.* Videotape equipment can be useful without recording anything whatsoever because it is in effect a basic closed-circuit TV system. A live picture can be transmitted from the camera to the monitor, entirely bypassing the recording stage.

Of course, there is a whole series of interchangeable qualities between video and film, and a person could learn much about film techniques by experimenting with video, and vice versa. The camera lenses, for example, are functionally the same, and many principles of picture composition and story-telling techniques are shared by both media. The basic point, however, is that neither film nor video should be considered simply a larger or smaller version of the other. Each has its own style, so to speak, and the following chapters will attempt to make this more clear.

It is also true that the nature of film has been pretty much established, and the ways of dealing with it are, by now, well known, whereas the possibilities of videotape are still being discovered. It has not, as someone said, been quite invented yet. What seems to be a limitation today may be no problem at all tomorrow. If videotape seems now only awkwardly adaptable to a certain use, some small technical or conceptual breakthrough around the corner might open up new possibilities.

This brings us back to the notion that videotape is on a comfortable human scale. If indeed it has not quite been invented, the people using it are continuing to invent it. Modifications have been made on

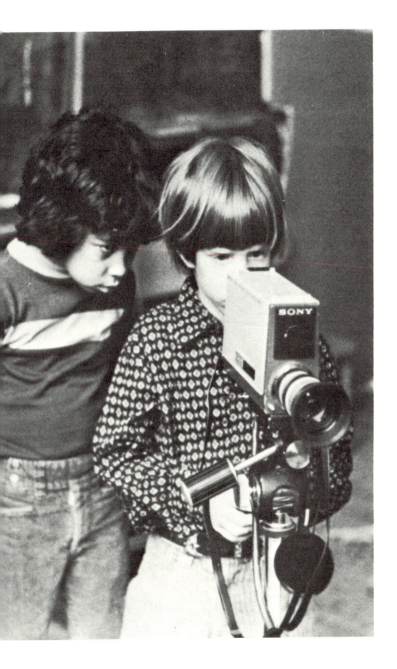

the equipment by the manufacturers under the pressure of real tasks that had to be accomplished. The electronic editing function on some half-inch models, for example, is a feature that the manufacturers overlooked until the buyers started insisting on it (another indication that the product was originally designed as a consumer toy). Around the country there is a growing information network about the handling and care of videotape equipment. New ideas in shooting, editing, wiring, adapting, buying, renting, carrying, and storing video components are freely traded around, as well as passionate opinions about what to use video for.

In a sense, everyone is at the learning stage with this medium, and so there is a feeling of freedom and community among those who are dealing with it. We may talk about the "nature" of TV and videotape, but there are really no rules or codes and, most of all, no restrictions on what anyone may cook up, either electronically or in terms of putting the thing to work.

The unique environment of a working ship poses
certain logistical and jurisdictional problems in
regard to student training. In at least one instance
the incredibly difficult working environment of the
engine room aboard the T.S. *Empire State IV* provided
the impetus for the pioneering use of videotape
as a training tool to facilitate the technical training of
Marine Engineering Cadets. The obstacles of noise,
heat, dirt, and congestion below decks set up barriers
to communication that would hardly be tolerated in a
learning situation anywhere else.

During the 1971 Summer Sea Term, I produced a
16-mm color film which detailed the procedure of
"changing burners" on the steam boilers of the
training ship, in addition to other auxiliary techniques.
However, it required several months before the results
of this labor could be put into practical classroom
use. From the utilitarian point of view, the possibility
of "instant playback," with the immediate feedback
feature of correcting improper techniques literally
on the spot, is the most compelling justification for the
effort involved in videotaping under such arduous
conditions. The very act of lifting the teaching
environment of the engine room visually out of the

bowels of the ship is a considerable achievement from the vantage point of those instructors who have doggedly struggled with the dilemma for years.

The other major contribution of videotape on its "maiden voyage" with the *Empire State IV* was the recording of boat exercises, that is, boat-handling drills involving ten cadets who are evaluated on their demonstration of proficiency in lowering, rowing, and maneuvering an open boat. Upon the cadets' return to the ship, the tape was played back in the main classroom where a twenty-three-inch monitor had been installed on a rigid metal pole frame to withstand the dynamic motion of the ship, with its pitch, roll, and yawl movements when under way. The act of confronting visual evidence of their boat-handling exercise proved to be a humbling experience for some, and elicited an enthusiastic response from both the cadets and the faculty concerned. While the physical exertion was still evident in terms of aching muscles, the cadets were able to reexperience their performance under the most vivid conditions, in a critique setting impossible with any other means except videotape.

Ronald C. Bowman, Director
Educational Communications Center
State University of New York
Maritime College
Fort Schuyler, Bronx, N.Y.

We first became involved with the Alternate Media Center in late August of last year. We were passing the afternoon playing guitars on a bench by playground 10 in Stuyvesant Town. Burnes and Eileen decided to tape our music as a part of their project on Stuyvesant Town, and they showed us how to operate the camera so that we could do some of the taping ourselves. When we went down to the Center to see the tapes, we were asked if we would like to participate in making other tapes in and around Stuyvesant Town. . . .

We shot our first tape with Burnes in Stuyvesant Oval. We tried interviewing children, young mothers, and old people concerning their satisfaction with life in the Stuyvesant community. We weren't very satisfied with these tapes for several reasons. First of all, we really were not very interested in the questions we were asking. Secondly, we were more concerned with our video image than we were with our subject. We felt a need to appear as professional as Chet Huntley, and as a result we appeared as uncomfortable as we felt, playing the role of a network news team. . . .

In the middle of September we decided to start a long-range serious project in the environment we were most familiar with: Stuyvesant High School. We first went about this by taping talks with students and other people on the block. These interviews were good in the sense that they had value for anyone interested in Stuyvesant High, but we felt that the people we talked with were not being totally honest with us, and the tape did not reflect a true or complete picture of Stuyvesant. . . .

The aim of our first Stuyvesant composite tape was to create a collage showing several aspects of a typical day. We shot segments of students hanging around the building before class, an environment class, an English class, boys' and girls' gym classes, a trip through the cafeteria, desk graffiti in an empty room (a scene which we later sound-dubbed with our version of "Teach Your Children"), and an orchestra rehearsal. We felt that this tape reflected the beginning of a new direction for us because for the first time we didn't have to depend on interviewing for our subject matter.

<div style="text-align:right">

Robert Swidler
Matthew Kasman
Catalog
Alternate Media Center

</div>

III. What is Video

One of the good things about video is that the equipment is designed to be operated by virtually anyone, from astronauts to English majors. The amount of basic electronics necessary is minimal, although it is probably helpful to the prospective user to understand some general principles and to understand also how the video industry is developing at the present time.

There are two extremes in people's approach to this field. On one hand there are those who shy away from anything that seems remotely complex. From my own experience in training people to work with tape, I have found that many teachers, social workers, and other professional people handle the recording decks with trepidation, especially fearful of such matters as threading the tape. The big push within the industry toward cassettes and other automatic devices is partly motivated by a desire to calm these fears. However, cassettes are at present basically designed for playback rather than for recording.

At the opposite extreme from the nervous fumbler

is the video freak, high on electronics. His world is full of sync pulses, rasters, and sawtooth sweep voltages, and his interest in videotape is in how the equipment does what it does and how it can be modified to do more or better things. These specialists are likely to be self-consciously wired into the electronic "revolution" and are fond of using electronic terminology—feedback, interface, input-output—in nonelectronic conversations. They can be unnecessarily intimidating to the person who is less educated in these mysteries but who is certainly capable of operating a video system.

Most of us are in between, trying to pick up whatever we can and often talking a better game than we play, in terms of technology. A brief description of what television is, however, may be helpful.

How Television Works

Like film, television is made up of a series of still pictures which are flashed quickly before our eyes (thirty times per second) so that persistence of vision in the eye and brain gives us the impression that we are watching a "moving" picture. The still pictures, again like film, are called "frames," but it should be remembered that they are the product of electronic messages rather than photographs.

Within a TV camera tube, light from a scene— a man seated at a desk, for example—is focused by lenses onto a light-sensitive screen, or target. The target becomes charged in accordance with the intensity of the light striking it, corresponding to the variations in light and shade in the original scene. The electrical image thus stored on the target cannot be transmitted as a whole, so the thousands of individual picture elements—similar to the dots in a news photograph—must be scanned, one at a time, by an electron scanning beam. The scanning is done in an orderly fashion from left to right and from top to bottom of the screen, one line at a time. As the

entire target is scanned, the electrical image stored on it is converted into a "video voltage." This is the TV signal.

To obtain the greatest amount of picture detail (called definition or resolution), there should be as many horizontal lines as possible for each image, all else being equal. Most half-inch videotape recorders have in the neighborhood of 300 lines per frame, which is a generally acceptable resolution for this type of machine. (Efforts to increase the horizontal resolution of videotape cameras and recorders have often caused worse problems in other areas, such as picture stability.) To avoid flickering, each frame is actually scanned twice, first the odd-numbered lines and then the even-numbered lines; these are called the two "fields" of each frame. Since the whole frame is repeated thirty times per second, there are, then, sixty fields per second.

Along with the picture signal, there is a sync signal, a pulse which assures that the picture received on the TV set is exactly the same as the picture transmitted from the camera. Thus, when the composite video signal (sync and picture signal together) arrives at the receiver, the matching sync pulse

guarantees that transmitter and receiver are operating (scanning) identically.

On the receiving end, the picture signal goes through a process not unlike what happened at the

transmitting end. The picture tube—the face of the TV set—has a phosphorescent coating on the inside. This means that it will release light when struck by electrons. An electron beam scans this screen, guided by the incoming signal, releasing light in direct relationship to amount of voltage. As a result, a replica of the picture scanned at the transmitter— the man at the desk—is produced by the changing brightness of the scanning spot on the receiver screen.

There are several ways of transmitting this picture from the camera to the receiver. The most common is by way of radio frequencies, the normal VHF channels (2 through 13) and UHF channels (14 to 80, potentially) that TV antennas can pick up out of the air (more or less, and with the aid of aluminum foil wands and other homemade inventions in areas of bad reception). This is an open circuit: anyone with an antenna in a given area can pick up the signal.

Closed-circuit transmission (CCTV) implies an actual wire or cable between the transmitter and the receiver. A school may have a closed-circuit system, for example, with a camera in a studio and monitors in various classrooms. Banks, stores, and other public

places use closed-circuit systems for surveillance purposes, where a camera watches over one room, transmitting what it sees by cable to a monitor in another room. At the bus terminal at the George

Washington Bridge in New York, monitors in the the waiting room let the passengers know when the buses have arrived at their gates.

A type of closed circuit that is growing very fast is CATV (Community Antenna TV), more familiarly known as cable television. Cable came into existence because some areas simply could not get good reception on the normal VHF channels. A town situated in a valley, for example, might have very poor reception of the open-circuit signal because of the surrounding geography. In these cases, a community antenna could be placed somewhere nearby where the reception was good, and the signal could be relayed from the antenna to each individual house through a cable. By now, of course, the ramifications of cable TV as a new avenue of communications have far transcended the problems of the TV-less town.

Then there is videotape. Here the transmission is interrupted before it arrives at any receiver, and the information (the signal) is stored for a later time. It can of course be mailed, shipped, or carried by hand to its destination. At that point, the signal may be transmitted from the tape deck to a receiver.

This process is possible because videotape, like audiotape, has a magnetic coating. The recording head of the video recorder changes the polarity of this magnetic coating according to the signal it receives from the camera or other source. When the tape is played back, this same polarity pattern induces a current which creates the picture on the receiver, just as we saw with direct transmission.

Types of Videotape

Videotape has gone through many technical developments in a very short time, and there are many different kinds of video systems now being used. These are usually distinguished first of all by the width of the tape being employed—two inch, one inch,

three-quarter inch, half inch, and quarter inch.
(In addition, there are several products that look
like tape in cartridge form but are really *film* adapted
to be played on home TV sets.) Generally speaking,
the wider the tape, the more information can be
stored on a given reel. Thus, other things being equal,
two-inch tape has the highest quality and quarter inch
has the lowest. From another point of view, of course,
two-inch tape is very unwieldy and quarter-inch
tape is very flexible.

Because of its cost and complexity, two-inch tape
is used in broadcasting and almost nowhere else.
One-inch tape, at this point, is in extensive use in
education, business, or wherever the videotape
demand is such that the institution maintains a TV
studio as part of its operations. The one-inch tape deck
produces an extremely effective job in terms of
picture stability, precision of electronic editing, and
the possibility of more than one sound track. The
equipment is not portable, however, and is at least five
times as expensive as a half-inch deck. (For further
information on this subject, the reader should refer to
Small-Studio Video Tape Production by John Quick
and Herbert Wolff.)

Half-inch and quarter-inch tape widths are used
for all portable systems. (To my knowledge, only one
company, Akai, is manufacturing quarter-inch
equipment.)

The Confused Marketplace

The video industry is only a few years old, and,
with typical American (and Japanese, since many of
these companies are based in Japan) energy and
inventiveness, it is still running off in all directions,
searching for the pot of gold, the sure thing,
the one indispensable system that will make all
others obsolete.

Great sums have been spent on research and
development in the video field. One of the most

heralded early projects was EVR (Electronic Video Recording) which CBS worked on and invested in to the extent of $34 million. EVR is one of the products that is not videotape at all but a special film process designed to be played through the home TV set. Because it had a jump on the market, EVR attracted considerable initial interest, but serious bugs turned up in the process, long delays ensued, and recently CBS has been disassociating itself from the whole thing. EVR continues, but its future is in doubt.

On another front, at this writing at least six companies are hard at work on a video disk, a device that will play on a turntable like a long-playing record, feeding sound and picture into anyone's TV set. The obvious advantages are in the area of mass marketing for the consumer, since a given show or movie could be stamped out, like a record, and thus distributed cheaply.

Within the field of videotape alone, companies have been falling over one another to catch the public's fancy with new developments in engineering or packaging. Understandably, buyers have become anxious about the possibility that if they invest in one format today, the entire industry may switch to another tomorrow; that if they like the half-inch mode, all cassettes may standardize at three-quarter inch; that if they want reel-to-reel systems, they will be abandoned when color becomes widespread; that, in short, they will be somehow left holding the bag. Videotape is, after all, a communications tool, and people want to be able to easily show their tapes to other people.

The question of color and the question of cassettes, for example, have recently compounded the confusion. Although some manufacturers are developing half-inch color cassettes, Sony, which has heretofore led in the half-inch field, has come up with a color cassette player/recorder called the "U-Matic," which uses *three-quarter-inch* tape. Big institutional users of videotape have found this unit an extremely

reliable and efficient way of distributing tapes on a large scale. (The United States Army, for example, has announced that it will be using from six to ten thousand machines of this type for training purposes.) As a result, other companies are entering the three-quarter-inch U-Matic market.

It should be noted, however, that the U-Matic variety is intended precisely for such customers as the U.S. Army—those whose main interest is in wide distribution. Although the unit has recording as well as playback capability, U-Matic tapes are most often made professionally in a studio on two-inch or one-inch tape (or on film) and then dubbed onto three-quarter-inch tapes for distribution. The many half-inch systems—reel-to-reel and cassette—in service or being developed are intended for more informal, more adventurous uses. To put it most simply: half-inch equipment is designed for the widespread *making* of tapes, rather than for the widespread distribution of tapes already made in a professional studio.

For this reason, color is not yet prevalent in the half-inch equipment. The newer models are all color adaptable, but no manufacturer has yet come up with a portable and inexpensive color *camera*. (A color camera costs at least $2,500.) Those institutions that have U-Matic machines at their disposal can record color programs off the air, but tapemakers, who are the focus of this book, will have to wait for the breakthrough in technology that will make the color portapak possible.

The EIAJ Standard

Despite its limitation in terms of color, the half-inch field is relatively stable and serene, compared to the feverish gyrations in other parts of the videotape market. In 1969, in an effort to soothe the anxieties of prospective buyers, the Electronic Industries Association of Japan (EIAJ), an organization of

electronic equipment manufacturers, established a standard to which most manufacturers of half-inch equipment now subscribe. The EIAJ standard sets certain electronic and mechanical requirements, such as tape speed, length of playing time, resolution, weight, and so forth, and the effect is that tapes made on one company's machine can be played back on a different company's machine. Sony, Shibaden, Panasonic, JVC, Concord, and Ampex are among the companies that have adopted the EIAJ standard for their new half-inch black-and-white equipment. In 1972, an EIAJ color standard was established, and although it is not yet clear how many companies are subscribing to it, most evidence indicates that non-EIAJ half-inch equipment is now being phased out.

Although its position is not clear on half-inch color tape, the Sony Corporation has been the unquestioned leader in developing the portapak, and the great majority of the units that are now around have been manufactured by Sony. The Sony models that follow the EIAJ standard are designated by the letters *AV*. (The portapak is model AV-3400; the portable deck, which is color adaptable, is model AV-8400; the editing deck is AV-3650.) The previous, pre-EIAJ, generation of Sony equipment used the letters *CV*. Although this book will refer most often to Sony equipment for its examples, other manufacturers in the EIAJ group are moving up fast, and Panasonic, in particular, has made a strong commitment to the half-inch format, most notably in color cassettes.

The move toward standardization may be frustrating to owners of pre-EIAJ machines. Perhaps there is consolation in the fact that much of the use of this kind of videotape recorder is internal—within the confines of one group or organization. As such, it usually doesn't matter if the tapes are capable of being played on another organization's machine, so long as tapes and replacement parts remain available. Also, a tape on one format can always be

copied onto a different format, although there will be some loss of quality.

Finding a Dealer

If portability, flexibility, and economy are important ingredients of any proposed video program, the half-inch equipment will probably serve best. Chapter IV will offer a detailed look at the hardware that makes up a basic portable video system. After going over these descriptions, the prospective buyer would be wise to shop around for the right kind of dealer. Ideally, the dealer should handle more than one brand of equipment so that he is able to maintain some objectivity about relative merits, and he should be sensitive to the customer's particular needs. Some time ago I bought my first portapak from a large dealer whose main trade was in closed-circuit surveillance systems for banks, stores, hospitals, and the like. As adjustments and repairs became necessary on my equipment, the company was reluctant to take time away from its big accounts to deal with my ten-dollar problems; neither, I think, did the employees really understand the function of the portapak or what I was doing with it. There are a growing number of dealers, however, who specialize in half-inch machines and who are apostles for the movement—each sale is another convert to an important view of life and electronics. They are well acquainted with the workings of the portapak and can often provide special adaptations that they have thought up themselves. Every portapak user, no matter how adept at electronics, will probably have occasion to need an engineer at some time, and since few of us can afford to have one on staff, it is comforting if he is only down the street, in the person of the dealer.

June 1. **At the community center in Harlem,
eleven sullen nine-year-old boys are herded into a
room carved out of a corridor. We are supposed to do
theater games and improvisations, to start "releasing
their creativity." After ten minutes, seven kids have
disappeared. The other four are induced to create
scenes and games which they do without enthusiasm.
Their point of reference is automatically TV: the
characters, the responses, the sense of** *acting,* **are
mostly from TV reality. One difference: they have fun
imitating junkies; they laugh at each other going
through the nodding, staggering, falling-down junkie
act. Junkies are foolish to them (sinister too), and they
react like kids in other times and other towns used to
react, and still react, to drunks, spastics, old people,
and other inexplicable, and frightening, examples of
human behavior.**

June 5. **This time I take the portapak and just walk
around the place taking pictures—in the playground
and gym mostly, talking with everybody as I go.
Enormous curiosity all around. "Is this for Channel 7?"
After a while they start organizing themselves. In the**

gym, a dozen kids, twelve to fifteen, pretend to run in for lay-ups—without a ball, and so with beautiful style, fancy dribbling and showboating. They do a commercial—two guys surrounded by thirty onlookers and then several others give the camera an earnest guided tour of the charts showing the progress and standing of the center's basketball teams. At the end of this, I announce, in the general confusion, that the tape will be shown on the old TV set in the lounge in ten minutes.

In the lounge I get set up and very few people are around; they've gone back to real basketball. I show the tape to those who are there. The word gets out. They start drifting in. It's really on TV. Unbelievable. They run out to drag in others. Soon everybody is there, screaming and yelling. I run it through twice and would have to keep showing it all night, but we're out of time.

June 8. Walking around the center with the portapak I am surrounded by almost every kid in the center; they keep leaping up and down in front of the lens, showing off, now that they know how the thing works. More than ever, they start to stage things, directing me here and there, improvising boxing, setting up athletic feats in the gym—swinging, climbing, etc. The older boys line up to make a short statement to the camera, announcing their names and some opinion about something, mostly sports.

Everybody is ready for the playback this time, and the scene is a tumult. We play it several times. They find new things in the crowded picture every time they watch it: a long shot of the playground, with fifty indistinguishable people in view. "Look at Ronald! There go Leslie! There go Darryl!"

June 12. Back to the group of nine-year-olds again, this time with portapak. Everyone's excited. We'll do a TV movie. They agree to improvise a story, and we will tape it as we go along. Who will be the pushers, who will be the cops? They spy some ladders piled in a corner. The jail. Two guys get in jail

and start banging on the bars. Another, now the jailer, starts yelling at them. Wait, I'm saying, what's the beginning? Is this it? How did they get in jail? The camera is only half set up. Some try to explain, but most are picking up the story from where it is, and jumping ahead. A jailbreak! I am ready to shoot but the scene is already well under way. I begin shooting as the perpetrators dash from the room, followed by the aroused cops. Wait, I'm shouting, wait for the camera. I hear the scene going on with great intensity in the next room. They have forgotten about me. In their minds they are *on* TV; they don't need the camera.

THE COURT: Gentlemen, to me, this [videotape] in its entirety is the best attempt that can be made as to an expression of this man's present physical condition, both visually and by sound, and these would be, I believe, for that reason exceptions to the hearsay rule, even though it is self-serving: if it is a present explanation of a person's then physical condition, it is admissible. . . .

The plaintiff in the case had suffered severe physical handicaps as a result of an industrial accident. Because of his physical condition, he had great difficulty in performing routine daily tasks. His lawyer, recognizing that this situation could not effectively be described solely by verbal questioning, sought the assistance of Dr. August F. Coppola, professor of interdisciplinary studies at California State College, Long Beach. . . .

DR. COPPOLA: I spent a day at Mr. Young's home, observing the main activities of that day, his routine, observing primarily his physical ability, his interaction with the other people, his responses to the various routines of that day. . . . I made the main observations . . . with the awareness of how I would then

communicate that on videotape. . . . I knew exactly what his schedule would be. He couldn't vary from that, and so unlike other kinds of production, we had to tailor our production to whatever would be feasible with the actual daily routine. . . .

The tape was shot on a Saturday by Dr. Coppola and two of his students. Two hours of videotape were compiled; this was edited down to forty-two minutes, removing malfunctions, dead-time lead-ins, and aspects of activities that were repetitive. It was this forty-two-minute tape that was first shown to the court in chambers, and that the judge admitted as evidence without alteration, after hearing objections. The tape was then shown on a large screen to the jury in open court, and became part of the official transcript of the case.

IV. The Hardware

A basic portable video system includes the following:

1. Tape deck ⎫ These two, as a unit,
2. Camera ⎭ constitute the *portapak*.
3. Microphone and earphones
4. Monitor
5. Tape

If editing is to be done, a table recording deck with a special editing function, such as the Sony AV-3650, and another monitor must be added to the list.

The Recording Deck

Both portapaks and table recording decks function similarly, except that the portapak takes a half-hour reel, as opposed to an hour, and the portapak lacks some of the refinements of the bigger model.
The tape path is more convoluted on the portapak.

In both cases the supply reel is mounted slightly higher than the take-up reel, so the tape is moving *downhill* along this path. For this reason, the video recording head scans the tape diagonally, in what is

called a *helical scan,* which extends the storage space on the tape. (Beginners have sometimes tried to straighten out the tape, so that it will look neater. This doesn't work.)

Sony AV-3400 Sony AV-3650

Most helical-scan recorders employ two video recording heads, one opposite the other at the two ends of what might look like a propeller, if we could see it, housed in a circular drum. During the scanning process, as the tape is moving along its path, this propeller rotates so that the two heads are moving in the opposite direction to the tape. Thus, although the tape may actually be moving around the scanning drum at 7½ inches per second (the EIAJ standard), the relative tape-to-head contact is much greater. The very fast rotation of the tape heads permits the recording of a great deal of information in a short space, and so makes possible the manageable size of the tape reel.

Most videotape recorder (VTR) units include the following controls for recording:

1. A control for *Forward, Fast Forward, Still Frame,* and *Rewind.* (Still Frame on the Sony portapak is a separate button.)

2. A switch to select input—what is being recorded. The possibilities are *TV* (recording off the air), *Line* (recording from another VTR), or *Camera.* (The portapak offers only *TV* and *Camera.*)

3. *Record* button.

4. *Counter.* The measure of tape used.

5. On table decks, switches to select either *Automatic* or *Manual Gain Control,* both for picture brightness and for sound volume.

6. *Edit* button on editing table decks and *Audio Dub* button on all decks, even the portapak. More on this later.

Most table decks (but not portapaks) have the following controls *for playback only:*

1. *Skew* control. This adjusts tape tension when the picture is bending at the top.

2. *Tracking* control. This deals with video "noise," or "snow," which comes from poor tracking. Unfortunately video noise can come from other things as well, such as lack of synchronization and clogged or dirty heads.

3. *External sync* control. Used when the playback video signal is locked to an external video signal. When the playback picture is unstable or noisy, the switch is held down (*Defeat*) to confirm whether the trouble is in the playback machine or elsewhere.

4. *Slow motion* control.

In addition, every VTR has receptacles to plug in the camera, microphone, and earphones. Table decks also have receptacles for a second sound source (*aux in*), another video source (*video in*), and just a plain AC outlet for plugging in the monitor, a lamp, or whatever. In outputs on the table deck there is the plug for the connector to the monitor (slightly different on the portapak); *video out* to send the picture to another recorder; *line out* which does the same for sound; and *RF out*. This last requires that a converter be placed within the recorder to convert the video signal to a radio frequency signal, like the ones that come over the air to the normal TV channels. Then a connection can be made between *RF out* and the antenna terminals on any TV set, and the tape can be played over an unused channel.

All of these features can be found on the Sony AV-3650 editing decks, but the models of other

manufacturers in the EIAJ group are similar. Panasonic has introduced solenoid (electromagnetic) buttons for its controls, which make for greater precision and ease of operation than Sony's mechanical switches.

The portapak deck differs significantly from the table model in that it contains a built-in battery which has a life of approximately forty minutes when fully charged. To operate from house current, the portapak uses an AC adapter from the wall socket to the deck.

The Camera

A TV camera is the easiest camera in the world to use. This is mainly because the viewfinder is in fact a small picture tube—a miniature TV set—so that what you see is literally what you get. This eliminates the problem of light meters, frantic squinting, or courageous guesswork about f-stops or depths of field by those with poor eyesight and/or uncertain knowledge of lenses or camera mechanics If the picture in the viewfinder is too dark or out of focus, then that's the way it will look on the TV set and something should be done about it. This is true of nearly every TV camera, from the huge studio model at NBC to the hand-held portapak. (Only Akai, to my

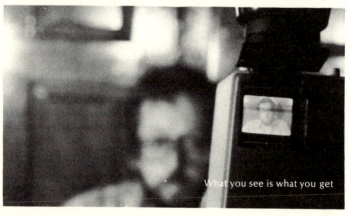

What you see is what you get

knowledge, produces a camera with an optical rather than electronic viewfinder.) Because it is a TV set, the portapak viewfinder can also be used for playback.

Chapter V will deal specifically with how to use a TV camera, but it is helpful to first understand its components and properties. The heart of the camera, as stated earlier, is a tube that contains the screen upon which light is focused. Equipment of the kind we are discussing, which does not have to meet the engineering standards of professional broadcasting, uses a *vidicon* tube which has proved to be a very stable, economical, and efficient tube, equal to most half-inch VTR demands. Other tubes with greater sensitivity are available, notably the *tivicon* (or *silicon diode*) tube. This can record an acceptable picture in extremely low light, but it is not a match for the vidicon in cost and in overall service and dependability.

Studio cameras that can be used with half-inch table decks vary from the portapak camera in several respects. The principal difference is that the studio camera is designed to be linked to a multicamera system by an external sync pulse (see Chapter VII) so that the whole studio system can function uniformly and compatibly. The portapak camera, although not specifically made for it, can work in a multi-camera setup if it is connected to a *camera adapter*. Also the studio camera, unlike the portapak, usually has controls for the brightness, contrast, and horizontal and vertical hold of the viewfinder picture, as on any TV set. These controls do not affect the picture transmitted, but are for matching up the viewfinder picture with the control-room monitor, so that director and cameraman are both looking at the same thing. Adjustments to the viewfinder picture of the portapak must be made inside the camera housing (by an expert).

Lenses

Lenses in television are just like lenses on any

Portapak Components

Panasonic video camera WV-3082

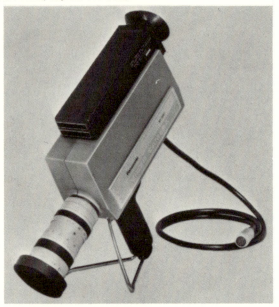

Sony AV-3400/AVC-3400 ensemble

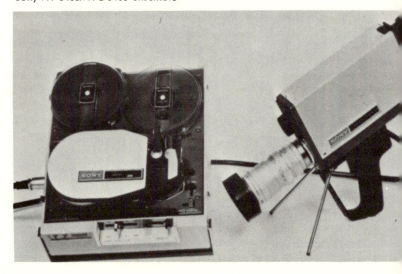

Akai portapak ensemble with monitor, VTS-110dx

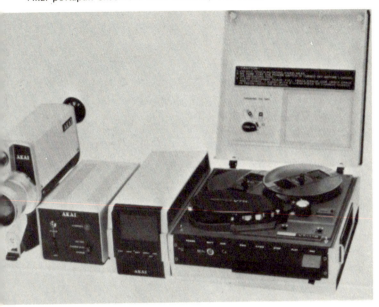

Editing Deck

Sony AV-3650

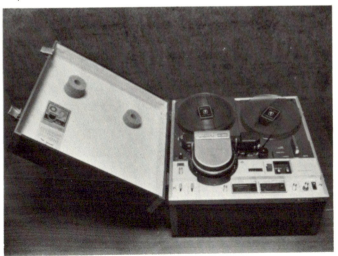

camera, and the possible types of lenses range roughly from "normal"—that is, equivalent to what the eye can see—to wide angle at one extreme and narrow angle or telephoto at the other.

A *wide-angle* lens will give a very broad picture of things close to the camera, giving good "depth of field," or a relatively sharp image of everything within its range. This means that a large, crowded scene, or a scene in which the camera must follow action moving near and far, can be caught without having many things out of focus. However, a wide-angle lens increases the appearance of distance in the shot—everything seems farther away than it really is.

The *narrow-angle, or telephoto,* lens will give a narrow picture of things far from the camera, and the depth of field is limited to exactly what it is focused on, with everything else appearing fuzzy. Because of the tightness of the focus, an extreme telephoto lens is hard to use with a hand-held camera because every movement of the camera is noticeable. With this lens, everything seems closer than it really is, and a person can seem to be running toward the camera for a long time without gaining ground, for example, although he has in fact covered a good distance.

Until recently, television and film cameras were usually equipped with turrets on which each of the three types of lenses was mounted, and one lens after another was revolved into place as needed. All portapak cameras now, however, and many film cameras, make use of the *zoom* lens, which can be considered many lenses in one. When the camera operator rotates the zoom lens barrel, the focal length gradually changes, and a wide-angle shot soon becomes normal and finally becomes telephoto, or the reverse. When the lens is zoomed out, the result is a long wide shot, and when it is zoomed in, the result is a tight close-up that takes in only a fraction of the previous wide shot. This can be done while the camera is operating, and the effect will be that the camera is moving in for a close-up or

moving out for a wide shot, when in fact only the lens has moved. The camera operator can make these moves very quickly and abruptly, or very slowly and imperceptibly. Of course, the zoom lens does not have to actually zoom, or move, during a shot, but rather can be used in a fixed position in its extreme telephoto focus, in extreme wide angle, or anywhere in between.

To focus the zoom lens, it must be zoomed in to the close-up telephoto position. The focusing is done by means of the focus ring which is the final control at the end of the lens barrel. Once in focus, the lens will remain so as it zooms back to a wider angle. Of course, if either the subject or the camera should move, as will happen in most cases, focus will have to be continually adjusted (which is called *follow focus*).

The lens barrel on the portapak and many other cameras is the screw-on, "C-mount" lens—the same type as is used on 16-millimeter movie cameras. Thus the lens can be easily removed and replaced with a different sort at any time.

Sound

People sometimes get so excited about the video-tape picture that they forget about the sound. The manufacturers of portapaks are guilty of this themselves, since the built-in microphone in most models is clearly an economy component and not up to the quality of the rest of the camera. Yet the automatic sync-sound of video is one of its most remarkable features, and, as we have noted, sound is at least 50 percent of the television experience. A VTR system that has been limping along with poor sound (the built-in portapak microphone) will seem to be enormously better with the simple addition of a good microphone.

Microphones come in several varieties and can be defined in several ways. All parts of the sound system, first of all, must be electronically compatible,

and this is indicated by a measure called *impedance*. Equipment is either "high impedance" or "low impedance," and to avoid distortion, microphones, earphones, and so on must be alike by this measure. Second, microphones can be described as *unidirectional* (picking up sounds from a single direction) or *omnidirectional* (picking up sounds from all directions). And finally, microphones can be distinguished by how they function physically in the taping setup: on booms, on lapels, hand held, etc.

In a studio, where there are few distracting noises, an omnidirectional microphone might serve very well for a discussion among a few people. If the room is not thoroughly soundproof, however, this microphone will also pick up passing fire engines, door slams, children playing, and all the other sounds that are always around us. In life, our brains filter out many of these sounds in the sense that we pay little attention to them. The microphone filters out nothing. (It is interesting to observe, in a videotape with a lot of outside noise, how little the participants in the tape seem to notice it.) In an outdoor situation, of course, the problem is multiplied many times. Here the unidirectional microphone can seem to be miraculous, and interviews can be conducted in the middle of traffic or near a construction project and the voices still come through with clarity. One of the most popular microphones is the "Cardioid" type, which picks up sound in a heart-shaped area in front and immediately to each side of the microphone.

The ideal indoor studio-type setup will use *several* microphones to cover all the participants and, depending on whether the director wants microphones to appear in the shot, they can be on stands, suspended from the ceiling or from booms, or worn around the neck (*lavaliers*). All microphones will have to be fed through a *microphone mixer* before they can be recorded on the tape.

The portapak has a receptacle for a microphone to be plugged in, and it will automatically cut out the built-in one in the camera. There are almost no

occasions when a portapak user would not be much better off with a separate microphone. The Sony ECM-22 is a superior unidirectional microphone, almost too sensitive for the rough and tumble of video work. It sometimes pops and rumbles as it contends with unpredictable outdoor conditions and less-than-gentle handling. A better bet for most portapak jobs (and half the price—around $50) is a microphone like the ElectroVoice 635A, a good, all-purpose, omni-directional microphone that is easy to handle and seems indestructible.

Headphones

The portapak has an outlet for the attachment of a sound-monitoring device, and headphones work better than anything else. The portapak has no control for adjusting sound levels, so the purpose of headphones is mainly to assure the crew that the sound is coming through. From time to time, in the normal confusion of portable shooting, the microphone plug may come loose or wires may become disconnected, and it is important that the shooting crew does not continue to record an entire afternoon of silent interviews. This happens more often than one might imagine, in the absence of headphones. (One preventive measure is to tie the microphone cable around the deck handle before plugging it in, so that tugs on the cable will pull the handle rather than the plug.)

It is often good for the camera operator to be wearing the headphones so that, in a noisy situation or at a distance from the subject, he can know what is being said. If he sees the subject pointing, for example, and is not able to hear, he doesn't know whether he should follow the pointing with his camera or stay with the subject. Monitoring sound can also be an interesting yet harmless job for the insistent volunteer. Youngsters particularly are fascinated by earphones and enjoy listening over the phones to a conversation that may be taking place right next to them.

Headphones should be comfortable and should stay on the head. Although portapaks are not geared for stereo sound, all good headphones now are, and they work just as well with a portapak. Like microphones, however, they must have the right impedance to work with the portapak sound system, and they must be equipped with a *mini-plug,* rather than the more common *phone plug.*

Monitor

A monitor is a TV set wired to receive the tape signal directly. Although a tape deck can be wired to a normal TV set by means of an RF adapter, the cleanest, clearest pictures in playback will come from a special monitor. Usually the monitor can also receive regular television programming, and so it is possible to record TV programs off the air by means of the monitor-to-deck connection.

Since monitors are often carried from place to place in the course of playback or editing, most tapemakers prefer the smaller models, at least in the basic video system.

Tape

Unlike film, videotape is opaque, and recording leaves no visible imprint on it. It looks, and is, quite sturdy, but it must be handled very carefully. The magnetic coating can be damaged in several ways. If the tape is dropped or treated roughly it can become scratched or creased. Similarly, dust or dirt can scratch the surface. Dust, scratches, creases, and other damage generally cause a phenomenon in the picture called "dropout," which appears as occasional white streaks on the screen. Dropout can be avoided by keeping the machines clean and by being sensible and careful with tape. When one of the ends of the tape becomes creased or wrinkled, for example, it should be cut off.

The following rules are generally good practice:

1. Keep the recorder clean. Ideally, tape guides and heads should be cleaned before each use. Several spray products on the market are designed specifically to clean video equipment.

2. Store the tape carefully—in a plastic bag within the manufacturer's box. Place the tape boxes upright on a shelf, like books, so there is no pressure on the reel flanges.

3. Avoid extremes of temperature and humidity.

Connections

Videotape, and television in general, rely fundamentally on electricity and thus on the way one component is hooked up to another. To the novice, this can be a dizzying array of inputs and outputs. To the expert, it is the whole game: how can the signal be channeled through more, or different, ins and outs in order to produce more effective results. In editing from one machine to another, for example, an astonishing amount of spaghettilike cable seems to accumulate.

Fortunately, the various connectors look quite different, so it is rarely possible to put the right plug in the wrong hole; it usually won't fit. Getting the connections made properly and the machines working, however, can be a frustrating and even panicking task, unless it is approached calmly and logically.

There are three main connections.

1. *Power.* Every element in a video setup must be driven by something, either house current or battery.

2. *Video.* The connection from camera to monitor or tape deck, or from deck to deck, or in general whatever conducts the picture from one place to another.

3. *Audio.* As in 2, but for sound instead of picture.

A coaxial connector carries the video signal. A "coax-to-coax" cable, for example, can send video from one VTR to another, for duplicating or

editing. The connection is made from "out" on one deck to "in" on another. The connector and receptacle look like this:

coaxial connector and receptacle

An 8-pin connector carries both video and audio, and it is the normal connection between a tape deck and a monitor. (There is no "in" or "out" receptacle because the signal can travel either way.) It looks like this:

8-pin to 8-pin cable

The portapak has its own unique connection: 8-pin on one end (to the monitor) and 10-pin on the other (to the deck). A 10-pin connector also connects the camera to the deck and carries power for the camera, as well as video and audio signals.

8-pin to 10-pin cable

There are four basic audio connectors, and it is a frequent source of frustration when working with different types of equipment—recording sound from an audiotape to a videotape, playing back a videotape with the sound amplified for a large audience, etc.—that one does not have the right connectors at hand. It is helpful, then, to have adapters that will convert one type of plug into another,

so that any type of jack can be accommodated. These are the four plugs:

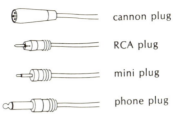

	cannon plug
	RCA plug
	mini plug
	phone plug

There are, in addition, many helpful accessories and apparently indispensable gadgets which can be added to any videotape system. However, the porta-pak user can operate quite effectively with the basic equipment described here, at an initial cost of approximately $2,000. When he has experimented thoroughly with the equipment, each tapemaker will develop a sense of where to spend his money next, always keeping in mind that a portapak is supposed to be portable and that he doesn't want to become so overloaded that he can't move.

Video Mediation

This is a mode originated by the People's Video Theater. Essentially it means taping one side in a conflict and showing it to the other. Then taping their response and showing it to the first group. And so on.

PVT first did this in Washington Square Park in New York. The park had been under reconstruction for over a year and a tense situation had developed between park people and local residents.

PVT first made a fifty-minute documentary of the situation in the park by talking to everyone who used it: blacks, students, pensioners, etc. From the tape it became apparent that people were very upset because construction, already past deadline for completion, limited available space.

PVT then made a six-minute tape of the park people talking about the documentary and a six-minute tape of local residents responding to that feedback. The resulting twelve-minute tape was shown to city

officials, local residents, and city planners. They responded to the questions posed, and the final tape, documentary with feedback, was then shown in the park.

<div align="center">
Michael Shamberg and Raindance Corporation

<i>Guerrilla Television</i>
</div>

Michael Goldberg, a Canadian video artist, constructed a *Room on Its Side* at the Vancouver Art Gallery. A wall was furnished as if it were the floor, with a rug, table, chairs, and working TV set and telephone fastened to it. A sofa faced up the wall with its back on the actual floor, so that the floor, then, seemed to be a wall, the ceiling another wall, etc. Just beyond the exit from the room was a closed-circuit TV monitor with a thirty-second video-loop delay. The hidden camera was installed sideways, so that visitors got a replay of themselves back in the room, walking sideways on the wall.

"When schools visited the gallery," Goldberg says, "the energy was very high. Almost everyone became completely involved in the room—but reactions varied when they saw themselves on the monitor. Typically, a few kids would peek around the corner and see the group on TV, but it would take a few seconds before they perceived themselves. At that point they would excitedly return to the room to check it out. Some would holler and jump up and down in front of the camera, then pull their friends out to watch it half a minute later on the monitor. Some would quietly come back and sit down (lie down, actually, against the sofa back, their feet up on the wall as if in a sitting position) and get into the room as if it were normal and everyone else was in the wrong dimension (the monitor outside proved that).

"Free [public] school students were the most sensitive; others were often too disciplined to get

"Room on Its Side"
Michael Goldberg
Vancouver Art Gallery
January, 1971

involved (it was an art gallery after all). 'Now, children, what is the first thing you notice?' asked some teachers in an attempt to rationalize the environment. Others took to it like a playground, wildly, noticing not the room but the reflection of themselves in the TV."

Proposal for a Video Project in Experimental Ritualizing

In *The Drama Review* (T51), Judith Malina of the Living Theatre tells how in Brazil, in trying to help the poor reach a greater degree of self-consciousness, they had them act out their dreams, which revealed deep feelings of being oppressed. I propose that at a class or workshop the participants be told at least a week in advance to start writing out their dreams. This is not always easy and it takes some people a few days to learn this. They should come to the class or workshop with one of their dreams typed out, a dream with a beginning, middle, and end. The typed sheet is anonymous. The person can give stage directions, if he wants, to help clarify specifics.

It depends on the dream to what extent the group will have to rehearse, get props, makeup, lighting, etc. There should be some effort to theatricalize the dreams to do justice to them.

The group acts out the dreams in no particular order. The performances, acted out back-to-back, are videotaped. This way, the group will be able to see the whole event as if it were the original dream and they will be able to reflect on it; so will visiting commentators from the arts or the social sciences.

The videotape allows the participants reflective distance from their own experience. The images are seen again objectively, out there, and the general pattern of the group's dream-level can be seen as a drama by the dramatists themselves. With the

video, there exists for the first time one group of people who are not, as before, divided into dreamer, actor, and critic. Now there is no division. There is one experiential, critical imagination whose judgment and reflection on the process is whole, and presumably, for that reason, more intelligent.

Anthony Scully
Woodstock College
Center for Religion and
 Worship

V. Shooting

People are more familiar with
the appearance of television than with any other
medium including the printed page. *We all know what
television should look like.* For this reason, most
people find it easy, almost instinctive, to put images
onto videotape. When they pick up a video camera
for the first time, it is as if some subconscious fund of
knowledge and skill were suddenly tapped: close-ups,
pans, and zooms are like a long-hidden second sight.

Some professionals are scornful of amateur tapes.
They feel that the viewer judges all tapes by network
standards and so all videotapes must be done with
network slickness and polish.

However, broadcast TV is not as polished as we
sometimes assume; and polish and slickness are not
necessarily important to all the uses of videotape. As
we have mentioned, there is a roughness inherent
in television which comes from the very wizardry of
its electronics. Technically, TV seems to leap over
gaps, to skip steps, in bringing reality suddenly from
one place to another. There is no time for slickness,

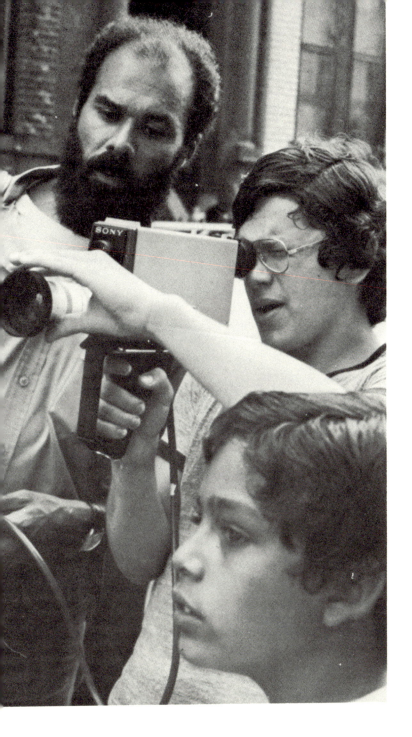

and it is only the apparent calm and suavity of
John Chancellor or Dick Cavett, for example, that
give us the impression that the picture, the sound, and
the transitions are all flowing smoothly, as they do
in a film. In fact, there are innumerable examples of
botched technical procedures in any given hour on
broadcast television, particularly on live shows:
pictures with no sound, or the reverse, jerking
cameras, blown lights, mistimed transitions. This is
all the more true, of course, with the often rough,
hand-held half-inch product.

But we don't mind. To get the immediacy—to
establish the communications link, which is what it is
all about—we will sacrifice the leisurely, craftsmanlike
polish possible in other media.

This is not to say that the viewer does not prefer a
good picture to a poor one, or that practice is not
a good thing, or that a person's work with videotape
will not improve and develop as he gathers
experience. Each person, however, can be largely
his own judge of how he is doing; he should be
concentrating on his objective, the specific com-
munication at hand, and not looking around for
rigid rules and regulations.

The beginner must get used to the idea that video-
tape footage *can be "wasted."* The person who
has had film experience, particularly, must overcome
the feeling that tape is in any way precious. An
entire half hour can be shot for practice or experiment,
and then, because it is erasable, shot again and again.
The strict measuring out of seconds and feet, as in
film, is unnecessary, and so the portapak user is
freer to develop his sense of improvisation.

Before taking flight, however, the video novice
must try to understand his tools and how to get them
functioning. It is always wise, first of all, to study
the manufacturer's operating manual carefully.
This is not always easy because the booklets are often
written in extremely opaque English, but the basic
mechanical instructions and maintenance information

are essential before any actual shooting can get
under way.

Loading the Tape

The Sony Corporation has only recently corrected
a design problem that had to do with threading
the tape. The tape, as the diagram indicates, should
go to the *inside* of the last post before the take-up
reel.

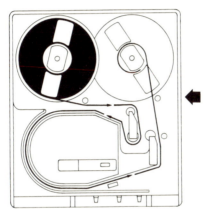

On the newest Sony portapak, a plastic wedge has
been strategically attached to this post, so that the
tape cannot jump to the outside, which it did with
frequency on the older models, causing the picture
to have streaks running through it because the
tape was not snug around the record-head drum. At
any sign of trouble with the viewfinder picture, owners
of older portapaks should check this minor item first.
 Tape should always be threaded while the recorder
is turned off, so that the record heads will not
come into contact with tape ends, fingers, or other
damaging things. This is not always easy to remember
because of the automatic shutoff feature on most
VTR machines. After a tape has been rewound, for
example, the recorder motor will stop automatically
while the switch is still in the rewind position. One

might remove this tape and start to thread another before realizing that the machine has not been switched off; it may start up again as the new tape is halfway threaded, and the heads might be damaged.

Once the tape is on, it is a good idea to let approximately thirty seconds of tape wind forward, both to make sure that the threading is correct and to provide a leader. The first foot or two of the tape is constantly being handled and is no place to have anything valuable recorded. Also, the leader will eliminate problems in the editing process later, when a perfect shot may be too close to the beginning to be successfully transferred.

No matter how experienced the cameraman, it is always important to make a short test before actually getting to work, just to make sure that everything is in order. The same is true, of course, for playing back a tape for any audience. There are enough minor things in either case that *could* be amiss that it is always worth taking a few minutes to check.

To get a picture on the viewfinder, the system must be put on "standby." On a portapak this is done by switching on "Record" and "Forward" together. A picture will appear in the viewfinder, but the tape will not move and nothing will be recorded until the camera trigger is pulled. In the standby position, the record heads are moving, and it should be remembered that if the machine continues in this mode for great lengths of time, the spinning heads may begin to rub oxide off that particular section of tape. Over a period of time, this can clog the heads. This is a fairly remote crisis, however, and the cameraman should not feel rushed while in the standby position, because he will need this time to work out the best type of shot, focus, lens opening, etc. Also, it takes approximately ten seconds for a VTR to warm up and for a picture to appear, once it has been switched on, and there are inevitable occasions when such a long wait would mean losing an important shot. At times like this (if they

can be foreseen) obviously the equipment should be kept in standby.

If everything has been turned on and yet no picture appears in the viewfinder after the ten-second warm-up:

1. Make sure everything is properly connected—power and video.
2. Make sure that the f-stop is not closed down completely.
3. Make sure that the input selector on the deck is switched to "Camera."
4. On a nonportable deck, make sure that the Automatic Gain Control has not been switched to Manual and turned to zero.

Light

Once everything is working, what we see in the viewfinder is determined first of all by the amount of light that the iris allows to strike the tube. Very generally, the camera operator has the option between good contrast on the one hand or good depth of field on the other, and the choice will depend on what the job is, what the shot is, and, perhaps most of all, what he thinks a good TV picture is—his "aesthetic" of television. A high contrast image is, of course, flatter and more two-dimensional; lower contrast (less light) can add dimension and detail for a deeper picture.

McLuhan wrote that "the TV image itself is a flat, two-dimensional mosaic. Most of the three-dimensional illusion is a carry-over of habitual viewing of film and photo." Technology has since improved, but the nature of the TV picture is still flat, like a painting, rather than deep, like a photograph, and anyone attempting to achieve interesting depth-of-field effects is doomed to disappointment. Nobody pays enough attention to TV to study details, and most TV sets are too small, worn, or badly adjusted to reproduce details even if they are transmitted. In addition, everyone is annoyed by dark, or uniformly

gray pictures on TV. Movies, for example, often contain night scenes that are dark and subtly lit for maximum effect in a movie theater. These scenes are usually a dead loss on TV, and we often find ourselves straining for *sound,* hoping for some clue as to what is happening.

My own feeling is that there are very few occasions when it is necessary to stop down the f-stop opening on a portapak, except when shooting outdoors in blazing sunlight and glaring surroundings. The vidicon tube in the portapak, although sturdy and efficient, operates best with good light, and the picture will become gray and grainy when lighting conditions are less than ideal. One can, as the manufacturers contend, get a picture indoors in normal house light, but it won't be a very sharp picture. Videotape beginners are often content with such pictures, but experience leads the camera operator to be thinking about light at all times and to be uncomfortable with dim contrasts.

In those instances when one must work with less than ideal light, it is important to simplify the camerawork and to bring everything forward. A close-up in dim light can still be worthwhile, but longer shots are less so. It is also helpful to put the subject against a dark background when the light is poor, in order to emphasize the contrast. With experience, one acquires an instinct about light— where it is coming from and at what intensity, how to make use of lone shafts of sunlight or hundred-watt bulbs, and so on. Also available are portable "sun-guns"—instruments that can be hand held or mounted on the camera to provide a direct beam of intense light wherever they are pointed. They can be cumbersome and overdramatic in many portable taping sessions, however.

In a studio, even a makeshift one, light can be more carefully manipulated and controlled. This presents new opportunities and problems which we will discuss in Chapter VII.

A final note: *it is important never to shoot directly at a bright light with a vidicon tube camera.* This may happen occasionally by accident, and the tube will be marked, at least temporarily, with what is called a "burn," which appears as a dark spot, or several spots, on all pictures. If the burn is not too serious it can be erased by aiming the camera, out of focus, at a neutral background—in any case the burn will simply disappear in time. A very serious burn, however, can destroy a vidicon tube.

Types of Shot

The shots available to the television camera are the same, basically, as those for film. They are worth mentioning briefly because their quality often changes in the context of TV.

1. *Long shot.* This can be a vital ingredient of a film, in which the viewer's eye is confronted with a large canvas and many small details. The shot might be taken from a crane or even a helicopter. Long shots in movies are often used as "establishing shots"—a view of the whole scene, a room, a street, or a wide countryside, which tells the audience where they are. After an establishing shot, the director can use many closer shots and the audience will assume that these are all taking place within the scene they saw in the long shot.

Although the long shot, in general, is not much help in TV, the notion of establishing shots is important. Any audience likes to have information about the environment within which a certain action is happening, whether it is an interview, a panel discussion, or a drama. An interview in the street, for example, might begin with relatively long shots of the neighborhood, or the particular location of the interview. A talk with a doctor about problems at a hospital would logically, or most dramatically, take place at the hospital, and so it might include long shots to establish that place. A panel discussion,

too, often opens with a view of the whole panel, so that the audience can orient itself to the scene before becoming involved with the give and take of the discussion, which would normally use much closer shots. This is not cut and dried, of course, any more than it is on film, and sometimes the most effective opening might be an extreme close-up, with the surrounding environment gradually revealed to the viewer.

Long shots can also be useful as "cutaways" in the editing process, and if it is known beforehand that extensive editing will be done, it can be helpful to have long shots of the setting from several different angles. We will go into this in more detail when we discuss editing.

2. *Medium shot.* This is usually described as a shot that will show a person from the knees up. It is used a great deal in films because in movie-theater scale this shot can show action and at the same time give a good view of faces. In television, however, we lose detail in the faces. The medium shot is as long as TV can use with any regularity, and it can often serve as an establishing shot within a small area. If an entire panel discussion, however, were to be shot with a medium shot only, the people would seem very remote.

3. *Medium Close-up.* The bread-and-butter shot of television, the medium close-up shows a person from roughly the elbows up and thus it can also reveal some background. This is familiar to us as the normal talk show, newscast, or presidential address picture. It seems a comfortable distance from which to watch someone speaking to the camera, and it can work well in other contexts where there is not too much action. Soap operas, for example, are composed largely of medium close shots.

4. *Extreme Close-up.* Many professional videotape makers consider the extreme close-up, which is confined to an area as small as a person's face, or even part of a face, as what TV is all about.

Unquestionably it is the shot that most exploits the immediacy, excitement, and informality of television. A medium close-up, as we have seen, can seem quite formal and can be appropriate for delivering a speech or teaching a lesson, but an extreme close-up seems to break through barriers and to bring us into that naked reality that TV communicates so well. This shot, however, is so intense that a long, uninterrupted series of them can be overwhelming.

In a professional television studio, the camera is most often shooting stationary people arranged in groups, so the normal parlance refers to *one-shots, two-shots, three-shots,* and *group-shots,* depending on the number of people in the picture. This is a handy and simplified terminology. It also emphasizes the no-nonsense aspect of television, which is most often just pictures of people, without camera tricks or fancy angles.

Picture Composition

In framing a picture:
1. It scarcely needs mentioning that perfect

symmetry is generally boring and that the camera is better off when positioned at an angle to the subject.

2. Although we have stressed the two-dimensional quality of the TV picture, the composition will be more effective when movement by the subject is toward or away from the camera, rather than from side to side in the same plane.

3. When the subject is a person, more space should be given to the side of the frame toward which he is looking. This helps to give a more definite impression that he is talking or listening to someone who is not in the shot, if that is what he is doing. It also gives the cameraman time to keep ahead of him, and thus keep him within the frame, if he should move in the direction he is facing.

Camera Movement

In addition to light, the relative size of the image, and composition, the cameraman must think about movement of the camera. This is obviously a different matter for a camera on a tripod in a studio than for a hand-held portapak camera, but the basic vocabulary is helpful.

PAN: The camera swivels horizontally from one side to the other.

TILT: Moving the camera vertically.

DOLLY: Moving toward or away from the subject.

TRUCK (or TRACK): Moving at a right angle to the subject, or moving parallel with a moving subject.

ZOOM: Apparent camera movement that is really
the changing focal length of the lens.

Most beginners, whether working in a studio or with
a portapak, tend to move the camera too much.
Because the cameraman is thinking about his shots
and is not thoroughly absorbed in the content, he
may feel that the viewer will be bored unless he
zooms and trucks around to offer visual interest.
The viewer, however, does not want to be reminded
that there is a camera operator on the scene; he
wants to concentrate on the scene itself, and he is
often quite content with a single shot for a long
stretch of time. The ease of using a zoom lens has
increased the temptation toward movement, and too
often the viewer has hardly had a chance to focus on
a medium shot before he is zoomed into a close-up
and then out again, all of which can produce
irritation and headaches. Another reason for mini-
mizing actual camera movement, such as pans and
tilts, is that the vidicon tube often has a slight
retention problem, which means that, in a quick move,
part of one image is carried into the next, particularly
in low light situations. Moves, in any case, should
be as slow and smooth as the script or situation
will allow.

For several reasons, the zoom lens is more important
to videotape than it is to film or even to television.
There is not much movement in broadcast tele-
vision, when we come right down to it, except the
kind of movement that comes from *film editing*—
the very swift replacement of one image by another.
This type of editing has reached its zenith in
television commercials. However, videotape, more
concerned with everyday reality, is always at least
leaning in the direction of being unedited, of being a
continuous, "real-time" picture. The only way a
real event, with its shifting points of focus, can be
followed is with the zoom, a lens infinitely and
immediately adjustable to the demands of the scene

because of its ability to pick out significant small
details at one moment and then pull back to follow
the larger pattern, all without breaking stride.
The goal is not a collection of small takes, as in film,
but rather one long, continuous flow. Of course,
with most videotape, editing will be helpful as a
means of sharpening the focus, but many tapes are
more faithful to life, and more fascinating to the
viewer, when a single, continuous situation, within a
contained area, spins itself out, longer and longer.

The general rule is that camera movement will
make sense only if it is motivated, that is, if it is
clearly necessary to follow the action. This is true for
a pan following a person walking, a tilt to show
something on the floor, a zoom to a tight close-up
when a person is saying something important, and
so forth. Aimless movement is distracting.

Thus, when shooting a spontaneous situation—an
interview, a meeting—the camera operator must be
tuned in to the event so that he chooses shots that will
have significance for the content. Most people can
recall or have head about Frank Costello's televised
testimony on rackets before a Senate committee during
the fifties. The picture was entirely of his hands,
drumming nervously, clenching and unclenching,
and this was thought to be very revealing of the man's
personality and feelings. Indeed, in many cases a
person's unconscious "body language" is more
expressive than his words are. It is the amateur
cameraman, however, who is *constantly* drawn to
these peripheral details—fingers, toes, knees, or
leaves falling from a nearby tree. These camera
movements invariably call attention to themselves and
are only rarely worth it.

A similar temptation at a meeting or some other
impromptu situation is for the camera operator to
move away from the main speaker to someone or
something else *which may indeed be more interesting,
but which has nothing to do with what the speaker
is saying.* At a large meeting of anti-drug-addiction

workers in New York, which I helped to tape, one man in the audience seemed very bizarre, dressed in a long robe, lying out flat on the seats or assuming various semi-yoga positions up against the wall on one side of the auditorium. At the same time, the speeches from the platform seemed to drone more monotonously as the day wore on, and our camera was often lured from the business at hand to the fascinating gentleman standing on his head. Unfortunately, when we came to edit the tape, many important remarks from the podium were accompanied by pictures of this unidentified person whose behavior had no discernible relation to what was being said. We could not use these sections and had to try to fit in the sound in other ways, with only middling success.

Steadying the Hand-held Camera

Shooting with a portapak, like shooting with any hand-held camera, has its own unique demands and problems. The most obvious is the difficulty of keeping the camera steady, to reduce possible distraction for the viewer. Designers of portable cameras have not yet come up with the perfect, lightweight, well-balanced instrument, and consequently many people have chosen to add some device that may help to reduce muscle strain and fatigue and so add stability when the shooting goes on over a long period of time. There are partisans for each of the following:

1. *Tripod.* This is invaluable—essential—for indoor, studio-type work, where everything can be controlled, but it is no help when the camera operator is roaming around, particularly doing outside work. The tripod does not permit the camera to go where the action is, and it takes time to set up and adjust.

2. *Monopod.* Similar to a tripod, the monopod has only one leg instead of three. The leg, resembling a walking stick, telescopes out and can rest on the ground, on steps, a wall, a parked car, or whatever is

at hand. It is more flexible than the tripod and it gives the camera support from below. The operator, however, has to hold on to it, to prevent horizontal swaying.

3. *Shoulder brace.* Photography supply stores as well as many video dealers sell a brace that can be used with various lighter-weight film or video cameras. The camera is mounted on the brace and the whole thing strapped to the operator, so that the lens is fixed, more or less, in front of his eye, and the weight of the camera is on his shoulder. In this way he can move relatively easily and has both hands free in order to control the zoom and focus simultaneously. Some people feel awkward with this brace, and it does restrict agility and make certain kinds of shots hard to manage—from low angles, for example.

Many good camera operators feel encumbered with any of these things and have developed their own methods for holding the camera steady. The traditional course is to brace the camera wih elbows dug firmly into the side of the body and then, on a pan for example, to pivot the whole body rather than just the arms and camera. Walking, to achieve a smooth "trucking" shot, is more of a problem, but long sliding steps can keep the picture steady if the operator has had practice. I know one very good cameraman who always shoots with the plastic eyepiece flipped up, so that his arms are extended, his head is away from the camera, and he is looking at the viewfinder as he would at a studio camera on a tripod. This puts the problem of steadiness entirely on his arms, and it requires him to perceive focus on the very small viewfinder from quite a distance. The great advantages are that he is always well aware of what is going on around him, as well as what is in the shot, and he can walk during a shot with considerable smoothness.

With practice, each person will develop a method that suits him and that he can feel comfortable with and rely on. The image will inevitably have its rough

moments, mainly because in most of these techniques it is not possible to zoom and focus at the same time. This is in the nature of improvisational shooting, where no rehearsal is possible: the camera may be in a full zoom close-up on one face when the scene shifts to something else. The cameraman doesn't want to lose whatever is happening, so he pulls the zoom back to the wide-angle position. To zoom in again for a new close-up will necessitate new focusing, so he holds the wide angle for as long as he can and then perhaps begins to move in—slowly, zooming a little, focusing a little. In a more active situation, the camera may have to move more quickly, and in these cases the viewer is very tolerant of the inherent problems. The camera may zoom to the wrong thing and then have to pull back and find the significant detail, go in again, and so on, with many a blurring focus as the process goes on. A certain amount of this confusion is unavoidable and may even contribute to the feeling of excitement in the tape.

Some videotape experts, on the other hand, prefer to move *themselves* around rather than playing with a lens, when doing this kind of verité work, because of the continual focus problems involved with the zoom. They prefer using a 10- or 12-millimeter wide-angle lens which gives a good depth of field, even with the iris wide open, and so diminishes the need for continual focusing. It does demand that the camera be quite close to whatever is being shot, and that it move physically from one thing to another, which might in some cases disconcert the subjects and block spontaneity. When it suits the personality of the cameraman and does not intrude too much on the subject, the wide-angle lens can provide a very natural sense of being right in the midst of the activity being taped.

Rehearsing the Shot

There are many occasions, even in the uncertain

conditions of outdoor shooting, when time will permit a certain amount of planning and practice, so that focus problems can be worked out ahead of time. While we were making an improvised adventure drama with a group of young boys, for example, they decided on a shot that began with some of them walking down the street toward the camera. The cameraman was on a stoop, and he panned with them as the group moved in his direction. As they passed him, the camera didn't follow them, but lingered instead on a car parked across the street. The camera then zoomed to the car, where another boy (one of the bad guys) sat behind the wheel. Obviously this had to be planned. With a fast rehearsal, the cameraman was able to work out exactly how best to do the pan and the zoom and keep everything in focus.

A shot can often be practiced even in less controllable situations: for example, if a shot needs to go from a long view of the outside of a building, to a medium shot of people in front, to a close-up of someone speaking, the *shot* can be rehearsed without asking the *people* to rehearse, so that spontaneity and informality are not sacrificed. Videotape work is easy, but it is not magic, and practice is always a help.

At the same time, improvisation is at the very heart of working with a portapak. Camera operators should learn to look at the viewfinder with one eye, while the other eye is aware of everything that is going on just past the fringes of the picture. Although we should reemphasize that one wants to avoid aimless, roving camera movement, there is always the possibility that something really significant may take place outside of the picture frame, and the cameraman should be alert for it and ready to move to it.

Sound

In any shooting situation, both camera and microphone bearers should be aware of certain sound

requirements which are important in an improvised taping as well as in a more formal one: (a) Let the camera roll for a count of five before recording any important sound (interview questions, dramatic dialogue, etc.). In this way, no sound will be accidentally unrecorded. (b) In an interview, try to let a question or statement end with a pause before the conversation is picked up. Small silences between important sections of sound are very helpful for clean editing.

It may sometimes seem important to conceal the microphone in the picture, even in semi-improvised situations. In most cases, of course, this will not be necessary; viewers are accustomed to seeing microphones in TV pictures. (It is interesting how even inexperienced subjects in the street automatically respond correctly to the microphone when they are being interviewed, waiting for it to be pointed in their direction, etc. They are playing a very familiar role.) A tape that I made for a community center, however, called for occasional hiding of the microphone. The tape was a "biography" of a group of boys and girls at the center, in which they tried to show a typical day in their lives. In some scenes they interviewed each other openly, but in others they wanted to give the impression of more casual behavior, as if the viewer were observing and listening to the group as they went through their daily routine. Simple ways had to be devised to hide the microphone, such as taping it to a broomstick, thus constructing a homemade boom. With this, one of the group could stand on a chair just outside the shot and hold the microphone over the group being taped in a cafeteria line. In other cases someone wriggled with the microphone under tables, hid behind chairs, or sometimes just lay down on the floor and pointed the microphone in the direction of the sound. The person with the headphones was always able to tell us if we were close enough.

The mysteries of a portapak camera are solved mainly by using it and getting used to it. If a person

has access to the equipment, he should have no
qualms about using it night and day and recording
many hours of frivolous and humdrum activities, until
he feels comfortable with it and the novelty begins
to wear off. He will teach himself by trial and error.
No matter how wretched or insignificant a certain
piece of tape may be, it can always be erased
and used again.

In this way, too, the beginner is developing his
sense of videotape, as he becomes aware that many
frivolous and humdrum recordings are strangely
fascinating, at least to him and the few others
involved—who are all that matter. Small sections
of life, which perhaps no one thought about as they
were passing by, can be retrieved and seen to be full
of interest, at least for a time. In many cases—
and this is not altogether bad—the beginner is so
involved with this kind of exercise work that he
doesn't have the heart to erase anything, and many
random and aimless tapes pile up. The tapes might
have been surprisingly important for the moment, but
they lose significance in the long run. The videotape
maker learns slowly that long-run significance is
usually beside the point. With practice, his eye grows
sharper, his techniques more assured, his short-range
goals more focused, and he soon feels at home with
the complicated electronic system he has slung over
his shoulder.

Perhaps most important of all, learning about videotape opened up a whole new way of looking at things. It's hard to use a script when you're taping a subject. The unexpected always happens, and you have to be prepared to take it all in with your camera. You begin looking for things, anticipating what is about to happen. The tape shapes itself as you record more and more information, and the finished product often comes out totally different from what was expected. Quite often you end up with a much more realistic view of the subject too, because you have recorded *what happened,* not what you *think* happened. I find I'm much more aware of rhythm and motion these days and sometimes I walk down the streets pretending I'm looking through a lens— just framing all the beautiful movements that I see.

<div align="right">

Rehana Hamid
High school student
Film Library Quarterly

</div>

The Patient as Cameraman

As the other group members came into the office my predominant feelings were of playful fun and a sense of being special as cameraman. . . .

Then an increasing sense of responsibility took over and I started to focus less for fun and more on what seemed important, what was really happening. My attention, and therefore the camera lens too, was focused primarily on hand, leg, and body movements. I noticed how often hand, leg, and foot movements were not parallel with verbal expressions. . . .

Although it's now a day later, I retain a clear visual image of what people looked like—what I was picking up on the camera: Mary's pained holding-back face showing strong emotions inside, which she was not expressing, and how long she sat this way, so very controlled but looking as if she might explode like dynamite at times and not knowing or able to control the continual slight movement of her foot. I recall, too, feeling how Sharon needed support as she kept looking at you or the floor, was so self-conscious and could never seem to get comfortable. I remember how she'd make small facial movements like turning down the corners of her mouth like she wanted to cry and giving off such an air of self-deprecation. . . .

The strongest impression I'm left with is how much significance I've placed up to now on what people were verbalizing and yet how small a component of their total expression that is.

> Milton M. Berger, M.D.
> "The Use of Videotape in Private Practice"

Jim, the group leader, says he had several meetings with the boys, and they want to tape a spy story. When I get there, with equipment, he is rounding them up. They have decided who is the victim,

who are the spies, and who the secret agents. Some of them have props—two cap pistols, a walkie-talkie set, and a bunch of papers with the words Atomic Secrets printed on top.

The first location is the subway stop at 103rd Street. Francisco is going to come up the subway steps, carrying the Atomic secrets, and turn up Lexington Avenue. When he goes up the street, three boys on the other side of the street (the spies) are going to cross over and follow him. We arrange all our signals—how to cue Francisco, how to cue the spies. Much yelling back and forth across Lexington, through the traffic. A crowd gathers, mostly teen-agers, but respectful. Somebody always asks, "Is this for the news?" I check out the camera. Finally I say, "Go!" and somehow this gets to Francisco as the tape is running. Up he comes. Zoom down to Atomic Secrets as he passes me. Pull back as he goes up Lexington. Guy behind me: "What channel is this?" Three spies move across Lexington through traffic, fall in, sauntering, behind Francisco as they move away from me.

Next shot. Francisco will be coming around a corner and pass by the camera. Camera holds on corner. Then the three spies will saunter around and move past the camera (still on the track!). Everything is set and we have our cues. I yell, "Go!" and start the camera. Beautiful picture of the corner, nobody there. A moment. Still nobody there. Another moment. A dog appears from the other direction, but no Francisco, no spies. Another moment. Jim comes around the corner into the picture. "Tell us when," he calls. Stop. Rewind.

The next location will be near Jim's apartment, in the nineties. We all move down the street, Maximo, the biggest, carrying the deck, me cradling the camera in my arms, Eric and Speedy carrying the props and firing the cap pistols, Francisco with the AC adapter, Pedro wearing the unplugged earphones and

singing into the unplugged microphone, others straggling behind.

Pedro goes up to a lady. "What do you think about pollution?" he asks, pointing the microphone at her. The others try to stay calm. The lady looks at all of us, tentative. "What?" she asks. "What is this for?"

"Channel 7," says Pedro.

"Uh—" She looks around. "What do I think about what?"

Pedro blows it. He starts laughing. The lady moves away, disgusted.

Later, in Jim's apartment. Francisco has been knocked out by spies and the Atomic secrets are gone. He wakes up, staggers to the phone. Close-up: "Get me the secret agents," he says. Eric is scrunched down, just out of the shot, holding the microphone for this. Speedy and Maximo, meanwhile, are poking around Jim's apartment. They knock over a bottle of ink, all over Speedy's shirt.

Later. A shot from out the window, five stories down, as the secret agents rush down the street, carrying the walkie-talkies, scattering pedestrians. They stop below, at the entrance, look around, confer, and enter. The tape still running, I step back from the window, pan slowly inside the room to the apartment door. There will be a spy, waiting.

Nobody is there. Nobody is anywhere. The whole crowd has gone out and down to the next floor where Eric has found a cat. They are now bored with the whole thing. I have let it get too fancy. They want to go swimming.

"How about next week?" says Jim to me. "We'll do some more then."

VI. The Portapak Project: Organizing and Carrying It Out

What makes the portapak unique is that it can be moved around so easily; videotape can go anywhere and do anything.

The Port Washington Public Library on Long Island, for example, has turned the whole town on to videotape, not just inside the library watching it but outside in the neighborhoods creating it. Hundreds of people have been trained in the use of the equipment and can now check out a camera and go out and make a tape. Over five hundred hours of tapes are presently on the shelves. The subject matter ranges through town planning-board meetings, interviews with older citizens, nursing home residents using video, football games of young children, conversations in bars, people in the street talking about youth and drugs, young people talking about drugs and themselves, volunteer firemen tournaments, interviews with local mayors, and many more. Over fifteen thousand people have come to the library to watch these home-produced tapes.

The New York Public Library has introduced the

videotape experience to young people in several of its branches, specifically to document a particular community or neighborhood. One group shot a "Profile of 53rd Street, East River to the Hudson." Over a period of several days, they walked crosstown, exploring with camera and microphone. This collection of interviews and vignettes, long shots and close-ups, rich streets and poor streets, good tape and boring tape, is a unique slice of New York.

A high school class in Boston wanted to put together a television version of *Romeo and Juliet* in modern dress, using both indoor and outdoor locations. They achieved a startling immediacy by shooting scenes between Romeo and his friends in the midst of Harvard Square, where the dense crowd of passersby was for the most part unaware of what was taking place.

How do such projects come about? How do they get organized, and how much planning must be done?

Getting Started: Video Workshops

On the theory that videotape can be handled easily and put to good use by virtually anyone, advocates of this new medium have developed the idea of *video workshops* as a means of spreading the word, of informing people about the potential of video, and of getting projects under way. Foundation-supported video groups, cable TV companies, and others have opened "access centers" where anyone can drop in to learn how to use a portapak and then can borrow one to make a tape. In the same way, groups of students in classrooms or club members in community centers have been involved in workshops, led by teachers, group workers, or visiting tapemakers, so that the youngsters will be able to make use of the institution's equipment.

The basic technique for the workshop leader is to hand over the camera, deck, microphone, and headphones to members of the group, along with a few

basic instructions, and then to get out of the way. (We are speaking here of the basic portapak, not editing decks.) It is important for the leader to emphasize, of course, that the equipment is sensitive in many ways and that it must be handled with reasonable care, but beyond that there is little hope, or value, in maintaining a very structured course, particularly at the beginning. I worked with one social worker who tried to create an atmosphere of discipline and step-by-step logic with a group of children who were experimenting with videotape for the first time. The children shrieked, fell down, made faces and rude remarks, told jokes, and howled. I tried to assure the worker, over the din, that nothing can really be wasted in these informal, introductory occasions—not time, not tape, not anything. Homemade TV is an initial shock to anyone, and people should be encouraged to relax and feel at home with it. (With very young children, of course, the weight of the portapak is prohibitive, and their activities will generally have to be limited to planning and performing. A camera on a tripod, however, can be handled even by many preschoolers.)

After the first excitement, learning about the portable equipment can be combined with thinking about what television is and, ultimately, what a portapak might be good for. I have been involved in workshops where young people alternated in various roles: camera operator, sound man, sound monitor (headphones), prop man, performer—even director, who, in one group, was the person who "decided what would be done" although this would always be hotly debated by the whole group.

Those who are performing may sometimes be intimidated by what they know of the formality of studio TV, and may freeze up because they want to do things *right*. The workshop is designed to break through this feeling. One method is to suggest that workshop members start out on familiar ground, creating their own versions of familiar television shows

and commercials. In this way, a sense of fun and parody is encouraged in which nothing is too important.

Once the basic techniques seem to be relatively understood, it is good to move immediately into an improvised project. What would the group like to show on tape? Perhaps a portrait, with interviews, of the nearby corridor, street corner, or playground. What would be the best way to go about it? The amount of planning should be kept to a minimum at this stage because the primary purpose is to give the group experience with every aspect of the equipment and with the basic *feel* of videotape. As time goes on, more planning will be necessary to develop video projects.

Planning

From one point of view, portapak projects should not be planned. In trying to capitalize on the casual nature of video, which aims to get the feel of what is going on rather than to pin it down in a totally organized and coherent way, one of the biggest dangers is a plan that is too rigid. However, because the uses of videotape are so varied, planning of some kind is often helpful, and even necessary. In dealing with youngsters, for example, planning may be as important for the group's development as the final product. Just as there are many video uses, there are many types of plan: an organization interested in professional documentation may be concentrating on how to produce a good finished product; a group using tape strictly for communication may be indifferent to production techniques, leaving the quality of the tape almost to chance, more interested in how it is put to use. And so on.

Video Drama: Scripts

A dramatic production, more than any other, will

require considerable concrete planning. The most thorough way to go about this is with a detailed script of some sort, worked out prior to the use of the camera itself. *A script for a studio production, such as one might find in books about television, will be quite different from the script that works best for a portapak production on location.* Because of the traditions of network television, studio techniques are geared to the simultaneous use of two or more cameras which, along with other visual and sound effects, feed into a central control booth where the final broadcast image is selected. (See Chapter VII.) The portable camera on location, on the other hand, is actually functioning more like a film camera, at least in that it is operating by itself, not as part of a system; everything is directed to a single camera eye. If a thorough plan is needed for this kind of shooting, the development of something like a finished film script or screenplay may be the most detailed preparation that can be done.

The following is a section from a typical screenplay for a film:

129. EXTERIOR TUNNEL TIM, JO DAY
A roaring sound builds and Jo's motorbike comes bursting out of the tunnel, Tim driving and Jo behind him. They are zipping along a picturesque road through the park on a bright sunny day.

130. EXT. GRASSY KNOLL TIM, JO DAY
They are sitting around a blanket spread under a tree in the park. They are having a picnic.
TIM (a drumstick in his hand): Come with me! Okay? I know exactly the kind of boat we want.
JO (laughing): *You* want! (They look at each other.) But you're tempting me. (He reaches for her and they kiss.)

131. EXT. CLOSE-UP JO DAY
JO (As they break. She is looking at him. Softly—): Okay.

132. EXT. MEDIUM SHOT TIM, JO DAY
Tim lets out a shout and throws the drumstick
into the air.
133. INT. "AT SEA" TIM, JO DAY
They are sitting at the controls of a flashy new
power boat. Tim looks rested and happy.
One can almost taste the salt spray in the air.
CAMERA PULLS BACK to reveal Tim and Jo
at the controls of a boat on a huge sales floor.
JO: . . . but just for a two-day visit. As soon as
I can get my boss to let me go.

The film script is thus broken up into shots, a new
one every time the camera must do something
different, and each one numbered. The setting, the
cast needed, and the indication of night or day are
emphasized so that the script can be analyzed
technically, and shooting and editing schedules
made. (The film crew may find it useful, for example,
to shoot several night scenes in one outing, although
they are widely separated in the script, or to shoot
two scenes with Character X on a single day, although
the scenes will appear at the beginning and the end
of the completed film.) As each shot is set up, the
director and cameraman choose each location and
decide where the camera will be placed, how the
scene will be lighted, how the sound will be recorded,
and so on. Some of this is indicated in the shooting
script, but much of it must be decided on the spot.
The shooting script guarantees, however, that no
major decision will be left to chance.
The screenplay itself is a dramatic illustration of
how films are considered a series of discrete chunks,
each numbered and isolated, that can ultimately
be fitted together in many different ways. A portapak
drama can be thought of in the same way and,
as with film, the order of the scenes can be rearranged,
and music and other sounds can be added, in the
editing process. Approaching a project in this
fashion, particularly with young people, can be very

instructive, as a lesson both in organization and in the nature of film and television. It involves a very real confrontation with the demands of visual storytelling.

Storyboards

Many people have found great value in the "storyboard"—a sort of shooting script made up of rudimentary drawings or still photographs instead of words. A professional storyboard, prepared by an advertising agency for a TV commercial, might look like the one below.

Some storyboards are even less elaborate, rapidly sketched with stick figures. The quality of the drawings is immaterial, as long as they convey in some fashion the images that will be shot—close-up, long shot, wide angle, and so on. As with a screenplay, the storyboard leaves many final details to be determined when the actual shooting takes place. It does, however, provide a concrete reference point—one that is visual and invites easy refinement and adjustment of the original idea. The arrangement of

TAKING PICTURES OF THE FAMILY GETS EASIER ALL THE TIME

storyboards on a wall makes a kind of movie, like a comic strip, and the essentials of perception *through a camera lens,* the way of telling a story through

pictures (would the close-up work better before the long shot or after?) can effectively be taught before the camera—TV or film—comes into play.

Scenarios and Outlines

When such thorough preparation is not necessary or not possible for a video drama, I have found that a semi-worked-out plan in the form of a scenario (a fairly extensive outline), and brief character sketches, can help to organize a group of young people around a story to be shot on location. Everyone in the group should know the basic plot, the main characters, and what will happen in each scene if not in each shot. This makes a good basis for improvisation, and the surprises that occur while shooting can be incorporated into the project. On one occasion, for example, a criminal in one of our stories was being marched to jail through a vacant lot by young actors playing policemen. When we were halfway through the scene, we noticed a police car parked at the corner. We stopped the camera, detoured the march, negotiated with the officers who agreed to let the

THE HANDY NEW KEYSTONE POCKET

YOU CAN FORGET ALL THAT MONKEYING AROUND WITH FLASH CUBES.

BECAUSE THE KEYSTONE HAS ITS OWN ELECTRONIC FLASH BUILT RIGHT IN.

JUST DROP IN THE FILM AND

boys be photographed climbing into the back seat of the car. This changed the story but it seemed too good to pass up at the time. On nearly every occasion

on location, the group found some unexpected real detail which they responded to and which subtly or dramatically influenced the direction and texture of the tape.

After each session, the group gathered to replay everything that had been shot up to that point. Afterward they would discuss what should happen next, within the confines of the general outline that had been established. Changes always had to be made; the fact of using the police car ruled out a prospective rescue attempt in the vacant lot—something new was now needed. Ultimately another general scheme would be cooked up—the basis for the next shooting, and itself inevitably changed.

The group working on *Romeo and Juliet* found that a combination of techniques worked best. Certain scenes had to be planned in thorough detail and others were improvised. By necessity the scene in Harvard Square could not be precisely set; it was shot from the top of a car across the street, using the zoom lens at its most telephoto position. The actors carried an audio tape recorder, concealed under a jacket, and spoke their lines as they moved through the crowd. Because of the camera angle and the distance, it was not necessary to get exact lip synchronization, and this sound track was dubbed into the scene in the editing process. At times the words are dim and the actors are temporarily obscured by the crowd, but where precision was lost, a rough vitality was gained.

A scene between Romeo and Juliet alone, however, was shot in a small room where almost all of the shooting conditions could be controlled. The planning here could be quite specific but because only the single portable camera was used, it was shot in the manner of a film on location rather than of a TV show in a studio.

Another young group took a slightly different approach. They worked for a period of six weeks among themselves developing a script for a drama,

called *The Orphan,* about adopted children. The play had six or seven scenes, culminating in a courtroom scene in which an adopted child's fate was decided. They worked out precise dialogue, cast all the roles, memorized the lines, and rehearsed the scenes, mostly on their own, concentrating on the meaning and emotional content but not thinking much about movement since, in this case, they were not familiar with videotape. At this point I was introduced to the group and we discussed various available locations: the community center library as a room in the foster care institution, the program director's office as the office of the social worker in the script, a large conference room as the courtroom. We finally shot the whole twenty-minute play in one long afternoon, moving from room to room, finding the best light and the best camera angle, making group decisions about when to zoom, how to manage entrances and exits, deciding where to break a scene in order to get the single microphone in the right position, and so on. Because it was all indoors, it was the kind of production that could have been done in a studio with several sets, but we all learned a good deal from treating it as a sort of film, done in various real locations.

Organizing Documentary Material

In taping nondramatic material, the storyboard and screenplay have obviously less value. In a videotape study of any subject, some research in form of still photographs might help the group get a feel for its visual aspects, but the reality of anything on location will *always* be different from what is expected, and sometimes a group is better off with as few preconceived notions as possible.

Here the non-plan may work best. Perhaps the crew only wants to sample life at a certain park bench, a certain bar, a certain office, church, or schoolroom. For this kind of exploratory venture, there is clearly

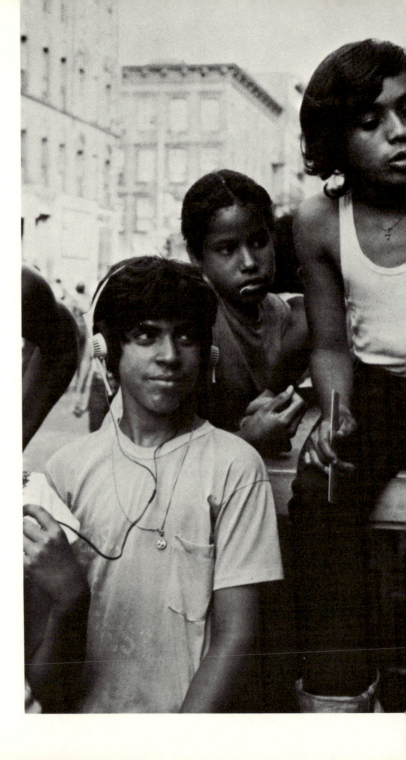

no point in trying to impose a structure ahead of time. Some of the most honest, most casual videotapes have been made in this fashion. From some points of view, it is within this totally unplanned, unedited framework that one can make the greatest discoveries with videotape.

More structured documentaries, however, are also valuable. To plan for these, the tapemakers should discuss the framework of the tape and what information they will be looking for. This is a time to make many lists. If, for example, a group should want to study the conditions on the subways, what might be the components of the study? Who should they talk to? Where? There will be inevitable taping in the subway itself: can they manage it at rush hour? Should they be concerned with fairness or push for a definite point of view?

The first realization the group might come to is that the subject is too broad, that it is more suitable for a network documentary than for a workshop tape. They might remind themselves that half-inch tape is for communication among people, not for creating "white papers." Perhaps the group could focus on a small corner of the subway subject: the threatened closing, for all but rush hours, of two subway entrances in the neighborhood. The list of possible interview subjects might include representatives of the transit authority, elderly riders who cannot easily get to other entrances, children who would have to cross more streets, newspaper and hot-dog vendors who might have to change locations, and so on. They might also decide to do a number of street interviews to see if the community at large has any feelings on the matter. To fully utilize the portapak's potential, they might show the senior-citizen tape to the transit authority and vice versa, and then tape the reactions of each group to what they had seen. There would also probably be the expected tapes within the subway, and others that would document the anticipated problems of the

children or the older people—the busy streets and longer walking distances. The possibilities are many and would vary with each particular subject, but the primary questions for the workshop group to ask are: *What precisely is the tape about? Why is it being done?* When the answers to these are clear, the smaller decisions are more likely to follow naturally.

These questions are just as vital when a taping crew, whether they are seventh graders or professionals, undertakes to cover some specific event—an assembly, a meeting, picnic, or whatever. The group must have the *purpose* of the tape in mind or their activities will become aimless and frustrating. If a committee meeting is to be taped, for example, will the tape be used (1) as an information piece, to show others what the committee is doing? (2) as a public relations piece, to show to constituents, for example, or to potential investors or donors, how *well* the committee works? (3) as a record, for the committee's own use, of what took place? (4) as a training piece? Each of these purposes would require a specific approach and technique. For public relations purposes, a subjective approach would be important, emphasizing the spirit of the event and the personalities involved and downplaying any negative elements. On the other hand, for the committee's own purposes of self-analysis, a more objective record would be needed. For the subjective approach, the camera might zoom around informally and lean heavily on close-ups; for the analysis, a more formal and removed camera technique would be preferable, using many long shots so that the viewer would have a sense of the whole process, the reactions and interactions.

Needless to say, this type of taping venture will not work at all unless the crew have been informed, or have informed themselves as much as possible, about the subject of the tape. A crew cannot function like the camera on the wall at the local bank; they must know something of what is going on, who the people are, and, in a general sense, how to interpret

whatever might happen. Unfortunately, there are many instances when a person in authority will ask for a tape of a meeting (seminar, assembly, boat ride, carnival, Christmas party, etc.) without establishing the purpose of the tape and without providing the pertinent facts and circumstances to the taping crew. The result is inevitably a waste of time for the crew, and most likely a tape that no one will care about. A portapak crew or workshop group are not likely to be machinelike technicians, and in fact they will usually work best when they can interact in a human way with whatever they are shooting.

Technical Planning

Technical planning is essential when using a portapak in the field, particularly if the crew is going on a specific assignment. They must estimate what the technical problems will be and what equipment to take along. Will power be available? Will the assignment require a special long-life battery? Will the light be adequate? What kind of microphone should be used?

In some cases it is hard to pinpoint this information, and here the crew must pack up everything that might conceivably be needed. This would include the following:

1. *The portapak itself.* Large video outfits will customarily take along a second portable unit, in case any bugs turn up in the first in the midst of important work. If the work is that important, presumably a group should be in a position to have a backup system.

2. The AC power adapter. This adapter enables the camera and deck to work from normal house current and is also the battery charger. It is a standard accessory with all portable equipment.

3. Videotape. The tape, ironically, is one essential ingredient that is often left behind. The crew will have to determine whether the occasion will demand

clean, virgin tape or recycled tape, and how much of either will be needed, depending on the purpose of the shooting. A tape that will definitely be edited and broadcast or distributed should, for best quality, be shot on new tape, whereas a workshop or less formal purpose may be served just as well with used tape.

4. An extra battery or long-life battery pack. The battery in the deck has a life of thirty to forty minutes, including, of course, standby time. This may not be long enough for the job, and the crew has the choice of bringing along other fully charged batteries to replace the original or, more easily, a special battery pack or power belt. These, worn around the waist or carried over the shoulder, have a battery life of from three to seven hours. A battery pack needs fourteen to sixteen hours for recharging, and it is a good idea in any case to have batteries charging when they are not in use, to be sure that the equipment is always ready. *A video system is portable only when the battery is working.*

5. Microphone.
6. Headphones.

7. Tripod, monopod, shoulder brace, etc. Any one or none of these. They have the advantages described in Chapter V, but obviously they are a drag on the overall portability.

8. Extension cable. There are several varieties of extension that, if not essential, are very valuable to a portapak system. The first is an extension for the camera. If the camera is going to be traveling around within one general space—a part of a street or a large room or auditorium—the extension will permit the camera operator to move without taking the deck with him. This has several advantages: (a) The cameraman is more maneuverable, not tied down by the weight of the deck. (b) The deck, staying in one place, is less subject to jolts and accidents. (c) House current can be used instead of the battery in many cases. Sometimes, depending on the amount of confusion, the camera operator will need help clearing the long cable over and around people and objects, and in every case someone should periodically check the deck, to make sure that it hasn't been knocked over or that it hasn't started to chew up tape.

Extensions for microphone and headphones may be necessary if an extension is being used for the camera. These are inexpensive and they provide the additional flexibility of permitting the sound to originate at a considerable distance from the camera or deck. Finally, several ordinary power extension cords are an important part of every video kit because of the unpredictable location of wall sockets.

9. RF Modulator or monitor. If the tape will be shown at the location, it is generally easier to use whatever television set may be there, rather than carrying around a monitor. For this, the deck must be equipped with an RF Modulator, and the crew must take along the wire that connects the deck to the antenna leads of the TV set. TV sets are notoriously various in quality, of course, and if a guaranteed good picture is necessary, the monitor is the only safe bet.

10. Lights. A lighting outfit is usually too complex and cumbersome to take to a location just as a matter of course. Lighting as a factor in any shooting must be thoroughly determined ahead of time.

11. Labels. Labels should be carried around and

used. The camera crew has the first responsibility for labeling, immediately and clearly, what they have shot, attaching the label to the reel and to every subsequent box the reel goes into.

12. Miscellaneous. There are several other handy items that should be thrown into the package: a three-prong adapter (or half a dozen to cover attrition) so that the three-pronged (grounded) portapak equipment can be plugged into the normal two-pronged wall socket; a screwdriver with which to attach the RF Modulator wire (and a Phillips screwdriver for anyone who is capable of dealing with problems inside the casings of camera and deck); gaffer's tape, a wondrously sticky gray tape that can be used to bind cables together, to fasten lighting fixtures to walls, and to do a hundred other important jobs.

All of this together, excluding a monitor, weighs in the neighborhood of forty pounds, and it depends on how strong you are whether you think that is portable. Besides weight, there is the simple problem of getting it all together and transporting it from one place to another. Some of the video manufacturers make a large suitcase with many styrofoam compartments and metal handles on either end and on top, designed to contain all of these components. This works all right if there are two people doing the lifting (the suitcase itself weighs fifteen pounds). Some crews are happier when the gear is distributed throughout several bags, with straps for as many shoulders as the group can enlist.

The Objectivity Myth: **The idea behind this activity
is to help kids see how much the videomaker's point
of view (and related camera and interviewing
techniques) color his documentation of a place or
event. The class is divided into three groups. An
appropriate subject is chosen for making three ten-
minute tapes. (For example, a student lunchroom, a
"McDonald's" hamburger stand, or a school athletic
event all provide good topics for this activity.) A
first group is sent to the site and asked to make an
"objective," "impartial" record of what is taking place.
This should include both some interviews of those
involved and some footage that records the activity
and environment of the selected topic. When the
first group returns, a second group is given the same
assignment, except that they are asked to use the
camera and conduct their interviews so as to effect a
"bad" or "negative" interpretation of the setting.
Finally, the third group aproaches the situation with
the bias of making it seem as "good" and "positive" as
they can. The tapes are viewed with an emphasis
on talking about how a videomaker can manage to
be "objective" and through what techniques he**

can manage to "load" his presentation. Three groups covering the same subject inevitably come up with quite different things. The children can discuss what aspects make one treatment better than another.

Street Shooting: **Here is an activity that, I think, points toward a deeper level of significance and uniqueness. A group of three students leave the environment of the school to interview someone. One student carries the portapak, one uses the camera, and the third handles a microphone that is plugged into the video deck. Their task is to interview someone—a shopkeeper, an old person in a park, a man on the street. But the job doesn't end there as it would, say, in a filmmaking or print journalism assignment. The students immediately rewind their tape and play it back (through the camera, on the spot) to the person they have been interviewing. After the entire interview has been replayed, the kids can continue to ask questions of the subject. The process repeats itself. When playing back such street interviews in class, have the children compare the first interview with the second one. Have them compare the way one gets to know his subject in this process as opposed to the technique and format used on commercial TV. Are there particular portions of the interview which, if used alone, would make quite different comments about the person they interviewed? What kind of responsibility does the videomaker have to a person or group being taped?**

<div style="text-align: right;">

Kit Laybourne
Doing the Media
The Center for Understanding
 Media

</div>

At Spofford Detention Center in the South Bronx we have been videotaping the drama workshops, which reflect the lives of the boys both within and

outside the institution. The workshops range from dance and song to intense improvisational drama. On playback, the kids have a chance to see themselves interact with each other in various roles and environments, which in turn leads to a discussion of what they saw and how they perceived themselves on TV.

It is hard to completely understand what videotape means to these boys. One boy, no more than sixteen, had been arrested for homicide. While at the Detention Center, he had written his autobiography. He came to us and asked if he could read his autobiography for the camera. He did this, and then we got him to talk to us more informally. It turned out he was not able to talk this way with either the staff or his friends there. He could be open only in talking to the camera.

Because of this and other similar experiences, we decided to set up an in-house news service run by the kids, which might bring about a better understanding and communication between the boys and the institutional staff. The boys will be doing their own journalistic probing with a video camera.

One of the toughest examples of these boys' desire for communication came from a thirteen-year-old whose mother, for some reason, did not want him at home. Apparently he had spoken with her a few times about it, but to no avail. He proposed to make a videotape of what he was like, and to show it to his mother, in the hope that this would persuade her.

The Video Group
Claude Beller
Stefan Moore
Ray Sundlin

VII. Adapting Studio Techniques

A TV studio is a professional workshop for the production of TV shows—a place where the sound and image can be carefully controlled and where the complex equipment can best function. A studio is a kind of machine; the technical standards of broadcast television, and of many other network and professionally produced programs, can only be met with the resources of this machine.

Many videotape enthusiasts do not need these resources. Indeed, many feel that broadcast resources are a distinct drag on freedom of creativity, owing to both weight and complexity and frequent dependence on, and interest in, great sums of money. However, for some television and videotape purposes, a studio, no matter how homemade, is indispensable.

Television is still much more "live" than film, even when it is on tape, and so technical control can be crucial. We have seen in the previous chapter a sample section from a film script containing five separate shots. In film shooting, that particular sequence might take several days to complete because

each shot would have to be set up, lit for a single camera, rehearsed, and finally filmed—probably filmed many times. (In addition to giving the actors several takes to reach their best, the director might want the shot covered from several different camera angles, from long master shot to close-up, so that he and the editor would have maximum flexibility when they came to assemble the final product.)

A broadcast television program, on the other hand, is most often considered as a whole, or as a series of long segments, even when it is videotaped. Although the whole studio apparatus *can* come to a halt in the midst of taping, and the program or segment can be started over again, this is not a common practice. TV takes advantage of the fact that tape can record continuously for long periods, in contrast to film where cameras must stop relatively often, whether the director likes it or not, in order to reload film.

What Happens in a Studio

To replace the painstaking process of film editing, studio television has a system by which programs are edited by the director in the control room as the show is in progress. The action is shot with two, three, or more cameras: one, for example, on a close-up of a speaker in a discussion, one on a medium shot of the whole panel at that moment, and a third on an exhibit object under discussion. The cameras will be shifting around as the program proceeds. During the taping or broadcast, the director decides which camera's shot should be "on the air." He also decides when he wants a camera to move, when to use film, slides, or sound, and so on. The multicamera setup is a convenient technique for making a certain kind of program, but both logistics and electronics require that everything be more or less in the same place—the studio.

In terms of space, a studio need be no more than a

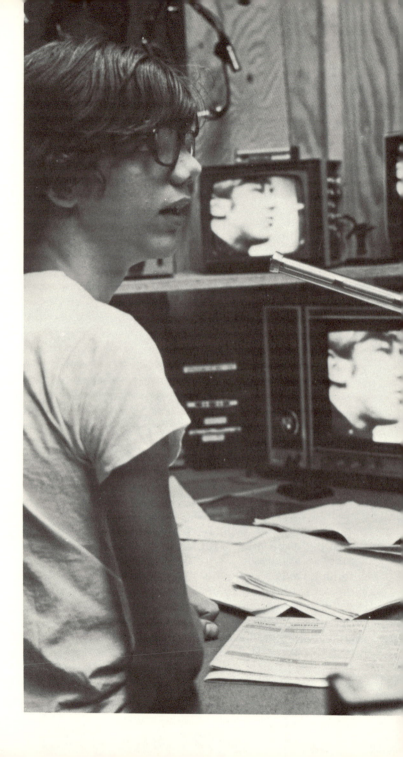

relatively large room, like a classroom or meeting room. In a multicamera setup there must be a fairly soundproof control room somewhere nearby—a large closet or coatroom will do. From here the director and his aides run the show, and they have to be able to talk and make whatever noise they want. It is extremely helpful if the control room has a window with a view of the studio itself, but this is not always possible in improvised situations; the main thing is that the director can see on his monitors what the *cameras* are seeing. Finally, in the control room is a piece of equipment that is the heart of the multicamera system: a device for switching back and forth among the cameras plugged into it, so that, although all cameras are turned on, only one of them is actually being recorded at any given time.

At its most basic level, then, a studio might have two cameras, both feeding into the device that switches from one to the other in the final tape. *As noted previously, the portapak camera, meant to be a roving camera, is not specifically designed for studio work or to record on any deck other than the portable one. For this reason, a camera adapter is necessary to permit this camera to work in the studio system.* (This adapter lists for approximately $120.)

The SEG

In a studio, the electronic synchronization from each element in the system must be matched up so that all elements operate together, without jumps in the picture as the director cuts from one camera to another. This is normally done by hooking all of the components to a *Special Effects Generator*. The *SEG*, as it is commonly called, has an internal sync generator which supplies the pulse to the whole setup. In addition, the SEG gives the director the opportunity to switch from one camera to another by means of a multitude of fancy techniques: wiping, superimposing, dissolving, fading, and so on.

123

A wipe, for example, is the technique whereby one image seems to take over the screen by creeping across, literally wiping out what was last there. In the following diagram, the shaded portion indicates the existing picture. The arrows show how the new picture will travel to take over the screen. The wipe can be halted at any point to create a split-screen effect.

Superimposing, dissolving, and the like are familiar to us from the movies as well as TV—they are all ways of fading one picture into another or fading it out altogether. In film, these effects are normally accomplished in the lab by a chemical process; in TV, they are done electronically on the spot.

The availability of wipes, dissolves, and split screens does not require that the director actually use them and, needless to say, the beginning director or experimenter in the studio will be wise to restrain himself. Like fancy camerawork, fancy transitions most often call attention to themselves and obscure the message.

The Studio Setup

In the control room, besides the SEG, there will be (a) monitors showing the pictures from each camera in the system, so that the director knows what his choices are; (b) a monitor for any film or slide machines that may be involved; and (c) a monitor showing which picture is being taped or broadcast at a given movement. The director, then, may be looking at five or six different pictures. Microphones

on the studio floor will be fed into a microphone mixer which delivers a single sound track to the recording deck.

Ideally, the director should be in voice contact with his camera operators by means of headphones so that he can easily convey his desires about where they should move and what shots they should be lining up. There should also be a headphone connection between the director and another important link in the chain—the stage manager or floor manager, who is the director's representative on the floor. During a taping he is a general troubleshooter and a liaison between the director and everyone else— particularly "the talent" (the performers), who have no earphones, of course, and so don't know how things are going. The floor manager can indicate to them the amount of time remaining, which camera is presently on the air so that they will be looking in the right direction, and so on.

Depending on the degree of sophistication of the studio, the director may be handling the controls himself, switching from camera to camera in the final recording, or he may be calling the shots so that engineers in the booth (or elsewhere with film and slide projections) will be punching them up on cue. In either case, the show as it is running is the responsibility of the director.

The Studio Script

Approaching television in this traditional way usually requires considerable preparation and rehearsal before taping; there is often a complex sequence of events and a need for precise timing. In this situation, the television script, as opposed to the film script, is used.

A page of a television script is divided in half: one side is devoted to what is seen, the other to what is heard. A section from a network news script, for example, looks like this:

VIDEO	AUDIO
Larry on camera 1	Our young people advise us today that nostalgia is big— very big—and this unites the young with those who were young twenty or thirty years ago. Even the sound of the big band is coming back. QBC's Susan Smith has a report.
Roll VT-38 (Smith)	
VIZ: BIG BANDS	
Take VT-38	
Smith runs: 2:06 Outcue: Susan Smith, QBC News	
Stand by camera 1	
Take camera 1 Larry on camera	On Wall Street, stock prices slumped again in light trading. The Dow-Jones industrial average closed down 7 points. Standard and Poor's five-hundred-stock index was down 0.68. Analysts attributed the drop to uneasiness over higher interest rates and talk of a credit squeeze on the economy. Herman will have tonight's comment in a moment.
VIZ: DOW-JONES −7 VIZ: STANDARD AND POOR −.68	
Roll VT-58	
Take VT-58	

The audio script here is clear enough, but the video notations are a kind of shorthand. Since this is the director's script, the notes in the left-hand column are his reminders to himself about how to keep the program moving from moment to moment. To take

them in order: *Larry on camera 1* indicates that the on-the-air image is the newscaster who is reading the words in the second column. At the point in these words where the director has noted *Roll VT-38,* he will give a signal to the operator of videotape machine number 38 to start the tape that is loaded on that machine, a report by Susan Smith. Previous trial runs for timing have indicated that the tape leader will elapse and the tape begin just when needed (at the end of Larry's speech).

A few seconds later *(VIZ: BIG BANDS),* the director signals another technician to punch up the slide reading Big Bands on the rear projection screen behind Larry. This is called a *vizmo* at this network. At the end of Larry's speech, the director looks to make sure that the Smith videotape is ready on its monitor, and then orders it to be switched on *(Take VT-38),* replacing the camera image of Larry. His next note tells him that the Smith report runs two minutes and six seconds. This is quite a long respite—probably time for a cup of coffee. At some point here he warns everyone in the studio to stand by for camera 1 to come up again on Larry *(Stand by camera 1).* The cue for this will be Smith's last words on the tape, *"Susan Smith, QBC News."* When these words are heard, he instructs the engineer to take camera 1. Once again, as Larry passes the appropriate cues in the script, the vizmo operator is told to bring in his stock market slides *(VIZ: DOW-JONES; VIZ: STANDARD AND POOR).* Then as Larry nears the end of the financial story, the director orders the videotape engineer to roll the tape on machine number 58, which is a commercial *(Roll VT-58).* As Larry finishes, the commercial is ready and the director calls for it to be switched on the air. The whole procedure, not including Smith's taped report, has consumed thirty-five seconds.

Notice that there are no visual instructions here in regard to the focal length, movement, or angle of the shot. This is partly because a standard visual routine

has been established for this show—usually a close shot, slightly off to one side of the performer—and the cameraman and director automatically set this up. If there are any hitches or innovations, they will be worked out in rehearsal or during the studio breaks when a commercial or a pretaped segment is on the air. In fact, many of the video cues that I have noted in the director's script would not be formalized, printed instructions but rather handwritten jottings that the director puts down whenever the show becomes more or less set. News programs of this kind, of course, are not finished until very close to air time.

Only broadcasters need to be so concerned with the split-second timing evident in this script. The network director must keep track of each second because he is operating *in* a network, with the time pressures that involves, and because he has strict obligations to both the advertisers and to the news itself. It can be helpful for novices, as a way of understanding television, to attempt to bring together a homemade news show with the same final precision that a network achieves. At the same time, everyone should realize that there is no inherent virtue in a videotape or TV program that is thirty minutes long as opposed to twenty-six or forty-one minutes.

Precise timing is also difficult for half-inch videotape users because they don't have access to the engineering facilities owned by the networks. Most noticeably, the less endowed studio will not often have the use of visual elements other than what the cameras are recording, whereas network news programs rely heavily on visual pieces inserted into the fairly straightforward and unexceptional broadcasting from the studio—the person behind the desk. This person's function is often simply to introduce the films, slides, and tapes that make up the news.

Film and Slides

Film and slides can be approximated in a homemade

studio. Professionals use a machine called a *film-and-slide chain,* or *telecine projector,* which looks like the mating of a film projector with a TV camera—which is what it is. A standard movie projector is focused on a mirror that angles the image to the video camera. This image, then, can be broadcast or fed to a videotape recorder. Lacking such a device, film and slides projected on a screen can simply be shot with the video camera. With this technique, moving pictures will flutter slightly, unless the projector speed can be adjusted. Slides, however, are often shot this way with effective results. Even on network programs, the "vizmo," or slide projected from the rear on a screen behind the speaker, is a common effect for headlines, photographs of people in the news, economic tables, etc.

Another useful and common technique is for a camera to "explore" a slide—a photograph of a painting, for example—zooming in on details, panning the whole scene, and so on. The frame of the video picture scans the scene slowly, emphasizing elements in the larger picture by isolating them, focusing and concentrating the viewer's perception.

Rear-screen projection will give the cameraman more freedom in shooting a slide, but front projection can also be used. Here the cameraman must devise a way to keep his shadow out of the scene, while still getting close enough. One method is to reduce the size of the projection as much as possible, thus permitting both slide projector and cameraman to get in close, so that the cameraman won't be standing between projector and projection. A projected image no more than two or three feet wide is still large enough to permit detail to be picked up by the camera's zoom. With either front or rear projection, the slides should be shown in a darkened room, so that the full contrast in the slide will come through. This is of course a video technique that can be used with any artwork that is large enough, such as maps, paintings, and the like.

Developing a Studio Production

When a video script of any sort is first written, it is
virtually all in one column: what will be said. What
the camera will do is most often decided *during
rehearsals* and is written down by anyone who needs
to refer to it—most of all the director. In preliminary
discussions with the set designer, the director will
necessarily already be forming his ideas, picturing for
himself where a scene will take place, from what
angle and with what kind of lens it will be shot. In a
dramatic production, when the actors are assembled,
he will spend some time having them read through
the script without moving, to begin developing the
characterizations and to discover the basic values in
the script. As soon as he starts to move the actors
around, however, the director looks at them with a
camera's eye, often consulting with his head camera-
man, deciding which shot is for camera 1, which for
camera 2, and so on. These decisions are noted,
in code and shorthand, in the appropriate scripts—
director, audio director, video director, floor manager,
and whoever else will need the information.

The actor, meanwhile, has written down his own
instructions, which he uses as a rehearsal guide.
On a particular line he moves to the telephone,
stopping exactly at a chalk mark on the floor,
and turns slightly to his right because at that
point camera 3 will be moving in for a close-up of
him. The cameramen, too busy with their hands to
worry about scripts, often have a large index card
taped to the camera beneath the viewfinder. This card
might contain a list of the shots they will be responsi-
ble for, a general description of each, and other
pertinent information that they may forget—there
are occasional problems, for example, in moving from
one shot to another so as to keep the cable untangled
and to stay out of another camera's shot. During
the rehearsals and the taping itself, the director will
be talking directly by headphone to the cameramen,

refining his original plans, and often reminding everyone of what they are supposed to be doing. ("Camera 3, tighten up on that shot. Camera 2, get ready to move to the sofa. Very tight, camera 3, frame it at her eyebrows. Take camera 3. Stand by camera 1 on the wide shot. Wait, the mike boom is in the picture—dolly in a fraction, camera 1. . . .")

A studio production is more "live" than film because all concerned are taking the risk that they can pull off a *sequence of events* without mishap, on the assumption that they will have gained efficiency and momentum in the process. Working in their favor is the fact that the number of possible shots available in a given studio on a given set with the given equipment is very limited, when compared with the possibilities of film or videotape outdoors.

The production of *The Orphan,* mentioned as a location shooting in Chapter VI, could have been shot in a makeshift studio if more than one camera had been available. The script of a short scene from this drama might have looked like this:

VIDEO	AUDIO
FADE IN	MUSIC FADES OUT
CU OPEN DOOR WITH SIGN: WILDMAN ADOPTION AGENCY	
ZOOM BACK TO MS AS TOM AND EILEEN COME IN DOOR AND STOP	TOM: I'm glad you decided to give up the baby.
MRS. WILDMAN ENTERS SHOT. REVERSE ANGLE MS TOWARD MRS. WILDMAN	MRS. WILDMAN: Can I help you? I'm Mrs. Wildman.

MS TOM AND EILEEN	TOM: We're Tom and Eileen Monroe. We're giving up our baby.
CU EILEEN'S FACE	We can't support her properly and we're not ready for her.
3-SHOT	MRS. WILDMAN: Please sit down and we'll discuss this.
FOLLOW AS ALL SIT AROUND DESK	
ZOOM TO CU OF BABY IN ARMS	

There are more video instructions here than a normal script would provide, but they help us to understand how the scene might be shot. If it were done with a simple two-camera arrangement, the set might consist of only that part of the room between the door and the desk. Camera 1 would be angled toward the door and camera 2 more or less toward the desk area.

Camera 1, then, would be called on to take the initial sequence—the close-up (CU) of the words on the door and the zoom back to show Tom and Eileen coming in, in a medium shot (MS). As Mrs. Wildman enters the scene, the director would switch to camera 2, which gives a front view of this new character. As this is happening, camera 1 is probably focusing on a tighter shot of Tom and Eileen, so that with Tom's line, "We're Tom and Eileen Monroe," the director can switch back to this shot. Once released, camera 2 would move to a close-up of Eileen, which will be his next responsibility. While that close-up is being recorded, camera 1 pulls back to a three-shot and prepares to follow this group on their move to the desk; once they are seated, he then zooms to a close-up of the baby, having worked out any focus problems in the rehearsal. (It is important, by the way, to keep camera 1 on the left and camera 2 on the right, no matter how much they move around, or everyone will get mixed up.)

To repeat: the same scene can be done very effectively with a single portapak, but if it were to look the same as the two-camera production, each piece of the scene would have to be shot separately, like a movie, with stops between pieces while the camera moved to its new angle. That is the whole difference.

Light

Conditions in a studio should be conducive, at the very least, to eliminating *poor* light. To light a tape *well*, however, is not easy. A film cameraman has the advantage in that he is usually lighting for just one angle—the picture only has to look good from where the lens is. In television, on the other hand, as shot after shot goes by without stopping, the lighting must do for all, close-ups and long shots, from the right and from the left.

Professional TV studios are equipped with an overhead grid from which many lighting instruments are hung—enough to illuminate, with whatever intensity the mood of the show requires, any corner of the room. TV studio lighting aims to cover any subject in three ways, and these may serve as a guideline for even the most rudimentary lighting systems. The camera operator should be concerned primarily with the following lights:

1. A *key light*—the main source of illumination for the subject in the picture—which may be one or more instruments generally mounted directly in front of the subject and at an angle high enough to give some relief to features without causing deep shadows on the face. If several people are together in a picture, the key light can be widened to include the group.

2. The *fill light*—less intense and direct and intended to provide general illumination over the whole scene.

3. The *back light*—instruments focused on the performer from directly overhead or from slightly behind. Back lights provide a barely distinct rim of light on the subject's head and shoulders and serve to distinguish him from the background.

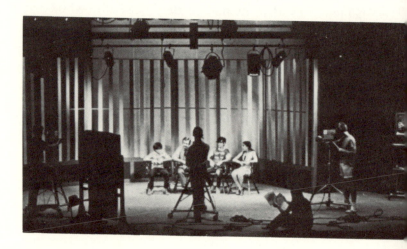

In addition, light is usually needed for the background itself, the walls of the set, but in a low key so that they do not overwhelm the subjects in the foreground.

Various manufacturers make lighting kits that fold up neatly into suitcases to be stored or carried around. These kits are generally lightweight and acceptable for many studio-type taping assignments, and they usually include five-hundred-watt spotlights with barn doors (blinderlike attachments used to focus light where it is needed and keep it off where it is not) and scrims (mesh screens that slide in front of the spotlight to give a more diffused effect). They also include the necessary stands, cables, and other minor accessories. Although these kits are quite satisfactory in many ways, we should emphasize that they are still only a makeshift solution for a studio. To investigate more permanent arrangements, check the many books on standard television production.

Settings

Settings, too, can be as elaborate or as simple as the video producer desires, but it is helpful to remember

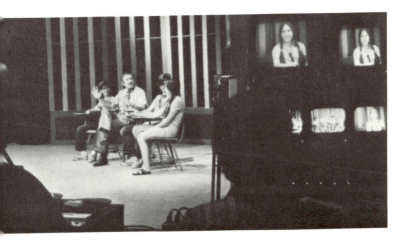

that settings need be no grander than what the camera can actually pick up, in terms of both size and detail. The panel discussion need not take place in an actual room, with a window and bookshelves (with real books) in the background, because for most of the program the background is no more than a blur. Certain recurring problems have to·be dealt with, such as the problem of *the desk,* which has troubled TV people since the medium was invented. A person behind a desk is usually noticeably obscured, and the desk itself has a way of looming ponderously over the whole picture. Changing the camera angle can help: if we are looking slightly *down* at the person, the desk is less of a problem. For discussions, talk shows, and the like, desks have occasionally been found unnecessary. However, the local NBC news program in New York recently attempted to eliminate desks, and the reporters were left floundering, tensely clutching papers because there was no place to put them, and trying to find the appropriate posture to announce the news while reclining in comfortable swivel chairs.

In general, the beginning director gradually learns how *little* in the way of settings is really necessary and yet how crucial a few realistic details can be in establishing a look of professional authenticity.

As with any tape, it is the *purpose* of the job, and the tastes and predilections of the producer or director, that will determine what the final tape will look like. If the ultimate goal of a particular tape is to provide instruction, how much will be gained by using an expensive set or specially recorded music? In another case, should the lesson be just told, or should there be some attempt at demonstration or dramatization? Does the use of a split screen contribute to or distract from the message? Ideally, the studio provides the means to answer questions of this kind in many different ways.

One of the exciting things about using a studio, even if it is not dazzlingly professional, is that a video

group can frankly imitate the forms that are familiar to us: news shows, panel shows, talk shows, quiz shows. However hackneyed the commercial products may be, we should notice that these too are people-oriented forms, and that, although there are many complexities involved in putting them together, they are constructed as direct, person-to-person experiences. To that extent they are pure TV, despite their stale content and sleepy traditions.

Working in a studio should be approached with the same spirit as roaming around with the portapak: the electronic resources are there to be used and experimented with, and tapes will come most alive when a group has learned the vocabulary, passed through the imitation stage, and is learning new ways to reach out and communicate.

Fifth Graders Make a Videotape

Along with mini-skirts and mini-cars has come a mini-news television program developed by mini-producers, directors, and announcers. The presentation is a twenty-minute news show, written, produced, and filmed by fifth-grade students at the Thomas W. Butcher Children's School, a laboratory school at the Kansas State Teachers College, Emporia, Kansas.

The class and its teacher originated the idea of a videotape program after seeing the equipment utilized in the building for teacher education courses. Because of interest in the classroom debates on social and political issues which they had just completed, they decided to do a news-style show. Every step of the program was organized by the students. They wrote their own script, designed the format of the show, provided student cameramen, directors, two student newscaster anchor men, and various other newsmen and newsworthy participants. The program was taped by the class cameramen, using university videotape equipment.

The program's format was planned to provide in-depth coverage of various topics. Those areas chosen

would surprise and inform most adults. These were
the major aspects:

A poll was conducted through "Man on the Street"
interviews with persons passing in front of the school,
on the topic "Is it ever right to break the law?"

Student protest did not escape the fifth graders.
They did a feature on "People Who Protest" with an
actual reenactment, complete with placards and
marching. Other news items were information reports
on "Gift of the Nile" and the "History of Peru."
A probing look at "The Challenge of City Living"
had a student newsman interviewing a girl in the class
who actually had lived in Detroit. The program
was rounded out with three student scientists
reporting on outer space and a final interview with
a girl author (each student had written a book a few
weeks before) on "How to Raise and Train Your
Puppy. . . ."

It was found that in their short association with
videotaping so far, the children improved in the
language arts—writing, spelling, speaking before
others. The advantages didn't stop here, however. It
definitely increased their interest in and knowledge of
the social and physical sciences. By researching various
topics and getting accurate information for broad-
casting, the students shared a wealth of knowledge
with each other in an interesting manner.

Janice I. Wilkison
Instructor Magazine

"My experimental television is not always interest-
ing," admits Nam June Paik, "but not always
uninteresting; like nature, which is not beautiful
because it changes beautifully, but simply because
it changes." Paik is the embodiment of East and West,
design scientist of the electron gun, pioneer ecologist
of the videosphere. . . . "Television has been attacking
us all our lives," he says, "now we can attack it
back. . . ."

There are approximately four million individual phosphor tracepoints on the face of a twenty-one-inch television screen at any given moment. Paik's canvas is the electromagnetic field that controls the distribution of these tracepoints in horizontal and vertical polar coordinates at 525 lines per second. By interfering, warping, and otherwise controlling the cathode's magnetic field, he controls the four million glowing traces. . .

Paik has outlined three general areas of variability with these techniques. . . . The first level of variability is the live transmission of the normal broadcast program "which is the most variable optical and semantical event of our times. . . . The beauty of distorted Nixon is different from the beauty of distorted football hero, or not always pretty but always stupid female announcer." Paik estimates that he can create at least five hundred different variations from one normal broadcast program.

The second level of variability involves the unique characteristics of circuitry in each individual television receiver. Paik has resurrected several dozen discarded sets from junkyards and brought them back to wilder life than ever before in their previous circuits. "I am proud to say that thirteen sets suffer thirteen different varieties of distortion," Paik once announced, and then added, "1957 model RCA sets are the best." By altering the circuitry of his receivers with resistors, interceptors, oscillators, grids, etc., Paik creates "prepared televisions" that are equivalent in concept to David Tudor's prepared pianos.

The third level of variability is the manipulation of these prepared TVs with wave-form generators, amplifiers, and tape recorders to produce various random, semirandom, or completely controlled effects, examples of which are: (a) the picture is changeable in three ways using hand switches; upside-down, right-left, positive-negative; (b) the picture can become smaller or larger in vertical or horizontal dimensions separately, according to the amplitude

of the tape recorder; (c) the horizontal and vertical electron-beam deflection of normal TV is changed into a spiral deflection using a yoke oscillator-amplifier, causing an average rectangular picture to become fanlike; (d) the picture can be "dissipated" by a strong demagnetizer whose location and rhythm contribute variety; (e) amplitude levels from radios or tape recorders can be made to intercept a relay signal at the grid of the output tube so that the picture is visible only when the amplitude changes; (f) asymmetrical sparks flash across the screen when a relay is intercepted at the AC 110-volt input and fed by a 25-watt amplifier without rectifier; (g) a 10-megohm resistor is placed at the vertical grid of the output tube and interacts with a sine wave to modulate the picture; (h) wave forms from a tape recorder are fed to the horizontal grid of the output tube, causing the horizontal lines to be warped according to the frequency and amplitude.

Once a set has been thus prepared, the simple flick of a switch results in breathtakingly beautiful imagery, from delicate Lissajous figures to spiraling phantasmagoric designs of surreal impact and dazzling brilliance. Tubular horizontal bands of color roll languidly toward the viewer like cresting waves; flaccid faces melt, twitch, and curl, ears replacing eyes; globs of iridescent colors flutter out of place. When videotape playback systems are used as image sources instead of broadcast programs, the extent of control is multiplied and the visual results are astounding.

Gene Youngblood
Expanded Cinema

VIII. Working with People

Production personnel
sometimes refer to those in front of the camera as "the
talent"—not necessarily in tribute but rather as a
handy way to distinguish the idle performers from all
the hard-working technicians. Working outdoors or in
a studio, with a portapak or an elaborate studio
camera, videotape makers can become so concerned
with the equipment that they neglect an essential part
of the whole experience: the people who are the
subject of the tape.

These people are not always "talented" in the
normal sense of the word, but most of the time they
don't have to be because the tape is more likely to be
concerned with them as people than as performers.
Techniques for helping people to relax and reveal
themselves as people, however, are virtually the same
as for helping them relax in order to play a role,
and in both cases the goal is the sort of reality and
informality that works best on television. McLuhan

says, "The TV actor does not have to project either his voice or himself. . . . TV acting is so extremely intimate, because of the peculiar involvement of the viewer with the completion or 'closing' of the TV image, that the actor must achieve a great degree of spontaneous casualness that would be irrelevant in a movie and lost on stage." Whether acting, or just being himself, the television performer is best when he is as unselfconscious as possible.

Interviewing

The interview has developed into the classic television method precisely because of its rough-edged informality. This holds true for the rambling exchange on a late-night talk show, the postgame analysis with the winning pitcher, the veiled hostilities of a press conference, and all the other shapes and sizes of the basic informal conversation that we might include under the label "interview." Consider how much of this would indeed be irrelevant in a movie— all of the false starts and backtracking, the stutterings, misunderstandings and recoveries that we follow with great interest on the home screen.

One factor that contributes significantly to the interest of almost any interview is the compulsion to truth and honesty apparently felt so often by both interviewer and subject. It sometimes seems easier for a questioner to talk directly about personal matters on videotape than when just sitting alone with the subject in a room, and, similarly, the subject seems more compelled to answer. Many people, for one thing, feel an obligation to the fact that their words are being *recorded*—the interviewer instinctively reaches for something significant, and the subject instinctively tries to provide it. Ironically, on some of the television talk shows, it is perhaps the very pull of this demand to record the truth that forces so much inane frivolity: frantic contortions to avoid what would be easiest—a simple, honest conversation.

Almost any documentary-type tape will rely in large measure on interviews. The visual record of, for example, a club, a team, a place, or an activity will need the glue of conversations *about* the subject—used directly or as voice-over descriptions of what is taking place visually—to hold the tape together and to give it shape. The alternative is to make heavy use of a narrator, which has a deadening effect on any tape.

I was involved in documenting a project in which a Manhattan community group took control of a filthy empty lot, cleaned it up, worked with architecture students to plan a playground, and finally built the playground with their own hands. The whole project

took nearly nine months, and I was able to tape pieces of the process as it went along. Visually, the tape is interesting because it shows vividly the "before, during, and after" stages of the vacant lot, evolving from a rat-ridden dump to a clean and happy playground. What is most effective about the tape, however, is the interviews—interviews with kids before and after, with parents, with the architects, with members of the committee. Even so, when I came to do the editing I realized that more information was necessary. I could have done an impersonal narration or voice-over, like a news reporter, but instead I went back to the organizer of the project and taped a conversation with him that covered the gaps. The informality and authority of this final interview, which is used throughout the tape, seem to knit the many segments of the documentary together.

When a documentary is devoted to a very general topic, material is often gathered by going into the street and taping random interviews. A group doing a video study of population growth spoke not only to experts but also took their portapak to playgrounds and talked to young mothers. Another group made

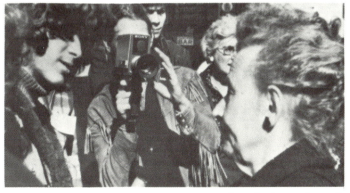

a tape for an organization concerned with the rights of mental patients, taping dramatic footage of confrontations between them and institutional authorities; as a sidelight, they also went into the street to get

the opinions of ordinary people. The first question to a passerby was, "Have you ever been a mental patient?" and a surprising number of people were intrigued enough to stop and volunteer their thoughts. One or two had indeed been patients and didn't mind speaking about it.

People will talk. They will talk for NBC or CBS and they will just as happily talk for the roaming videotape maker; just the appearance of a microphone is often enough to induce people in the street to drop their inhibitions and speak their minds. They will talk, in fact, even when they probably shouldn't, and much of the responsibility is on the *interviewer* to protect the privacy of the subject. Respect for the people he deals with will automatically balance the interviewer's desire for frankness, and the portapak will not become just another way to pry into people's lives.

The shy person can, of course, be encouraged and supported, and here, the experience and talent of the interviewer are important. A pleasant and ingratiating manner is necessary with strangers, as it would be under any circumstances, and the interviewer must be

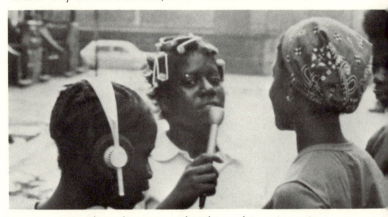

secure enough to *listen* to what his subject is saying, without feeling pressured to keep on too rigid a track. The conversation can then be steered in a natural way to find answers to the questions the

interviewer is interested in. He should not be too eager in any case to jump in and "keep the interview going" because one can never be sure when something remarkable may pop out of anyone's mouth. This kind of tape will inevitably have to be edited. It won't matter, then, if an interesting talker should wander from the subject or stop dead in thought. If there is any possibility that he will eventually say something interesting, he should be given the chance. Although devoted to a particular subject, a tape like this cannot be preshaped, and it is the odd turns and quirks of interviews that decide the final result.

Studio Performing

A panel discussion or interview in a studio is a different matter, of course, where a multicamera setup is taping an entire discussion without stopping. Here the interviewer has the difficult job of balancing his willingness to let the subject expand in any direction with the necessity of keeping the overall tape, with its restricted time limit, on a straight track. Another problem in the studio is that the same person who might be eloquent on a street corner may become stiff as a board when sitting behind some studio desk, squinting into the lights. Often studio tapes are made by performers who are not performers at all: a company vice-president or a chemistry professor, for example. If the vice-president must make a speech or the instructor give a lesson, a way must be found to encourage them to be themselves, to let their individual personalities emerge.

Reading a speech from a script, needless to say, is almost always an awkward procedure. If word-for-word accuracy is necessary (and it almost never is) the performer might read his speech or lecture from a teleprompter. The informality of television, however, lends itself to less exact approaches, and tapes of this kind will work best when the speechmaker is

operating only from notes—which he can have in his hand for all the world to see, or which may be written on large cue cards (or "idiot" cards) that the floor manager can hold up at appropriate moments. Even more informality can be gained if the vice-president is interviewed by someone whose job is to elicit all the important points, or if the instructor tries to get his message across in a work session with several students. In either case, (a) the viewer would be more involved because some process would be happening on the tape, instead of the sterility of a speech, and (b) the performer would be more relaxed because he would be *doing* something— the key to successful performing.

Acting

Basic acting techniques can be helpful, in this regard, for speechmakers, instructors, and others who may be inexperienced with the TV medium. At its simplest level, again, good acting is a concentration on *doing* something. This does not mean that the performer is always physically active, but rather that as a character he is always trying to *accomplish some objective,* even when he may appear to be standing or sitting quite still. At a certain moment, a character's goal may be to reassure someone, or to encourage someone, or to embarrass, or to shame, or to amuse, or anything else under the sun. But he has specific, if often unconscious, tasks to achieve, just as people do in life; if he has lines, they too are spoken to achieve some purpose.

It is more difficult for the speechmaker to find such concrete goals, but any TV performer is most relaxed if he has a task to perform—even if it is no more than listening to and answering an interviewer's questions. That, in itself, helps to focus his mind on the topic rather than on himself. Props can often be a help toward making the tape seem more natural—as long as the props are honestly connected to the theme

and not so hard to handle that they betray the nervousness of the performer. Even experienced actors often require felt cloth on the bottom of teacups to eliminate rattling, and it is not fair to ask an inexperienced and uneasy teacher, for example, to perform movements that are even vaguely intricate. If simple demonstrations are necessary for a presentation, they can be done by someone else and shown on a split screen or in an entirely separate shot. (This is commonplace on commercial TV; the hand seen pouring the beer in close-up seldom belongs to the huckster holding the bottle in the previous shot.)

In studio tapings, performers will sometimes panic at the idea that they cannot stop and start over whenever some minor fluff occurs. It is probably most helpful to remind them that television is full of fluffs and that spontaneity, fluffs and all, is more interesting than stony precision.

A similar problem sometimes presents itself with young people who, because they are afraid of failing, have trouble improvising and being spontaneous, whether the tape is a drama or a plain discussion, in the studio or even out in the street. I worked once with a group of boys and girls who, while trying to improvise a short adventure tale, spent most of their time memorizing what they were going to say, stopping themselves in frustration at any missing preposition or conjunction. The result on tape was glassy-eyed stares from all of them as they pronounced the dramatic dialogue, straining for exactness and entirely forgetting the situation.

With practice, the group began to understand a scene in terms of *what happens* rather than *what is said*. This basic principle holds true even in studio or otherwise planned situations when the dialogue is necessarily memorized. The words may have to be correctly spoken for all kinds of reasons—to provide cues for camera and director, and to properly convey the playwright's vision—but the scene will be

dead unless the actor has a clear and active grasp of what the character is *doing,* what he is after.

Where there is a director, it is his job, whether the tape is scripted or improvised, to present a given scene to the actors in specific active terms. An improvised scene should not be described as one in which one character says, "Are those the diamonds there?" and then the other character says, "Well, I don't know. Maybe so—" and then the first character says, and so on. Rather, the same scene should be described as one in which one character tries to get the diamonds and the other character won't let him. The *action* is clear; let the actors take it from there. Likewise, even a scene that actors have conscientiously learned should, in rehearsal, be referred to constantly in terms of action—what is happening—rather than in terms of dialogue. In time, dialogue becomes second nature, and the actor is free to play the action of the scene.

There are many books that contain examples of acting exercises—so-called game exercises (based on the rules and objectives of children's games) and "method" exercises, based on techniques developed by American followers of the great acting teacher Stanislavsky. Both of these types of exercises have value, both concentrate on action, and both, by the way, make valuable subjects, in themselves, for video workshops. The definitive "game" book is *Improvisations for the Theater* by Viola Spolin (Evanston: Northwestern University Press, 1963). In one exercise, for example, a player starts a pantomime activity in a specific but imaginary place (pushing a cart at a supermarket). As other players see and understand what he is doing, they may join him in that place, doing whatever other activities are appropriate (operating a cash register, stamping prices on boxes, weighing, etc.). Soon all of the players may be involved in the place and interacting, wordlessly, with each other. Such an exercise can be taped and then replayed immediately for the group. Out of this they

may discover where concentration gave way and where flashes of creativity emerged, and the visible relationships in the scene may stimulate them to suggest further games and further scenes. Spolin's book is full of other imaginative exercises.

Actually, most young people are amazingly free in their acting for videotape, even though they may be extremely inhibited in front of an audience. The audience experience is not only embarrassing, but it seems out of the ordinary—it is easy to dismiss stage acting as a peculiar and rarefied activity. TV acting, however, is in many cases not even considered acting. It is simply the normal behavior one sees on TV, and therefore comfortable and fun to imitate. There will be new dimensions to learn, of course: young performers may be interested to discover such things as the *spatial* limits of a scene—that you can't normally continue a story from one room to another without stopping to regroup in the second location, or that slight adjustments in placement can allow everyone in the group to be *seen* in a shot as well as *heard*—technical problems. TV behavior, however, is certainly not new, and most people tend to fall into it quickly and gracefully, and, what is most important, to enjoy it.

OPHULS: People have a great urge to communicate because of loneliness, because of insecurity, because of bottled-up complexes. To exploit this professionally brings its own problems and depressions for me. As a filmmaker you're always doing that, exploiting. It's part of modern life.

Q.: Was there something you thought you wouldn't get and then the person turned out to be incredibly amenable?

OPHULS: Oh yes, all the time. It happens much more than the opposite. One example is Klein, the shop-keeper in *The Sorrow and the Pity*. He had placed an ad in a local paper in 1941 or '42 stating that he was not, despite his name, Jewish. He was of course trapped to some extent because he did not know when I began asking questions that I had seen the ad, but he knew everything else. He knew I was making a film about the occupation of France, he knew I was going to ask about what he was doing at the time, and what he had observed at the time, and even

the revelation that I had read the ad did not throw him at all. Well, he was thrown, but not sufficiently to say "get the hell out of here." We were all ready to drop the camera and go, in which case we couldn't have used the interview, because we can only use interviews when people are willing. . . .

Q.: Could you describe your interview technique?

OPHULS: You sort of involve yourself in what you're doing by the questions you ask and this then replaces what used to be the function of commentary in documentary filmmaking. You create a sort of mosaic of information and that leads logically to a certain technique of cross-cutting and a certain technique of telling the story. . . . This type of interviewing technique and putting interviews back in fashion (you know, they were out of fashion) has to do with the movement that occurred generally in Europe four or five years ago when there began to be a consensus that there is no such thing as objective reportage in television, or that if there is such a thing it is apt to be dull and bland and not really say anything. Once some people realized this and started to find reasons for this and analyze it, the technique developed.

> Marcel Ophuls
> Interviewed in
> *Filmmakers Newsletter*

Cold Spring Dock

Carole and I went down to the fishing dock in Cape May and talked to the old and young fishermen. At first they were a bit defensive, but once they saw themselves on the monitor they were fascinated. They finally opened up to us and we got a very heavy conversation going on among the men of all ages. They talked about the threat of nature, dying, education, the poetics of the sea, the futility of the

future, and the Russian vessels. Since some of the men were local and the town thrives on its fishing industry, this tape brought us a whole new audience.

This is one of our favorite tapes; it really illustrates the concept of letting people tell their own story.

Mayor Gauvry

The mayor of Cape May made a tape with us sitting on a bench at a busy street corner in town. We wanted the tape to be informal and true to the nature of Cape May. People passed and stopped to talk. We raised every controversial issue in town. . . . In playing back the tape, the mayor became quite enthusiastic about using video for City Council meetings, etc. The tape ran three times over cable that week.

Gar at the Gas Station

This was Gar's first tape. One night, while on the all-night shift at the gas station, he brought the equipment with him and made a tape. It is a lovely self-portrait and one really gets the feel of the gas station and the people who come all night. It is very personal, and we were happy to see a tape of this nature; it alleviated our natural fear that people might imitate broadcast. I think this was a result of how video was introduced. Though the product for cable is important, the emphasis was always elsewhere.

Gar put the camera on its tiny tripod on a shelf and shot down at himself.

Catalog
Alternate Media Center

IX. Editing

Editing is one of the most
fascinating aspects of videotape and at the same time
one of the most complex and even controversial. I
have tried to suggest that taking pictures with a video
camera is a simple, almost instinctive, procedure.
Organizing the material that has been shot so that it
evolves into a coherent and interesting pattern, how-
ever, is another matter.

We have noted that film is, in essence, an edited
medium, and television seems somehow more live,
more real, and less tampered with. Even the network
show, shot in the studio and "edited," so to speak,
as it goes along, is still taking place in a single,
seamless time span, with nearly everything recorded
just as it is occurring in the studio. To an even greater
extent *outside* the studio, the orientation of videotape
is toward a gradually unwinding process and toward
the casual minutiae that are necessarily bypassed
in the rushing and hard-edged momentum of film.

Editing vs. "Real Time"

Thea Sklover, the director of Open Channel, a New York group dedicated to expanding public access to cable television, says:

> We encourage people to try "real-time" programming, that is, programming without any editing. Our intent is that neither shaky, amateurish camerawork nor slick, professional editing should intrude on the content. One of the best examples of real-time programming was the telecast by the Alternate Media Center at New York University of a thirty-three-hour marathon community school planning weekend in Greenwich Village when teachers, parents, architects, and social scientists worked for three days and nights to develop plans for an experimental school. . . . If one couldn't actually participate in all the sessions, one could watch from his home because the meetings were also carried on the cable.
>
> . . . The format of broadcast television news—abrupt one- or two-minute film clips and a newscaster reading a script—removes us considerably from the essence and purpose of the subject matter. The world is much more than just this heavily edited, "hard" news parade. We tend to forget the personal importance and impact of everyday, commonplace events.

Letting "content" speak for itself, however, is a goal not always easy to achieve. Even when a tape is recorded in "real time," scores of editorial judgments are constantly being made by the director and/or cameraman as they choose to take a close-up at one moment and a medium shot at another, to concentrate on the person listening rather than the person speaking, or vice versa, to shoot from a low angle or a high angle (which will subtly influence the viewer's response), and so on. If they simply plant the camera so that it will take in everything in one master shot, one cannot escape the feeling that the potential of the TV medium has been ignored.

Also, even though the "real-time" broadcast of a

long community meeting may be of interest to the members of that community (who are, of course, its primary target), it may be decided later that the meeting could be shown to other communities with similar problems. Inevitably, someone would have to boil down the thirty-three hours to manageable size, thus exercising editorial judgment about what is important and what is not.

There is, further, the unavoidable fact of an aesthetic ingredient in all but the most prosaic videotape uses. Although it is an extraordinary communications device, videotape is *not* like the telephone, which is simply an open channel for messages and which everyone uses with virtually equal skill. Tape must be managed and molded, in the camera as it is shot as well as in the editing process. As a communications tool, videotape is never neutral, never transmitting pure "content," and it is always expressing some particular point of view. The degree to which anything is successfully communicated depends at least partly on the molding and managing talents of the tapemaker.

Several conclusions with regard to editing emerge from all this.

1. Videotape makers should always be seeking ways to best utilize the unedited real-time flow that the equipment is capable of (that film is not capable of).

2. Large editorial decisions in social or community work should be made, as much as possible, either by, or in consultation with, the people directly involved in the project, those who have first-hand knowledge of the subject and the situation and who have a clear grasp of the purposes of the tape. In this way, no impersonal "news editor" can make judgments about the importance of any event. At the same time, the group that is the subject of a tape should understand that editing will not necessarily "intrude on content" any more than camera work will, but that editing is rather another tool to *improve* communication and make full use of the medium.

3. The tapemaker, for his part, should be fully aware of the power he has, both in shooting and editing, to interpret reality. Distortion, to some degree, can scarcely be avoided, because life cannot be captured in a totally faithful slice by any camera. The tapemaker can only be honest to his view of what he saw (or the view of his consultants) and not make up things later because, for example, he happens to have a nice segment of tape which is very interesting but thoroughly misleading.

It would also be helpful if those who make use of videotapes for analysis or study—therapists, teachers, social workers, or whatever—would also bear in mind the particular nature of tape: the fact that, edited or not, tape is always a selection and cannot ever provide the complete context in which something was said or done. A person using tapes can make useful judgments about *what he sees,* but he should not assume either that what he sees is a scientifically exact copy of reality *or* that he is being lied to. What is needed on his part is a measure of sophistication about what a tape is and how it should be viewed— but then this attitude is necessary for everything we see on television.

Camera Editing

The most basic type of editing is *camera editing,* a technique that is possible with video more than with film because the video camera can erase what has been shot and can add another scene in its place. If the videotape maker has a very clear idea of what he wants the final tape to look like, and if he is forming a coherent pattern out of the various scenes he is recording, then the completed tape will be in the proper sequence and no further editing may be necessary. As he is going along, if he should make a false start, or if a particular scene does not contribute to the overall shape that he is building, he will rewind, watch the viewfinder to find the exact

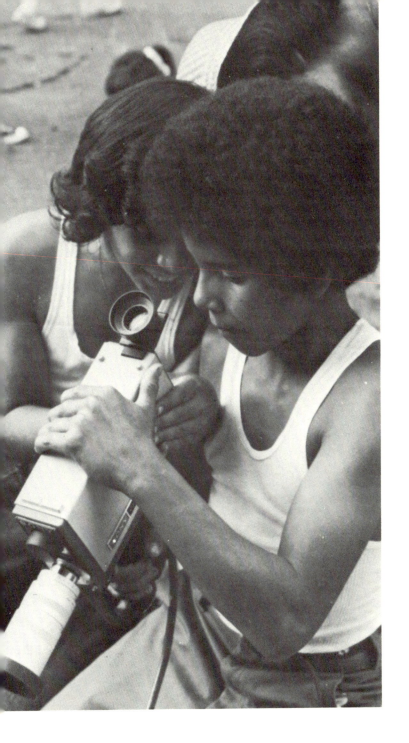

point where he went wrong, and then shoot something else over it. He can do this as many times as he likes, until he has what he wants.

This technique can most successfully be used in a tape that is thoroughly planned and predictable, such as a drama, so that nothing gets into the tape that doesn't belong there. In a film, of course, if the script calls for scene 1 to be on a rooftop, scene 2 in the basement, and scene 3 on the rooftop again, the director will probably shoot scenes 1 and 3—both on the rooftop—and then move down to the basement for scene 2. The three scenes will be put into the proper sequence in the editing room. Video editing in the camera, however, requires climbing up and down, doing the scenes in their final order. This is obviously more trouble, but it is workable for those who may not have an editing deck.

One problem with camera editing: each time a new take is recorded there will be a momentary roll or slight breakup of the picture, resulting from the unavoidable second or two that elapses before the deck is moving at speed. For this reason, camera editing can never have as finished and professional a look as editing between one deck and another.

Electronic Editing

Technically, editing videotape with two decks is an

electronic process of *copying* segments from one or more tapes onto the final edited tape. Unlike film editing, there is no cutting and pasting and therefore no possibility of destroying the original. Tape *can* be spliced, but there are many reasons not to: (1) the helical scan configuration and the opacity of the tape make it virtually impossible to read visually and to cut accurately; (2) less than perfect splices may be rough enough to damage the video record heads. In any case, most of the time, splicing is simply not necessary. It is true that copying one tape onto another does result in a slight loss in quality and diminished stability—copies of copies, particularly after the third generation, are noticeably inferior— but there is no discernible difference between the original and the first edited copy.

Editing then is basically a matter of assembly— recording a bit from tape A, a bit from tape B, another bit from tape A, and so on, onto a final tape. Unless the two decks being used have a common sync pulse, however, there will be a considerable breakup in the edited picture at the start of each new segment. This problem is avoided by using a machine that has specific editing capability. In simple terms, a component of the copying machine, called the *capstan-servo*, pulls the tape along exactly in sync with the deck which is providing the incoming picture. The two are locked together, so that if the incoming pulse should vary, the motor will follow that variance. What happens in the editing process, then, is this: both machines are operating at speed; when the "Edit" button on the copying deck is pushed, both decks lock together in sync; when the "Record" button is pushed, the new information should be recorded on the copying tape with no roll or breakup at the start. (The popular Sony editing deck, model AV-3650, lists at approximately $1,300. Panasonic has recently introduced a more sophisticated and more expensive model, NV-3130.)

With an editing deck, any other deck can be used

163

to feed in the original tape—the portapak, a table
playback unit (Sony AV-3600), or another editing deck.
The connections are simple to make: *video out*
on the original deck to *video in* on the editing deck,
line out (audio) on the original to *auxiliary in* on the
editor. Each deck must have its own monitor.

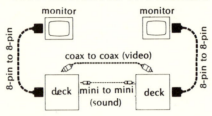

The portapak must have its own special connection
to be used in an editing system. This is called an
octopus cable, and it is attached to an 8-pin female-
female connector which in turn is attached to the
8-pin-to-10-pin cable that comes with the deck.

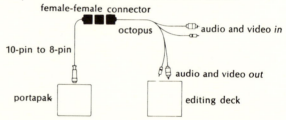

Cueing

Despite the many good features of the new editing
decks, the technology is still relatively primitive and
not capable of the split-second, absolutely clean cuts
possible with film and with one-inch or two-inch
tape systems—at least not every time. Editing,
consequently, often involves trying a particular cut
over and over until one has caught the exact cue
and is satisfied with the sharpness of the transition.
This is not made any easier by the fact that both the
original and the copying deck must be moving
at speed when the "Record" button is pushed. Thus,
cueing becomes the biggest problem in editing
half-inch tape.

The cue on the original tape is the precise beginning of the segment to be copied; the cue on the copying tape is the precise end of the previously copied segment. Both machines must be set in motion, and both cues must be reached simultaneously. There is no guaranteed way to achieve this because no two machines operate at exactly the same speed, nor does even a single machine operate at the same speed all the time.

All cueing methods are ways of backing up the two machines so that, even though they may be moving at different speeds, they will both hit the finish line—the simultaneous edit cue—at the same time. The counter on the face of the deck is one measure, but it is unreliable: counters vary from deck to deck, the reel speed varies depending on how far along the reel is, and as the tape is wound back and forth the measurement slips; a cue that was originally found at 100 on the counter may later be at 97 or 105.

In any case, the first stab at editing should be as follows: (1) Set both counters at 000 at the exact point of both cues. (2) Rewind each deck to 995. (3) Turn them both to "Forward" at exactly the same moment. (4) Watch the counter numbers as they wind forward and when the *slower* machine reaches 000, turn off both machines simultaneously. Thus, one counter will read 000 and the other will read 001, 003, or what have you. (5) Rewind again, putting the 000 deck again at 995 and putting the other as many numbers below 995 as it ran over, so that if it ended up at 001, it would be spotted at 994, etc. (6) Start them forward again. The two cues should now come up at the same time.

A similar procedure can be done with a stopwatch instead of the counter.

A different system is described in H. Allan Fredericksen's *Community Access Video* (see bibliography). His suggestion is as follows: (1) Set up the tapes on both machines so that they are at the exact edit point. (2) Put a mark with a felt-tipped pen

on the back of the tapes just past the audio record head. (3) Manually rewind each tape until the mark is even with the tension bar. (4) Then put *another* mark on each tape just past the audio record head. (5) Rewind again until *this* mark is even with the tension bar. (6) Start both machines at exactly the same moment. When the first mark passes the audio record head, push "Edit"; when the second mark passes, push "Record." (It is important, incidentally, on the Sony equipment at least, to push these buttons firmly and decisively to have the best chance of a clean edit.)

There are other editing systems, and some dealers will make modifications on the equipment to ease the editing process, but precise edits cannot be made by mechanical systems alone, no matter how ingenious. The equipment is just not that refined. The editor must primarily keep his eye on the *monitors* (once his system has been set up) because it is only from watching the tapes themselves that he can be absolutely sure the cues will match at any given time. There is inevitable trial and error involved, and both patience and luck are necessary.

For rough edits, this process can be speeded up by using the "Still" button on the original deck. This is particularly useful when editing from a portapak to a larger deck because the "Still" control on the Sony AV-3400 portapak is so easy to handle. In this technique, the cue on the original is found and the tape held at that point on "Still." Then there is only the copying deck to worry about. The cue on the copying deck is found, that deck is rewound five or ten numbers on the counter and then started forward again. The "Edit" button is punched. When the copying deck comes to *its* cue as seen on the monitor, the "Still" button on the original is released just as "Record" is hit on the editing deck. These are rough edits because, although the record heads are moving while the machine is on "Still," when the picture begins moving again there may be a slight stutter or

instability. Where it is possible (where the incoming cue does not have to be precise to the split second), it is a help to release "Still" on machine A a second or two early, so that both machines are moving normally when "Record" is pushed on machine B.

A word of caution about this procedure: when the tape is held in the "Still" position, the record heads continue to scan the stationary tape. If this situation should occur too often or go on too long, the heads may remove oxide from the tape, and this is not good for either tape or heads.

Although sound and image are synchronized perfectly, they are actually being recorded at slightly different times because the two record heads are physically separated; when the "Record" button is pushed, the picture is picked up instantly, but there will be no sound for a second or two. Thus, if a piece of tape is copied which is supposed to begin with a man saying, "The mouse ran up the clock," it will have to be recorded starting several seconds earlier, at some point during, "Hickory, dickory dock"—but we will not hear any sound until the desired cue. Similarly, if we cut to a different scene after "the mouse ran up the clock," the picture will switch at the right place, but we may have a few words from the next line lingering on mysteriously in the next scene.

This problem is not nearly as severe on recent Sony equipment as it has been, and there is always talk that it will ultimately be corrected altogether by the major manufacturers. In the meantime, many dealers and servicemen can eliminate this problem in the deck. In any case, the following two principles will help to ease the aggravation:

1. Editing must be concerned, almost primarily, with sound, and cues from one segment to another must nearly always be sound cues. This is occasionally inconvenient, but it does serve to remind the video operator that sound is more than 50 percent of the finished tape. In the editing process, he will be looking for transitions, cuts between one segment and another,

that are based on the sound track; he will have an ear out for the helpful pauses that may give a graceful beginning or end to a certain segment; he will be building the edited tape in terms of what is said even more than what is seen; and, in time, he will develop the ability to start a particular recording exactly on cue, even if the cue is buried in a thicket of other words and sounds.

2. *Outcues* are important for both sound and picture at all times. The editor must know how and when a certain segment ends. The outcue for video may be established in only a general way, and in fact it is always wise to record more video than one is going to use; the unwanted part will be erased when the next segment is added, and in the meantime there is a greater margin of safety at the transition point. The outcue for audio, however, is crucial, because sound must be stopped *precisely* at the end of the segment. One way to achieve this is to *pull the audio plug* from the editing deck at the exact moment that the sound must stop; the silent picture may continue on. This leaves a good, clean cue when the next section is added, and, more important, the sound has its full impact without being muddied up by extra words and half sentences.

Another method is to turn the Manual Gain Control to zero, and to leave the switch on Automatic while recording. When the cue is reached, the switch is thrown to Manual, which has the effect of simply switching it off. (Other than this, it seems to me better to leave the Gain Control—both audio and video— in Automatic, unless a valuable section of sound or picture is clearly poor and experiments have shown exactly how the dial should be set to improve it.)

Rough Edits

Tapes are edited from the beginning to the end, each segment built on top of the previous one in the

sequence. This is because half-inch tape is not as adaptable to *inserts* as film is. Manufacturers claim an insert capability for half-inch tape, but as a practical matter, since segments are being copied onto a final tape rather than spliced together, there is no way to separate two pieces, *unstick* them, so to speak, to insert a new piece in between. The whole thing must be rerecorded and the so-called insert recorded in its proper place.

For this reason, many people think it is important to consider the first edit of a particular tape as a *rough edit*—not a finished product—and indeed some of the most serious video workers will go through many edits as they gradually refine the structure of their tape. After a tape has been assembled for the first time, for example, the editor may see that, in terms of the whole, one section is too long, another too short, or that a certain section should not be included in its entirety but should be broken into smaller pieces. In similar circumstances, a writer or a film editor can attack a rough draft directly, snipping out some sections and transposing others. The videotape editor, however, must make notations of what to change and then go back and re-edit the entire piece.

It is a time-consuming task, particularly if the tape most go through a number of rough edits, but a finished and professional-looking tape often requires this kind of patience. With each new attempt, the editor will become more precise with each cut, his sense of where music or narration may be used becomes more secure, his sense of what is essentially extraneous or self-indulgent becomes sharper.

Not all tapes—not even most tapes—need go through such thorough refining. The tapemaker should consider carefully the *purpose* of the tape in order to determine the amount of professional polish it requires. If immediacy is important, heavy editing is beside the point. For the majority of cases, a single edit, if it has been well prepared for and is carefully done, may suffice.

Cataloging

The first ingredient in being well prepared to edit is to be thoroughly acquainted with the raw footage—everything that has been shot. Each editor must devise for himself some basic cataloging system, so that at least the following information is written down: Column 1, the counter number; Column 2, Video—what the picture is at that number, whether it is of serviceable quality, and some indication as to whether it bears an important relation to the theme of the tape; Column 3, Audio—the same as Column 2, but for sound. If the editor is doing his own cataloging, his notes can be more personal and code-like than if the list is being compiled for someone else. (In fact, trying to edit a tape from someone else's notes is difficult because there can be little real objectivity in these written descriptions. The editor will inevitably end up going over the footage himself, making his own catalog. If a group is working on a tape, one person's catalog should do for everyone because presumably everyone will be familiar with the original tape and will use the catalog as a reminder.)

No amount of lengthy and precise description of what is taking place, camera angles and movement, sound quality and the like, can replace simple immersion in the tape itself—watching it over and over again, so that the potential rhythm and flow of the edited version begin to emerge from the basic footage. I have found it valuable myself, after watching an unedited tape several times, to list the moments that would seem most likely to contribute to the final version. One can then work from the list rather than from the tape. Perhaps repetitions will appear on the list, and choices will have to be made among similar scenes. A particular scene may stand out as an intriguing opening, another long scene as a necessary *weight* for the tape, to be placed somewhere near the end. One will get a feel for transitions—how a quiet scene can be effectively followed by a noisy one,

how a line of dialogue about *time* at the end of one
scene may nicely lead into a fortuitous close-up
of a clock at the beginning of another. On a yellow
pad, then, possible juxtapositions can be worked out,
the list revised, and the segments juggled. As the
list becomes more concrete, one can go back to the
significant sections in the tape: is it necessary to see
this entire interview, or would it be better to see some
of it, and then to *hear* other parts of it as a voice-over
during another scene? Is another segment long
enough to have any impact? Is still another segment,
although fascinating, really relevant to the overall
purpose? In this way, a general scheme can be
planned, always, of course, subject to intense revision
once the actual editing process has begun.

Recording Sound Separately

One of the major decisions at this point concerns
the possibilities of sound as a separate element—
music, narration, and the like. The editing deck has the
capability of replacing the original sound that was
recorded; the process is the same as with normal
editing except that "Audio" is pushed rather than
"Record." A microphone can be plugged into the
editing deck so that new sound can be recorded
directly, but a much safer method is to prerecord the
desired new sound on an audio cassette and then
to work from that. In this way the timing can be exact,
and the quality of the new sound can be carefully
monitored. Sound from other segments of the
videotape can be used as well, of course, and the
editor will frequently use portions of a videotaped
interview, for example, as audio only, with a different
picture.

Credits

To begin the whole editing process, the equipment

must be cleaned and then hooked up as previously described. As always, a test should be run to make sure that there are no problems. Finally, a comfortable amount of "black" should be recorded as leader; this is done by pressing "Record" on the editing machine while nothing is feeding into it or by simply putting the function switch on "Camera," rather than "Line."

The first image in many cases will be a title and opening credits. If the editor knows that he will be making rough cuts, he can save this chore until after he has made his way through the material at least once. For those who expect to make the final cut on the first go-round, however, titles must be shot and edited in before anything else. If they are forgotten, one of the foundations of the whole step-by-step editing structure will be irretrievably missing.

Actually, the production of titles can be another creative aspect of the video experience. Titles can be printed, drawn, or acted out. Very professional-looking titles can be made with *transfer letters,* available under many trade names, which are letters in various typefaces that can be rubbed off onto a card.

A *crawl* is another typical TV titling device in which credits are put on a long sheet of paper and wrapped around a drum. Slowly the drum turns and the credits

move down, or across, the TV screen. At the networks, these are motor driven, but they can also be put together with more homespun materials. All credits, needless to say, should be shot with a camera on a tripod, as the slightest movement will be noticeable. Superimposing titles or "keying" (where the title letters, or any other shape, seem to be punched out of the existing picture) are possible only with a fairly sophisticated Special Effects Generator (see Chapter VII).

Titles, like anything else, must have sound, so the tapemaker is confronted at once with the possibilities of incidental background sound. He must decide what happens to the sound at the end of the credits. Does it go out abruptly or does it fade out gradually during the following scene? If it fades out, then the scene must be edited in before any sound is added to the titles, and the editor will have to be certain about where to fade out, so that the sound does not run on too long, obliterating the first words of the first scene.

Editing Effects

It should be noted that in editing from one scene to another, the tapemaker does not have the many effects that are available to the film editor or the video engineer using a Special Effects Generator. Simple half-inch editing can fade in and fade out, using Manual Gain Control, but dissolves, wipes, and other fancy tricks are not possible with today's machines. Other kinds of tricks *are* available, but they are not as useful in the long run as they might seem. A particular favorite is the still frame, which can freeze the tape at any point, and of course the still picture can be re-corded from the original to the edited version. A still, however, does not have the visual quality of moving videotape because it represents only one field, exactly half (every other line) of the TV frame, and the difference is noticeable. The still-frame control may

be helpful for such direct uses as locating a reference point in discussions, and it may be a mechanical aid in editing, but it is not a very worthwhile "effect." The same is true, to an even greater degree, of slow motion; here the frames are clearly visible moving through the picture and the effect has no relation to the smooth slow motion familiar to us from film or TV sports.

Jump Cuts

There are various aesthetic principles of good editing that apply to both film and tape and, therefore, have been thoroughly covered in many other books. Since most videotape editing is a matter of piecing together interviews and other documentary material, however, the video editor is confronted with the problem of *jump cuts* more often than his movie colleague. A jump cut results when the continuity of an action or speech is condensed by removing a piece from the middle: shot 1—a woman opens a car door as if to climb in; shot 2—inside the car, she is starting the motor. We have skipped the business of actually getting into the car, settling into the seat, and so on; we assume that this happened, without thinking about it.

Such cuts are necessary and automatic when editing action, as long as the two shots are visually quite different and not, for example, two separated pieces of what was once a single shot: shot 1—a long shot of a man walking down a street; shot 2—the same shot from the same angle, except that the man is now halfway up the steps of a brownstone. How did he get there? What happened in between? If shot 2, in this example, were a medium or close shot of the man on the steps, from a different angle, we would make the connection without a problem and the jump wouldn't bother us. Even greater condensations can be made by cutting to something else in between a jump: shot 1—a long shot of a man walking down a

street, a small boy in the foreground looking in his direction; shot 2—close-up of the boy, watching; shot 3—the man climbing the steps. The *cutaway* shot of the small boy has made a large jump seem natural.

In documentary situations, the cameraman seldom has a chance to cover his shot from various angles and focal lengths, so that raw jump cuts, with nothing to ease the transition, are more common on videotape. They are one of the factors that contribute to the jazzed-up immediacy of tape—an undisguised jump seems to be leaping toward the significance of a scene, the way the mind does. It is not unlike the effect, mentioned earlier, of the camera zooming in on a crowd scene out of focus, then focusing on one person, then panning, in a blur, to a more important person, and so on. We not only accept the crudeness of such techniques, but they unwittingly help to convey the quality of the event. TV broadcast news, which is shot on film, presents a similar roughness in many cases—the film is shot and edited in a rush, and no one worries about an occasional lack of studio-like fluidity.

The interview or meeting—anything comprised mainly of people speaking—can often be helped in the editing room so that necessary jump cuts are not distracting. If the beginning and the end of a person's answer to a question are clear and forceful, but the middle is full of stumbling and repetition, it can be jarring to the viewer if the offending section is simply chopped out. A hand that was quiet is now suddenly scratching an eyebrow, a cigarette in the mouth has suddenly vanished, a smile has been cut off abruptly, all in an instant. The problem can be eased by a cutaway—a shot of something else—inserted between the two segments. The cutaway shot can be the questioner, listening and nodding, as the *voice* of the speaker continues; in street interviews, it can be a shot of the environment, or people watching. In any case, when we cut back to the speaker, the fact that

something has been excised may not be noticeable at all.

News teams have a practice of specifically filming potential cutaway shots when they have the opportunity, so that the editor will have flexibility in putting the film or tape together. During an interview, for example, most of the footage will naturally be of the person questioned, with the camera looking toward him over the reporter's shoulder. The cameraman will also try, however, to get a shot of the reverse angle—the reporter listening, as seen over the shoulder of the subject of the interview. In addition, after the interview, the crew will frequently film the interviewer in close-up, asking the questions that he has just asked, one after another, although of course no one is there to answer him. This permits the editor to put these into the final version when necessary, as if they were part of the original interview, so that he can cut away from the subject in the middle of an answer and move right on to the next question.

From one point of view, half-inch video equipment, miraculous as it is, requires ingenuity, perseverance, luck, and hard work, on the part of the user who wants to edit. From another point of view, however, editing is where video is at its most creative. Many portapak owners who do not have editing decks have found it useful to make arrangements with individuals or institutions where they can borrow or lease the equipment for occasional jobs. Ultimately, anyone who becomes slightly involved with videotape will want to be in a position to bring shape and focus, at least some of the time, to the stream of reality he is capturing with his camera.

The Irish Tapes **began as a somewhat undefined
project in the summer of 1971 with some taping of
official IRA members in Dublin; the taping continued
for more than a year in America and in the North
of Ireland. Many people devoted their time, energy,
and skills to the project, which resulted in three edited
tapes by the fall of 1972. Although all of these
initial tapes were of value, we were convinced that
there must be a more dramatic and revealing way of
presenting the complex human and political conflicts
in Ireland. We felt also that the medium of video
had not been used to its full potential. Shooting with
portable, half-inch video aided us in attaining a certain
verité quality which might not have otherwise been
achieved—particularly in some of the action
sequences in Northern Ireland—but there was some-
thing about our linear and rational approach to the
editing which we felt was restrictive.**

**Global Village, which is codirected by John Reilly,
is one group which has pioneered the concept of
multichannel video (running more than one tape**

simultaneously on a bank of monitors). We began to apply this concept to the work in progress. Multi-channel video has been with us for a while now, but what made this project unique was that we were using multichannel video as a narrative technique in a full-length documentary. We had already begun a rough, single-channel edit which began to achieve a texture and movement we felt was lacking in previous edits. A basic narrative line was there. But when we introduced a second channel, certain segments seemed to take on a surreal quality. A videospace in which a parade could be seen from a myriad of angles, constantly changing positions on a bank of eight to ten monitors, rendered a larger-than-life vision of reality—a sort of total environment—which seemed to capture the essence of the event. On the other hand, certain juxtapositions of material—such as a woman shot in the face over another segment of parade—achieved enormous dimensions of meaning and emotion which were impossible on single-channel. The flow of things and events on multichannel videotape imbued the work as a whole with a movement and counterpoint which seemed to characterize, and deepen our understanding of, the real-life situation we wanted to portray.

<div align="right">
Stefan Moore

John Reilly
</div>

In Buffalo Grove, Illinois, a suburb of Chicago, when a particular real estate broker gets word that a house has come on the market, he loads his portapak into a station wagon and drives off to have a look. With the camera he makes an "establishing shot" of the street and the exterior of the house. Inside, he tapes a general picture of each room. He shoots close-ups of special features—the dishwasher, the built-in bar, the antique moldings. Back at his office, he does a fast edit, eliminating rough spots or

time-consuming lead-ins and recording a new sound track. This track is his commentary and a description of other aspects of the house not shown on the tape. The tape is then filed.

Later, a couple will come to his office looking for a house, expecting to spend several days driving around Buffalo Grove. Instead, they will be offered comfortable chairs, and the broker will give them a videotape rundown of what he has listed. On the basis of seeing a dozen homes on tape, the couple may decide to take a closer look at only three. After these have been examined, and perhaps others from other brokers, they may come back to the tapes again in order to check their memories on certain points and to make final comparisons. Finally, they buy a house and that particular tape is erased.

According to a newspaper report, this broker has found that every family whose house is taped finds some excuse to drop by his office and see their own home on TV.

X. Video at Work

Once videotape has been introduced for some specific purpose at a school, a hospital, a corporation, or a community center, imaginative people are often stimulated to start exploring the medium's potential. In a high school, what was originally and exclusively a tool for the coach to train his players in foul shooting becomes also the recorder of a student play in the English department, of a street documentary for social studies, or of a community bulletin board to spread information among faculty and students. In business, video may seem immediately useful in training or public relations, but in many cases it moves from department to department, and often its use increases in importance as its value is more and more appreciated.

Education

Video most often makes its first appearance in any institution as an instrument for training, or within

some kind of educational framework. The possibilities of television in the education field have been dazzling to specialists for many years, and what is commonly called Instructional Television (ITV), or Educational Television (ETV), has been attempted in various forms in the classroom, the workshop, the sales room, the doctor's office, and hundreds of other settings, as well as on closed-circuit, cable, or network television. The *audiovisual* approach is assumed to be extremely effective for teaching, although there have been intense disagreements about how to use it. Many books and articles have been written on the subject and a great deal of money has been spent. (One expert has estimated that the Ford Foundation alone has contributed between $200 million and $1 *billion* over the years to various educational TV experiments and programs.)

Prior to do-it-yourself television, classroom TV was inevitably as removed from the students as commercial TV, except that it was not usually as interesting. Program developers wavered among unappetizing possibilities: panel discussions, demonstrations, or outright lectures performed often by "TV teachers" who were cast for their ebullience or sincerity. Were these methods more effective than a regular teacher doing his regular thing, live and in person? Clearly, the variables were so plentiful that no one could be certain, and so the issue has been hotly debated right up to the present time. In 1972, Congressman Orval Hansen (R-Idaho) chaired a House Republican Task Force on Education and Training which attempted to bring education and technology together. One of the commitee's findings: "A large part of the problem regarding the use of video recording equipment can be laid at education's doorstep. Educators have thus far successfully resisted providing manufacturers with precise descriptions of the qualities they need in products to facilitate the educational process, *much less with an accurate definition of the instructional objectives they*

hope to reach through the use of the equipment."
(Emphasis added.)

Educators, in the committee's mind, are mixed up
about videotape. What will serve them best—
cassettes? portapaks? elaborate studios? There has
been no consensus. Part of the confusion arises from
an old assumption that TV is really a simpler, shorter
version of something else, that TV can do what a
film can do (or even what a book can do or what a
teacher can do). In fact, TV is best only when it is
doing *what TV can do.* Is it, most effectively,
something to sit back and look at, or is it something
to become actively involved in? It can be both, as it
turns out, but in one case it can do only a serviceable
teaching job, and in another it can revitalize
education and training in startling ways.

Certainly TV, just as a simple distribution service,
can be of value in providing lessons to students
who cannot, for whatever reason, get them any
other way. It is not the specific qualities of television
that offer the value here, however, but rather the
lack of something else—the real teacher. If the teacher
were present, the TV set could be turned off. On a
less fundamental level, television can be helpful in
bringing any element to the classroom that could not,
because of logistics, normally be there, such as an
interview with an expert who could not attend
personally. In this way, TV is offering material that is
an adjunct to the normal curriculum, not a substitute
for it. One cassette firm, for example, is distributing
interviews with noteworthy contemporary intel-
lectuals (recorded initially on two-inch broadcast
facilities and transferred to three-quarter-inch
cassettes), and a school might find it valuable to
purchase or rent tapes of this kind for occasional view-
ing by the students. But certainly if the experience
could be live instead of taped, the student would be
better off.

Still in the area of TV as something to *watch,* the
medium is gaining new popularity in the direct

teaching of *skills*, particularly when used in a system of individualized self-pacing instruction. A speed-reading course, for example, is available on cassettes; this type of skill is particularly adaptable to a visual medium, since the duration and speed of words on the screen can be precisely controlled. In this case, the student can take the lessons at his own pace, watching the tape on his home TV or in a library study carrel equipped for video. There are many school and college applications of this principle, including courses in the Chicago school system that use cassettes in individualized instruction for deaf children. Similar tapes are often made for industrial training, so that students of mechanics, for example, can be led step by step through a certain machine assembly. In all of these cases, it is the *convenience* of videotape and TV that is important; film cannot easily be screened for individual students at odd moments. Other than that, the special properties of the video medium have not been much exploited.

On the other hand, the educator who is capable of making his own television lessons will be able to tailor them to his own specific needs and, even more important, *to use the making process* as a vital ingredient of the lesson. Until now, the cameras and tape decks were studio bound, and they were also complex enough to intimidate the educator and to warrant a special audiovisual organization in the institution which, more often than not, stood between him and his ideas. The arrival of the portapak is helping to crack through these barriers. Now the most effective use of TV in education permits the student to watch tapes that are personal and that he himself may have made or taken part in.

Schools of education have long made use of this personal approach, in the form of mini-lessons or micro-lessons. (Indeed, many audiovisual departments exist primarily for this purpose.) The student prepares a sample lesson either for his colleagues or for actual students—mini or micro in terms of length and

scope—which is then taped. The student's performance is viewed and critiqued by teacher and/or class. The tape can be rewound to locate significant details, or referred to again at a later date. Clearly, videotape makes all the difference here: the student has a vivid, objective record of his performance and is able to evaluate himself in the light of the criticisms offered by his professor or his peers. Absolutely no other instructional tool can duplicate this effect.

This technique has also become important for training in business. A grocery products company, for example, uses videotape in a course for its new salespeople. An elaborate set has been built which represents the average grocery store: ninety-six feet of grocery shelves in front of a giant photo mural of a supermarket. The trainees enact the roles of seller and prospective buyer, and the interview is usually observed live by the class and then examined more carefully on tape after several interviews have been recorded. Specific sales techniques may be worked on at different times—"using visual aids" at one time, for example, or "responding to a customer's nonverbal signals" at another.

Using videotape in role-playing situations is also common in some courses in medical and social work schools, where the students must acquire skill in specific types of encounters with people. A necessary tool for medical diagnosis, for example, is the interview with the patient, from which the doctor must pick up essential information, follow up hidden clues and, again, read nonverbal communications. Those assigned to be "patients" in this kind of training bone up on the details of a certain disease pattern, and the "doctors" in the class have the problem of digging out what they need to know. The interviews are taped and often are purposely not played back for a day or two, so that the players themselves can gain an objective view of the scene. Prospective social

workers can benefit from the same kind of exercise in their own field.

Role playing with videotape, in any field, has certain drawbacks which can get in the way of successful training if they are not handled with care. Role playing even *without* videotape can produce anxiety among the participants, causing them to tense up or to perform in an untypical manner. Most people have a deep uneasiness about "performing." The fact that a role situation is also being videotaped can add enormously to the anxiety of a given situation, and in extreme cases it can inflict real damage to the trainee's self-confidence.

Several procedures can help overcome these problems. (1) As with the workshops described in Chapter VI, the instructor must devote plenty of time to simply experimenting with the medium, allowing the students to interview each other, clown around, or simply stare at themselves until they have accepted the reality of the way they look and sound. A series of warm-up exercises based on the clichés of commercial TV—quiz shows, news broadcasts, etc.— can often introduce a group to the video medium

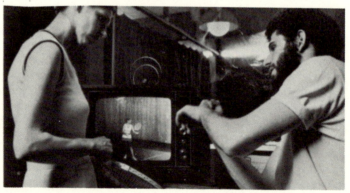

with a minimal amount of trouble and time and with a relaxing amount of fun. (2) The utmost sensitivity must be employed by anyone leading a critique of a tape as it is being played back. This is only

common sense, and should be true whatever the training tool, but it is worthwhile to emphasize again how powerful the video medium is and how vulnerable an individual is to thoughtless criticism of his appearance, voice, and mannerisms. The fact that the student's performance is in some sense removed and objective does not necessarily mean that he is less intimately involved with it. Instructors in any field should resist the temptation to pseudoanalytic interpretation of what they see, and for this reason it is helpful to have precise goals for each taping session and to restrict the critique to the consideration of just those goals. (3) *N.B. Most people feel easier with the assurance that a particular tape will be automatically erased when its limited objectives have been met.*

Apart from role playing, using videotape in training —wherever self-observation is helpful—extends to countless fields. We have already mentioned, for example, the coach who uses video to show his teams their lapses in form. The same is true for all sports on all levels. Many commercial tennis and golf clinics automatically provide video feedback to assist the trainee and to measure his progress, and one enterprising young tapemaker occasionally hires himself out to bowling alleys where a local pro will scan the tapes with the bowler, pointing out the subtle defects that keep his score down. Music teachers have discovered that recording both sound and picture can show the pupil, as a mirror could never do, where his physical approach to the instrument is affecting his ability to produce the desired sound. As part of a pilot project in the Mamaroneck, N.Y., school system, teachers were enlisted to observe each other with videotape and to meet on a regular basis, at which times the tapes were reviewed and critiqued by the whole group. Several fire departments have deliberately set fires in isolated, abandoned buildings, complete with victims (dummies within the flames or real people, with simulated injuries, lying

about the periphery) and have taped, from several different angles, the response of the fire-fighting and first-aid units. The results provide an indisputable record of the whole performance—an invaluable lesson to those who took part, and perhaps an object lesson to other groups of trainees who may come along later.

One basic videotape use in education, then, is feeding back the student's behavior so that he can see what he is doing wrong—or right. It is also becoming apparent that when a class, whether seventh graders or a college seminar, undertakes a video examination of some subject, with no training purpose in mind whatever, they are likely to discover that the intense focus of the TV camera will illuminate that subject to a surprising degree. For instance, the School of Architecture at Carleton University in Ottawa, the School of Design at Harvard, and other architecture schools have been making extensive training use of the equipment for taping student presentations, but they have also found that video is a valuable aid in examining how structures respond to stress. Students build models of various structures, made from cardboard, string, balsa, or other materials, and then cause the structures to collapse, so that they can see how and why the failure happens. In life, it happens too fast to give any real instruction to the class, so it is videotaped and can be replayed again and again, and in slow motion, until the phenomenon has been understood.

Some colleges have concentrated work with video in their urban affairs programs. Livingston College at Rutgers maintains an extensive Urban Communications Teaching and Research Center which is a vital ingredient of the college's concentration on community concerns: housing, social service, health, economics, and planning. As part of the various course requirements, students spend time working as "communications facilitators" in metropolitan com-

munities. The center reports, "A videotape made with a welfare mother about her housing problems led to a series of tapes of federally sponsored housing programs that ultimately force many people into substandard housing. The web of social service agencies that ran the woman's life led to further tapes, which resulted in a change in those agencies' insensitivity to the woman's problems." A similar project is under way at Antioch College, Baltimore-Washington campus, where a video group works with the Social Research and Action Center, developing video techniques to assess and document community needs and problems. A course at a Massachusetts college designed to investigate contemporary social questions required the students, in teams, to take out a portapak and interview proponents of both sides of a particular issue and to document the problem visually in any way possible. Following this, the students had to take roles on one side or the other, by lot, and debate the issues. These debates were also taped and later analyzed by the whole class, both in terms of how fairly each side represented its constituents and in terms of the merits of the basic positions.

A similar technique can work with much younger children. The Center for Understanding Media in New York has developed several experimental programs which attempt to integrate film and video into the basic primary grades curriculum. Many of these experiments are documented in the center's publication *Doing the Media* (see bibliography). A social studies course, for example, might approach such current events as space shots, elections, or Earth Day within the format of a *telethon*. Teams of students might be assigned to develop specific areas of the big story—interviews, facts and figures, paintings and photographs, models—and these could be presented throughout an entire afternoon. The presentation would be held together by "anchor men" or a rotating panel; guests would be called upon, exhibits displayed,

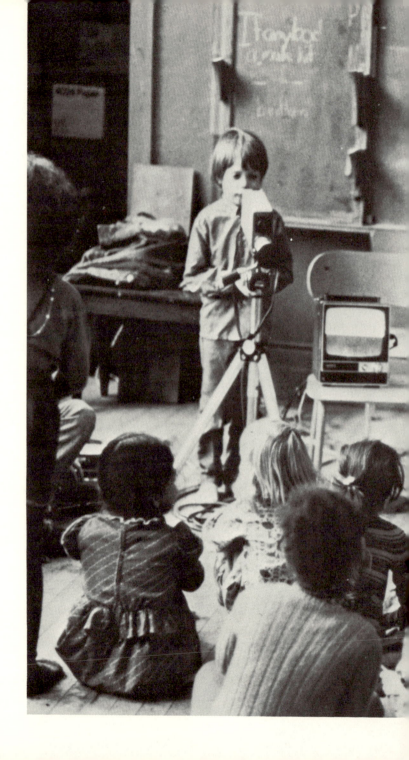

fresh news reported. The entire thing would be videotaped or relayed to other classrooms by closed circuit (where another class might tune in and out at will, as one does with telethons). The basic effect of the TV camera here is to give a sort of relaxed focus to the learning process.

A class studying other cultures might find it instructive not only to document their findings about Eskimos, for example, but also to role play, in an improvised manner, the daily life experiences of an Eskimo family. Taping such an experience not only provides a framework and an added excitement to the role playing, but it also offers a concrete starting point for later discussion.

In the development of reading and language, videotape can give a special interest to such things as book reports. In telling the story of a book on tape, the student might include pictures—either pictures from the book itself or illustrations he himself has drawn. Taking this even further, students might create an extensive storyboard drama of the book, laying it out like a long comic strip. This could be shot by the video camera as the children tell the story in their own words or read appropriate sections from the book itself. A talk show format could be used to conduct "interviews" with the main characters. Finally, students might act out several major scenes for the video camera; in this case, thorough planning, casting, costume gathering, and the like would be an important part of the experience.

The School of Education at the University of Massachusetts is working with fifth- and sixth-grade elementary school children in Amherst and Holyoke, helping them to assume all the functions of TV production so that they can prepare their own programs for broadcast over cable facilities on a regular basis. The project director sees many benefits arising out of this project: (a) to help the child communicate visually; (b) to make educational TV personal and immediate; (c) "to extend the school curriculum

into the 'real world,' and to bring the 'real world' into the school" by means of TV and video; and (d) to provide teachers with direct experience that will help them see the potential of all media as a vehicle for learning.

Several schools across the country have experimented with using the production of film and video as a means to teach the entire curriculum in the early primary grades. The planning and execution of a video project can be shaped to include specific training in reading, writing, arithmetic, social studies, and other basic subjects. This is not likely to happen automatically, of course, and the experience must be consciously structured by the teacher so that the creative energy of the children carries them instinctively into new learning.

A bonus effect is that children can also sharpen their critical perception of broadcast TV and can better understand what the media are all about. Any TV program can be taped directly off the air and then studied. With rudimentary editing techniques, segments can be rearranged in an effort to reslant the material or simply to compare various methods of presentation. Comparisons can be made in news stories, for example, between one network and another. Material taken from broadcast programs can be interspersed with material shot with a portapak in the classroom or in the street. In this sense, the giant networks become just more grist for the mill, entirely at the service of some energetic, imaginative fifth-grade class.

Just as many of today's children do not mind performing for the portapak but would not dream of performing on stage, so in fact many of them will learn from TV what they have difficulty learning any other way. I worked with one fourteen-year-old who had been suspended from school for disrupting class routines; for whatever reason, he could not cope with books and with the established learning situations in which he found himself. He was, how-

ever, a fiend with a portapak—one of the best cameramen I have ever worked with. His sense of organization, of where the gist of the situation was moving, of when to zoom, of when to hold a longer shot, and all the rest, was remarkable. He may be exceptional, but like so many of his peers, his first instinct for expression is visual. The hope is that video can be the fuel that will launch these children into wider areas of knowledge.

As video has found its use in the classroom for training or research, inevitably the portapak has also been seen as a primary means of communication for the school community—for example, communication from administration to student body and vice versa. A teachers college in a large Eastern city is housed in an ancient structure in the midst of the black ghetto. The inadequacy of the school's physical resources has been a constant aggravation to the students, and at one point their irritation focused on the decaying school library which was cramped, crumbling, and underequipped.

To present their complaint to the school authorities with the greatest impact, students videotaped the worst aspects of the library. Sections of the tape took the viewer on a guided tour of the cracked walls and flaking plaster; another section followed a student through the procedure of trying to locate and borrow a book, as he confronted out-of-date catalogs, antiquated procedures, and ultimately an empty space on the shelf. Then the portapak was taken to the libraries of other colleges in the area. Good aspects of these facilities were shown and discussed on tape. Students at these colleges were interviewed concerning how their library worked and what they thought was good and bad about it. Finally the whole thing was shown to school authorities, trustees, and anyone who would watch, and the tape became a valuable tool in planning a new facility.

The idea of TV and videotape as a conduit for all

kinds of information, a sort of bulletin board, is common in many academic environments, from the University of Maine to Henderson State College in Arkansas. These "bulletin boards" take different forms, but typically there are monitors in various heavy traffic areas across the campus, and at set times, such as between classes or at two or three fixed hours, the monitors carry a closed-circuit transmission. This may be simply a printout of local interest news and announcements, or it may include student-made interviews and tapes on any subject. The programs are usually short and repeated often enough so that the flow of pedestrian traffic need never come to a standstill. This type of bulletin board has played a unique role at Gallaudet College in Washington, D.C., a school for the deaf, where audible announcements cannot be used.

Health

In the fields of health and medicine, videotape has already proved to be particularly suited to special instructional and communications needs. A huge number of prepackaged cassettes dealing with a wide range of medical subjects are appearing on the market as the videocassette industry mushrooms: *Care of Children with Surgical Problems; Maternity Nursing; Crutch Walking; Process of Catheterization with a Foley Catheter; Be Healthy! Be Happy!* A large pharmaceutical company puts together a series of short tapes on new medical developments and procedures, and these tapes are distributed mainly to hospitals (the cost is reasonable because the company includes a short commercial for its products with each tape). Many medical "networks" are forming to facilitate the communication of information, some of it extremely technical and designed for highly specialized viewers, some of a more general nature that attempts to fill in the gaps for the average practitioner (*Office Psychiatry*). Much of the information is intended for students, but many of the net-

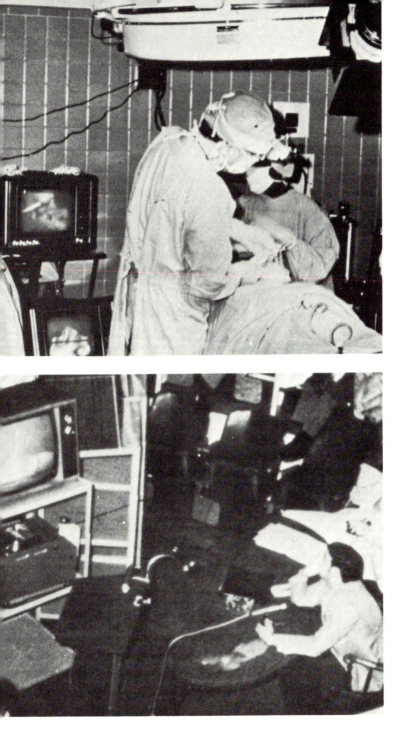

works hope to reach even the most experienced physicians with a service akin to that of a medical journal. The Indiana University School of Medicine, for example, has established a statewide medical telecommunications network. The network reaches doctors in the state through closed-circuit broadcasts and a videotape service.

Tapes of this sort are invariably produced professionally and are duplicated on cassettes for distribution to the network. (Indeed, many such tapes were made originally as films and have been transferred to tape.) The subject matter, in most cases, is too technical and complex to be handled by any but experienced and professional tapemakers. Color, for example, is indispensable for the identification of many medical problems and is often necessary even to tell one vein or organ from another. Also, medical topics can usually benefit from other electronic aids not available to the portapak operator: time lapse, magnification, split screen, and the like.

Closed-circuit TV combined with video has been found valuable for certain kinds of medical training, specifically in surgery. In a typical case, two color cameras are trained on the operation from different angles, and separate monitors transmit both pictures to the observers, who are in another room. An audio connection is maintained between the operating surgeon and the viewers, so that they can ask questions and he can make observations as the surgery is taking place. (It has been observed that the surgeon himself may occasionally check the close-up picture on the monitor during the operation.) Finally, and by no means least important, picture and sound are being videotaped as well as transmitted live, so that any member of the group, or other groups, can later review any portion of the procedure.

Physical therapy and rehabilitation is another field that can obviously make use of prepackaged tapes as training aids (The Paraplegic Patient; Putting on a Full Body Brace in a Wheelchair). This is also, how-

ever, an area where less sophisticated, less polished productions may have an even greater impact. Patient progress, for example, can best be documented for staff conferences (and for the patient himself and his family) by means of homemade and relatively crude video pictures of the individual. Staff training, too, may be more effective if the models and settings in the tape are familiar to all. At a camp for handicapped children, I made a tape demonstrating, among other things, how to move a paralyzed child from a wheelchair into the swimming pool. With this tape, the trainee is told something about a specific set of physical circumstances—*this* swimming pool—and the people in the tape are members of the staff he is likely to know. (It was also a good experience for the children, who showed off for the camera and later, in replay, had tangible evidence of their prowess.) When a patient is ready to leave a hospital rehabilitation environment and return home, his family may be in need of education about how to handle him and assist in his further development. A videotape— not professionally produced with an anonymous patient, but made by hospital personnel with *this* patient—can explicitly and graphically demonstrate the various methods and practices the family will need to know.

It is a common feeling that people do not have enough information on health problems and that the highly technical nature of medical science is frightening to most people and an unnecessary barrier to the exchange of useful—even essential—information. Various groups have undertaken video projects with the aim of humanizing such forbidding institutions as a typical hospital. What is emergency room procedure, for example? Children's first visits can be traumatic. This can be eased if children are shown a videotape of the experience—all the more so if the doctors are questioned not by Walter Cronkite but by a delegation from their own community, kids from their own block.

Survival Arts Media in New York, formerly the People's Video Theater, has been particularly interested in easing community fears in regard to health problems. In the publication *Radical Software,* they described one of their projects: "We went to a busy street with a doctor and nurse, set up our equipment with live feedback, and began asking people about venereal disease. People quickly got into using the doctor and nurse as an information resource for their practical questions about VD as well as for checking out some of their fears and fantasies of what it was all about. People with personal experience with various kinds of VD . . . began to fill out the linear, medical descriptions with graphic stories of what it felt like and how they handled it. In this way, people began to exchange information, deal with each other's attitudes, with everyone digging each other on the live feedback—and the street temporarily became a place devoted to people's creating information for themselves."

The notion of live feedback—the core of the videotape experience—has proved to be a revolutionary aid for one particular segment of the health field, that of psychotherapy. This technique has been pioneered by Milton M. Berger, M.D., of Columbia University, among others, and its use is rapidly growing. It is a logical extension of the various means that have been used over the years to get the patient to "confront" himself—to see himself as others see him. In video therapy, not only does the individual see and hear an objective image of himself, but he is able to do this instantaneously, while the original scene and his feelings about it are still fresh in his mind. In group therapy, for example, a person will usually remember his feelings in great detail as he watches a replay of the session, but he may also become aware that what he was communicating to the others was *not* what he was feeling. During further sessions, this person can keep checking his progress and deepening his self-understanding by means of sub-

sequent tapes. As one doctor put it, "The emotional insights from video ('I looked at myself and saw my mother. I nearly dropped dead!') combine with the intellectual insights from other aspects of therapy."

Similarly, in family treatment, each member can begin to understand through video what are called "family arrangements"—those automatic patterns that are so seldom recognized in the normal flow of life: the wife's recurrent martyrdom, the husband's incessant preaching, and so on. Video also reveals the tones of voice, the silences, the facial expressions, the body language, all of which are so much a part of the vocabulary of relationships.

When using videotape in this framework, one understands the degree to which television can isolate and magnify pieces of reality. I took part in a demonstration of the use of videotape in psycho-drama, in which a large number of people were divided into small groups and each group was asked to develop a short pantomime representing their feelings on a certain kind of childhood experience. These pantomimes were then performed for the entire class and videotaped in the process, one after the other, without comment. Once all the tapes were made, each was replayed and discussed. Many of us commented on the fact that, although we had seen each skit live, our concentration was much more focused on the video replay. This happened mainly because the playback eliminated many of the inherent tensions and distractions of the crowded room and gave us just the skit itself.

Videotape experiments have been made through the whole range of psychiatric practice and have been found useful with hospitalized psychotic patients, where even severely regressed individuals were stimulated to respond to the playback. Video has been used extensively in encounter groups and marathons, introduced at selected times in order to bring a focus to the group's discussions. (In most group therapy work, therapists have found that there is no

point in trying to hide or disguise the presence of the camera—in short order it becomes a member of the group, so to speak.) Its use is growing in more traditional modes of therapy, and Dr. Berger has observed that videotape can even make a significant contribution to the growth of the therapist himself: "The use of video renews our sense of humility and decreases our omniscience as we learn how much more has been going on in the therapeutic relationship than we heretofore realized. To learn more of the subtleties of what is involved in establishing, maintaining, and regulating relationships is an aid to the ongoing growth of the therapist as well as to his patients."

Business

The continuing refinement of the videotape cassette has recently intensified the commitment of business to videotape as a means of training and communication. The companies most interested are the very large organizations that must maintain close contact with a far-flung network of dealers, branch offices, or representatives, and this is why cassettes make such a difference—efficient *distribution* is invariably the most important factor. Many companies, however, have discovered the versatility of videotape and have not been afraid of imaginative improvisation.

The Chase Manhattan Bank is an example of an organization that maintains constant international communications, tying together its offices in New York, London, Paris, Frankfurt, and elsewhere. The bank is working on a program to accomplish this through the exchange of videotape. "The project offers real time- and energy-saving ways of getting around mountains of paper that never get read," one bank official observes. "It will show New York activities to the European offices, and European activities to headquarters over here, offering direct information

of a nuts-and-bolts nature. Its present use is for upper decision-making management, but once the network is established, it can also be used for teller training, for messages from the chairman, or as an outlet for continuing education for the employees." The bank has its own television studio and also employs outside production facilities for making certain tapes. All tapes are finally dubbed onto cassettes so that they can be transported easily and played without difficulty on the receiving end. Still, the bank is not overly concerned with glittering production techniques and disagrees with the point of view that "in-house" tapes have to be as smooth as anything on the air. "If someone knows his field and is articulate," the spokesman says, "and you can *see* him, and if any graphics used are legible, then for our internal purposes this is sufficient. As it is, a lot of the material that we are sending back and forth is very technical, of interest only internally, and all that is required of the person appearing before the camera is that he know what he is talking about."

Other large companies have made extensive use of videocassettes in order to communicate with the hinterlands. Several advantages have become evident from this process. (1) New products, technological developments, or maintenance tips can be introduced to employees in the field, without the expense of bringing everyone together for a general meeting. (2) New advertising and promotion campaigns can be previewed by the regional sales staffs. (3) Cassettes can be used as a direct sales tool. The Ford Motor Company, for example, provides cassettes to its many dealers, some purely for dealer information and education but others specifically for the customer— a slickly made commercial demonstrating the good features of each car model, available in every show room.

Coca-Cola is investing $2 million in a project to use videocassettes to reach its bottlers and salesmen. One of the pilot programs teaches dealers how to

use margin, markup, and turnover to sell Coke's profitability to retailers, and another shows bottlers how to remove impurities from water. Illinois Bell Telephone Company in Chicago broadcasts periodically over closed-circuit TV to twenty viewing centers where regional managers are gathered. Some of the presentation is on tape and other parts are live, so that the viewers can telephone questions and comments to the main studio.

The desirability of this kind of direct, personal feedback—a two-way communication—is as apparent in business as in any other field, although this aspect of television is not always recognized by the corporate planners. Most often, the videocassette is intended for use with an impersonal instructional package—a workbook, for example, that comes into play at specified moments during the televised lesson, in the hope that interplay between viewer and machine will approximate a kind of feedback.

It must be conceded that videotape of the one-way variety can be a unique sales device for demonstrating something to the potential buyer that might be impossible or less effective in any other form. Travel agents are being supplied with videocassette blurbs for hotels, resorts, luxury liners, and so on. The undecided traveler can thus survey his options and dream of his vacation while relaxing in the agent's office. Likewise, there are several commercial and noncommercial personnel placement offices that have begun operating on the same principle: taping interviews with job applicants that are then shipped to whatever job markets the agency may be in touch with. The University of Maine has had success in placing graduates in this manner, and many commercial employment agencies have taken it up. An organization in New York City called Cassette Casting Inc. describes its service to actors in an advertisement: "We'll make a 1½-minute color tape of you in our studios. It can consist of new material or any recent commercials you've done—whatever you think shows

you at your best. This tape will be at the right people's fingertips at all times. From now on you won't be a faded photo in an outdated casting book!!! You'll be alive and there doing your stuff."

Other businesses have been experimenting with tape as a vehicle for testing and market research. It has long been a practice for manufacturers of a consumer product to gather small groups of people together and invite them to test the product and discuss their attitudes toward it while a management team looks on and makes notes. In recent years, it has become convenient to videotape this type of session, thereby preserving exactly the reactions of the test group and giving the executives the opportunity to watch the session at their convenience, and over and over again if they should wish.

Many companies use the video bulletin board concept just as colleges and other large organizations do, and in fact some have found that an in-house TV show is replacing the traditional newsletter as a vehicle for corporate communications. At AT&T, for example, monitors are placed strategically throughout headquarters buildings, and regularly scheduled news broadcasts inform employees about what is happening within the company, on both the personal and the policy level, and also explore national issues, such as drugs or the economy, particularly as they affect AT&T.

Surveillance

There are "big brother" overtones to all this, of course, particularly in one of video's largest areas of use—security and surveillance. This aspect of CCTV has grown more rapidly than any other, and more businesses have purchased TV equipment for this purpose than for any other. In most cases, one or more cameras are installed high on walls or in ceilings to keep watch on sensitive or troublesome places: corridors, entrance gates, or warehouses. Often these

cameras are equipped with a silicon diode, or tivicon, tube which can transmit images in very low light or, with the help of an infrared lamp, in pitch darkness. If there are several cameras in several different locations, the system will often use a sequential switcher, which turns on one camera after another for a predetermined time span. Other gadgets can be added: a motion detector, for example, which appears as a bright line that can be moved anywhere on the screen. If any activity occurs in the area of the line, an alarm can go off, the VTR can start recording, or almost any chosen effect can happen. If desired, the time of day and the date can be recorded continuously on the tape so that the captured image can be precisely identified. Where long stretches of time must be monitored, time-lapse recording is available so that recording is done only at selected intervals—part of every minute, for instance, or every third or fifth minute. Most time-lapse decks can record, at most, sixty-six consecutive hours on one hour of tape, or one minute out of every sixty-one. (Apart from their security value, time-lapse VTRs give an uncanny effect of collapsed time when played back.)

Equipment that is intended for surveillance is seldom of much value for anything else, and so this use of video cannot easily be blended with others. The surveillance camera usually has no viewfinder or zoom lens because no one ever operates it, and security system monitors must be simple and accessible, while CCTV monitors are sensitive and usually buried away in control rooms. On the other hand, such devices as the time-lapse VTR, designed for a watchdog role, can have more creative uses, and in general the surge in demand for video security systems, with its attendant surge of money, may be an impetus to designers and manufacturers to come up with other new developments in tubes, lenses, and the like that will be of benefit to all VTR users.

The Arts

Our concentration so far has been on videotape as a medium of communication, a conduit for the speedy and personal transmission of information from individual to individual. On the other hand, many artists—painters, poets, filmmakers, sculptors—have been attracted to video as a medium of expression, quite apart from the social context. Their experiments have achieved new and essentially *video* images.

The phenomenon of visual feedback is at the heart of most of these experiments. On a basic level, this can be demonstrated with a portapak hooked to a TV set by means of the RF connection. A live, closed-circuit system is thus created—what the camera sees is shown on the TV set. When the camera is pointed at the TV set itself, it is taking a picture of its own picture, so to speak, and the visual feedback effect occurs. This effect is described by William Gwin of the National Center for Experiments in Television:

> Changing the relationship between the camera and the monitor will alter the feedback. A camera standing upright will give a spiral pattern; when the camera is tilted slightly, a circle occurs; a camera placed at a 90° angle produces a rectangular shape. . . . After the camera/monitor relationship is set, the optical variables to manipulate are the f-stop, zoom and focus of the camera's lens.
>
> Combining elements—any kind of material—with feedbacks means introducing other images into the light pattern of the feedback loop, thereby changing the original feedback pattern. Using two cameras, this can be done with any sort of object, a person, or with reflective surfaces such as pieces of mirror mylar. In the latter case, feedback becomes the fixed element, with the camera set and unattended, and the changes are produced by moving lights on the mylar pieces and by moving the camera which is picking up the mylar reflections.
>
> Use of feedback becomes more sophisticated as electronic variables are introduced into the loop—

Video images by Nam June Paik.

additional cameras, level control from a switching device, reversed polarity, color, "special effects" (particularly keying), and time delays.

Video artists have found many ways to capitalize on the properties of television for abstract effects. The first step is to come to terms with the nature of television as an electronic medium. Brice Howard, director of the National Center for Experiments in Television, the organization cited above, describes one of the fundamental perceptions—the frantic yet ordered "static" pattern on the monitor screen as it waits for an image: "The monitor screen has some remarkable characteristics. Among other things, it itself is information irrespective of anything you put on it—sign, symbol, rhythm, duration, or anything. It is delicious all by itself, if you want to enjoy it, though its matter is apparently of a totally random character. It is different, for example, from the reflective surface, which is a movie screen, off which light bounces with the image intact. But television is an electronic surface whose very motion is affecting the motion that you're putting into it."

And that is only the beginning. Techniques to

Otto Piene: *Electronic Light Ballet,* 1969

explore the video image, to make use of its specifically electronic properties, include the following:

1. *De-beaming,* or deliberately cutting down the current of the electron beam that scans the screen in the camera, so that parts of the image are retained longer than others, giving an effect of blurring and smearing. (A similar effect, usually accidental, can happen when using a portapak outdoors at night. A distant streetlight, for instance, may look like the streak of a comet as the camera moves and the bright portion of the image is retained.) The de-beaming process is highly technical, not available to novices.

2. *Keying,* the insertion of part of one image into another, done with a Special Effects Generator. As mentioned in Chapter IX, keying is commonly used to imprint titles on a previously existing picture.

3. *Video-loop delay,* or the process of playing back the video image several seconds after it has been shot. This requires two decks: deck 1 records what the camera feeds, but the tape proceeds to deck 2 rather than to a take-up reel on deck 1; the image is played back on deck 2 and thus is not instantaneous with the recording. The result is a kind of bizarre time machine.

In addition, although television hardware—cameras,

switchers, monitors, and the like—has been designed to do fairly straightforward work, it can be *re*designed in many ways by electronic experts to alter the electronic makeup. In this way, a virtually unlimited number of distortion possibilities are within reach of the artist. Nam June Paik and Eric Siegel are two artists who have invented video synthesizers that vastly extend the available electronic effects.

Abstract video can be achieved more simply, of course, in ways the video experimenter can easily discover for himself. The magnification of the zoom lens in full close-up will automatically distort objects and surfaces that are close at hand—a pool of water, a brick wall, a shaggy rug, the bark or leaves of a tree. This will be all the more true if other variables are added—if focus is blurred, for example, or if a pattern of light is reflected on the surface. It can be fascinating to tape the effect of light moving and shining *through* a basically abstract cutout, such as a pegboard, and to move the camera so that the holes are photographed from various extreme angles, giving the impression of circles of light fanning out in smaller and smaller dots or swirling across the screen. The imaginative experimenter can then set these patterns to music or to some unexpected sound, such as bells ringing, or a series of taped weather reports.

Working on a less abstract level, many artists are fascinated by the principle of "random feed"— shooting whatever is happening and then shooting the participants' reaction to *that*, and so on—a kind of rudimentary feedback. Often combined with this are experiments exploring the strange leap from reality to video and back again, epitomized by the following portion of a performance by the artist Joan Jonas, described in *The Drama Review:*

> . . . looking into the mirror, Joan points to her right eye, saying, "This is my right eye." And pointing to her left, says, "This is my left eye." Then, pointing with

one hand to her right eye on the monitor and with
her other hand to her actual right eye, she says, "This
is my right eye." She does the same with her left eye.
Finally, picking up a mirror and looking into it over
her shoulder, where the audience sees her image
reversed, she again points to her right and left eye,
repeating, "This is my right eye. This is my left eye."

Experimental videotapes are often shown on a bank
of monitors, looking not unlike the TV sales area
in a department store. There is an obvious aesthetic
effect gained from watching six or eight monitors
simultaneously, one entirely different from the normal
effect of TV watching on a single set. This is true when
the same image is on all monitors and is even more
forceful when several different images from different
sources are mixed among the monitors in the bank.
A performance may include the images from two
tape decks and one live camera, and the monitors
may at one time all be carrying the image from one
of these sources, at another time be evenly divided
among the three sources, still later be carrying source
A on eight monitors and source B on just one, at
another time be carrying source C on two monitors
with the others blank, and so on ad infinitum.
This performance technique was used with great
effect by Video Free America in *The Continuing Story
of Carol and Ferd,* which they describe as "a closed-
circuit, multiple-image, videotape novel about
pornography, sexual identities, the institution of
marriage, and the effect of living too close to an
electronic medium." The subject matter of this tape is,
first of all, the marriage of Carol and Ferd, a real
event. The couple discuss their plans and their
problems (with sex and drugs primarily). We see
the wedding and the wedding night. We see them
some months later, in a middle-class environment
away from the New York drug scene, trying to
straighten out their lives. We see them finally after
the marriage has broken up, as they look at tapes of

the earlier part of the story. The performance is full of startling juxtapositions, such as images of love-making on some of the monitors combined with close-ups of Ferd injecting heroin on others. It is the juxtapositions of *time,* however, that are most effective, as the technique condenses three or four different time periods, jumps back and forth, shows several events simultaneously, and even shows the people in the tape watching parts of the tape that the viewer has already seen and is at that moment seeing again on one or two of the monitors.

The aesthetic potential of videotape has only recently attracted attention, but there is suddenly an avalanche of experimentation. Woody Vasulka, one of the pioneers and the entrepreneur behind The Kitchen, a well-known viewing center in New York, had this explanation in a newspaper interview: "Video is cheap. The low cost of videotape puts the artist at ease and encourages him to experiment more extensively. Extensive experimentation will lead him to many random and important discoveries. What is special about video art at this time is that it isn't trapped in rigid rules. There aren't any clichés yet."

A bakery company in New Jersey was losing such merchandise as bags of caraway seeds valued at $150 each, sacks of flour, rolls, and bread. They seemed to disappear from the loading platform. Also, every morning the manager found pieces of dough rolled in little pellets all over floors, walls, and ceilings.

The system was designed to cover both areas. Cameras were used to survey each loading platform; a total of four cameras were used to watch the mixing area, and the preparing and baking areas. In these three areas a monitor was also mounted near the camera. All cameras were wired to feed a sequential switcher. A monitor and videotape recorder followed the switcher.

The system functioned in this manner: Management in the executive offices monitored all seven cameras during the day. The videotape recorder was used during the evening hours when management was not present. It could tape a full twelve hours of real time for later review by management at their convenience.

With this system, any irregularities on the loading

platform or in production could be observed. The monitors installed in the production areas alerted the men that they were on television. Apparently during the evening hours, the men were involved in such boyish pranks as throwing dough pellets at each other. After the system was in operation, almost 100 percent of the pilferage and malicious damage ceased, and the production areas remained clean.

> Leonard Cohen
> "A New Approach to Security"
> *Educational and Industrial Television*

Dan Graham's TV Camera/Monitor Performance

Spectators are seated in about ten rows of chairs. In front of them is a wide platform; behind them is a large television monitor.

Holding a television camera, the creator of the performance (Dan Graham) climbs on the "stage" and lies down, aiming the camera at the monitor. The image of what the camera sees—the monitor itself—appears on the screen. Graham begins to roll, keeping his body parallel to the ends of the platform. Even when he is on top of the camera, which is connected by a cord to the monitor, he keeps it pointed at the screen at the rear of the room. On the screen, the image revolves as the camera turns over and over. Slowly and continuously, Graham rolls from one side of the platform to the other and back again. The spectators may watch either the performer or the television picture; they turn from one to the other comparing them. In the television picture, one might see the faces of those who are watching—or the back of his own head.

> *The Drama Review*

Working with the Social Research and Action faculty, we are developing video techniques to assess and document needs and problems, to process and evaluate that information, and to feed it back into an institution or situation so that it catalyzes change and growth.

We ask everyone who is involved in or affected by the problem to talk about their roles and conflicts. With VTR we record their impressions, confusion, ideas, and plans. Some of what is recorded has been said before, and, frequently, things that have been thought often but never before said are captured on tape. Sometimes we use psychodrama and role-playing processes. Then we edit and play back the same information. Implicit assumptions become explicit, needs are clarified and sharpened, ambiguous conflicts in goals and values become obvious, demands are shaped and a forward-moving, problem-solving direction begins to emerge.

We've used and developed these techniques and processes in youth-police encounters, a VA hospital drug abuse program, a training school for young girls, a community college, and an academic audit for a graduate school of education. We've designed programs in community storefront video to examine issues in a local political campaign and to facilitate a crime prevention project.

We're organizing a conference for a critical examination of the use and abuse of methadone. With VTR we are collecting information nationwide on alternatives to methadone maintenance, the economics of the drug industry, the politics of health services delivery and [the needs of] the people most affected by the programs, the methadone addicts, ex-addicts, and drug abuse personnel.

Videoball
Antioch College
Baltimore Campus

217

TermaVision Has Taken Your Inspection Out of the Dark

It's no longer a mystery! Never again need there be any lingering doubt as to the conditions to be found by a termite inspection of your premises. "You are there" with the inspector. True conditions are shown through the TV camera "live" . . . and can also be videotaped to be "replayed" at a later time.

THE AGE OF TELEVISION PROVES THAT "A LIVING PICTURE IS WORTH 1000 WORDS."

1. The Hydrex . . . Hostess meets the homeowner and invites her to step out onto her own driveway, or the curb, where the TermaVision "Mobile Parlor" is parked.

2. Next the Hydrex . . . Hostess briefly explains how the inspection proceeds, with every detail visible through a closed-circuit television receiver inside the van.

3. Homeowner and Hostess now enter the Mobile Parlor for a comfortable "loge seat" and a coffee or soft drink.

The TV picture and sound go on . . . !

. . . and now the inspection begins. Lights! Action! Camera! Suddenly we are under the house, in the attic, or in other areas you have perhaps never seen before in or around your own home.

As he aims his camera and lights, in some remote location he reveals the innermost "health secrets" of your house. He speaks into his microphone, directly to you as you sit comfortably in the Hydrex Van.

Perhaps he says, "Mrs. Homeowner, I am now entering the sub-area of your home. You can now see the girders and pipes, and right over here please notice . . ."

And then . . . wonder of wonders . . . without raising your voice you can converse with him, asking him questions, requesting that he focus the camera on thus and so . . .

The "replay" feature of the videotape recording,

made simultaneously with the screening you witness in the Hydrex Mobile Parlor, permits rerunning the entire inspection later, for the benefit of family members who were not present. The tape could also be shown, if desired, to real estate brokers, insurance agents or to prospective buyers of the property.

TermaVision is going to revolutionize the termite inspection industry! It will have imitators, because the public will demand *evidence* instead of *hearsay* when it comes to a termite report.

Brochure
Hydrex Termite and Pest Control
North Hollywood, California

XI. Reaching an Audience

Anyone who makes a tape for any reason must give thought to how he will *show* it and to whom. This involves problems of performance or distribution, of setting up "alternate media," communication systems apart from the established, institutional ones.

Generally, the prospective audience is limited by definition: *this* parents' group, for example, or *that* group of tenants, or *this* tennis player are interested in information that applies, in the main, to them only. On the most intimate level, it will be an audience of one (the violin student watching his own technique), or it may be a family (watching a tape of the children on the home TV set), or a block (watching the "101st Street News" out in the street), or a slightly larger community (watching a debate on a local zoning issue). The established media cannot handle these jobs and are not interested in them; personal and vital communications of this kind must travel along different routes. The fact that such routes are more and more available has wide social

implications; perhaps this is where video will ultimately have its greatest impact.

Communication strictly within the confines of a small group—a class, a club, or a workshop—presents no problem; the tape is simply played back on the monitor. As the potential audience grows, however, the means of reaching it become more complex: (a) a tape can be mailed or physically taken to groups, clubs, street corners, or wherever small audiences may be found; (b) permanent viewing centers, not unlike theaters, can be set up where audiences can drop in on a regular basis; (c) a tape can be transmitted to its special audience over closed-circuit or cable television. Each of these methods has its own advantages and its own special technical problems.

Tape Exchange

Many video groups are attempting to put together informal networks across the country through which tapes can be shipped back and forth among member groups. For example, some of the groups in the list of Resource Organizations will send a tape to anyone who sends them one, on a direct exchange. In this way, tape libraries are built up and the small-scale tapemaker is establishing contact with the wide community that shares his interest. In this way, too, cooperatives have been organized which can provide tapes from various sources on specific subjects— drugs, inner-city problems, etc.—to interested audiences.

Video Performances

It is part of the nature of all television that it is best shown to small clusters of people (although in a broadcast situation there may be millions of clusters) rather than to large assembled crowds. Thus, the use of videotape at even a small meeting—more than twenty people—raises the technical question of how to

make sure that everyone can see and hear. A single television set cannot reach that many people without strain; the experience is qualitatively different from the intimate surroundings of the living room. *Video projectors* that throw the TV image on a screen, like a film, have been much talked about but so far can offer only a partial solution, for several reasons.

1. At this writing, there is not a fully satisfactory projector for half-inch tape on the market. The best machines are unwieldy and extremely expensive, and the image is only a remote and fuzzy reproduction of the original.

2. In any case, projected TV is not TV. It is really more like film, except that the quality is, in film terms, wretched. It loses entirely the vibrant effect of the TV picture, which is lit from within, and the intimate relationship between screen and viewer.

If a large projected image is necessary for some reason, the tapemaker might consider having his edited tape transferred to film, a process offered by many film labs at a reasonable cost (less than fifteen dollars per minute of tape, half inch to 16mm). The result will not *look* like film because all of the imperfections

of the TV picture will be magnified on the large screen. One can never be absolutely sure of the results because problems with electronic instability, focus, and the like may not become apparent until the tape is transferred, but it can be done.

Probably the most successful way to show TV to a relatively large assembled group is by means of a number of TV sets. With videotape, the image from a single tape deck can be fed into more than one monitor in a simple process called "looping." This is accomplished by connecting the tape deck to monitor number 1 by means of the normal 8-pin-to-8-pin cable. From this point, all connections from one monitor to the next are made from the *in* receptacles, both audio and video—*in* on one monitor to *in* on the next. (This is why monitors are equipped with two *in* receptacles—one for the cable coming in and one for the cable going out.)

The monitors can of course be arranged in any configuration and in any type of environment, depending only on the length of the cables connecting them. As we have mentioned, some tapemakers prefer the effect of stacking monitors on top of each other in a sort of wall or bank. This can have a powerful effect, particularly if several different images are being shown simultaneously. In general, however, stacking is not very helpful for a large audience because, although there may be a multiplication of the same

image, each is still no larger than a single TV set. Other groups have gone to some lengths to create comfortable and intimate settings that stress the specific qualities of TV watching: various monitors around a room facing in many directions, where

small groups can gather to watch and chat. (Large pillows on the floor are typically part of the decor, reflecting an apparent preference for watching television lying down.) At a more formal meeting, where an audience is seated facing the speakers' platform, monitors can be spaced around the room judiciously, so that everyone has a relatively near view.

The creation of a TV-watching environment is primarily useful in viewing centers, permanent places where the audience can be assembled without difficulty and where problems of electronics, design, and comfort can be completely under control. Often, of course, tape must be taken out of the viewing room and brought directly to its audience. The Community Video Center in Washington, D.C., has been making tapes that are of direct interest to the inner-city population (*Join the War on Rats, Kids and Drugs,* and so on), and the organization does its own distribution, like circuit riders with tape and monitor, traveling wherever they are asked. At present they are also developing a project to take tapes on a regular basis to clinics, waiting rooms, schools, libraries, and other public places. The physical setups may occasionally be crude, but the tape is getting to its audience.

Videocassettes

The logistics of getting tape around on a large scale have been facilitated for some users by the emergence of the videocassette, now the hottest commercial item in the video field. A cassette, as we have seen, is just a package that simplifies the process of getting copies out to a network of receivers—all Ford dealers, or all physicians interested in a certain problem, or all trainees in a certain subject, from *Introduction to a Boat* to *So You Want to Be a Home Appliance Service Technician*. A recent catalog lists approximately ten thousand videocassettes available for sale

or rent. Although Panasonic, among other manu-
facturers, produces a cassette on which half-inch tapes
can be wound, the objective of the major cassette
packagers is not unlike that of the established media:
to reach a large, although specialized, audience with
a slickly made product. The portapak user and the
community-oriented tapemaker, on the other hand,
have no particular stake in the development of such a
widespread system and have sought an alternate way
of sharing information within a given community.
This turns out to be CATV, or cable television.

Cable Television

The cable system, as mentioned in Chapter III,
is a means of transmitting the television signal through
wires rather than over the "airwaves." Although it
originated as a community antenna for small towns,
this mode of transmission has grown, especially since
its impact has been felt in the larger cities (or the "100
top markets"). At some point in the future, each TV set
in a cable system will presumably be capable of
receiving as many as a hundred channels with great
clarity, as opposed to the blurred seven, at most, that
now come in over VHF channels. Although there are at
present still only a few cable channels available
in any area, the National Cable Television Association
reports that approximately eighty thousand new
subscribers to cable are being added every month,
nearly one million each year. The Sloan Commission
on Cable Communications, established by the Alfred
P. Sloan Foundation, has estimated that by 1980 from
40 to 60 percent of American homes will be wired
for cable, and substantially more in metropolitan areas.
The estimate may be exaggerated, and in fact, at this
writing, the cable industry is going through hard times.
Nevertheless, the ultimate growth of cable TV seems
inevitable.

Any cable system is basically a network of actual

cables that connect the transmitting source to the many receivers. The signal originates from what is called the *"head end"* of the system. From the head end, a trunk line extends out to a specific community; from the trunk line, branches, or feeder lines, run to a particular group of homes or apartments; from the feeder lines, drop lines can be hooked directly to each TV set within a given residence. Many head ends can be connected to provide one large network, but, more important, *each head end can also serve as the signal source for its own relatively small community.*
Cable TV is able to provide a clear signal for all television broadcasting, but, as the Sloan Commission states, "Whatever other capability [cable television] may possess, it is able, as conventional television is not, to serve its own community and that community alone."

Because it represents "abundant" television instead of "scarce" television, there should be none of the pressure on cable now felt by the broadcast networks to use a few precious channels to produce programs for mass tastes and interests. Ultimately the local PTA, or even smaller organizations could transmit their meetings on one of the one hundred cable channels, and viewers who were not interested would have ninety-nine other possibilities to choose from. An election issue affecting only one small section of a city could be expounded and debated on TV in that section alone. Communication among members of a special group—senior citizens, Presbyterians, homosexuals, or hardware dealers—could be freely engaged in without fear of intruding on the time or patience of other groups. Stamp collectors, chamber music enthusiasts, and bocci players would all have ample channel space for their own pursuits.

In addition, because a cable system can interact with computers, it may sooner or later provide the viewer with direct personal feedback opportunities. As money and checks give way to credit cards, for example, the individual may be able to make transactions with

his bank, merchant, or stockbroker by punching code numbers on the TV receiver or by inserting his card in a convenient slot. With a similar device he may be able to communicate with his doctor, his public library, or anything else. The computer might "read" all the messages on millions of TV receivers at regular intervals—say, every few minutes—so that subscribers could vote, or express opinions on given issues, or even call for help, with the expectation of instant communication with the outside world.

Thus, if commercial VHF television has been programmed to ignore the individual, cable TV is capable of coming to his rescue. A background paper for the Aspen Workshop in Uses of Cable in August, 1972, said: "The cable gives us a second—and perhaps last—chance to determine whether television can be used to teach, to inspire, to change man's life for the better. The task will be demanding and expensive."

So much for the promise of cable TV. The present fact is a different story. As cable franchise agreements are being worked out in thousands of localities across the country, the great expense of establishing the system leaves the field in most cases to those well-heeled communications giants (TelePrompter, Warners Communications, Viacom International, and the like) who can undertake the initial investment. These organizations are for the most part already heavily involved in existing media and they probably view the development of cable as an ultimate financial bonanza, whatever the short-term sacrifices. The initial financial demands are so great, in fact, that many of the cable systems have been consolidated under single ownership, and before long almost all systems will probably be controlled by a few operators. Cable is big business.

One result is that cable programming at present looks like a pale imitation of network programming—sports, movies, cartoons, and "I Love Lucy." Cable subscribers must pay a monthly fee (five or six dollars) and the operator must find programs that will attract

a large enough number to make the system economically viable. His first appeal must be to the upper- and middle-class viewer, and in many cases the cable operator does not even bother to go into poor or ghetto neighborhoods or into rural areas where the population is either too sparse or too poor.

Community coalitions have been formed in many areas to exert pressure on local governments during the franchising process, in order to win more community participation in cable management and programming. Many groups, sponsored by schools, churches, foundations, and other organizations, are engaged in a nationwide program to inform citizens about cable and to alert them to the possibility that cable systems may be turned over to commercial interests before the people as a whole even know what is happening. The federal government too has been studying the situation and has begun to set some broad guidelines. However, mainly because of the present costs and possible future profits, the matter is still confused, and it is likely to remain so for some time.

Public Access

The main concession that community groups have won so far is called "public access." An FCC ruling of April, 1972, requires that within five years all cable companies in the top 100 markets must provide one public-access channel for use by the community, and that if this channel is utilized 80 percent of the time, the company must activate another, and so on. The use of such channels is open to absolutely anyone who wants to communicate by TV; the cable companies can make no stipulations about the use of the channel except to protect themselves from criminal prosecution. (In practice, this means that programs may not contain libelous or obscene material, incite to violence, or promote commercial ventures.) Thus the communities have gained some

kind of voice—a voice without benefit of interpreter, reporter, or editor.

How are people to use this access? Obviously individuals cannot just wander into the studio, turn on a camera, and broadcast their messages. In the first place, to operate studios and to broadcast public-access channels involves some expense. In New York City, the two cable operators are picking up the tab as a public relations gesture. Other communities have experimented with using some small portion of the subscribers' fees to subsidize public access.

The role of half-inch videotape is uniquely important here. From the FCC report: "It is apparent that our goal of creating a low-cost, nondiscriminatory means of access cannot be attained unless members of the public have reasonable production facilities available to them. We expect that many cable systems will have facilities with which to originate programming that will also be available to produce program material for public access. *Hopefully, colleges and universities, high schools, recreation departments, churches, unions, and other community groups will have low-cost videotaping equipment for public use. . . . We note specifically that the use of half-inch videotape is a growing and hopeful indication that low-cost recording equipment can and will be made available to the public."* (Emphasis added.)

Half-inch video has become the major tool of public access. Many video groups have become energetic proselytizers for cable casting, undertaking to train groups or individuals in tapemaking and to midwife any organization's tape from the idea stage to its final showing on cable. The Community Video Center in Washington has been mentioned, and there are such other groups as the Alternate Media Center, Open Channel, Global Village, and Survival Arts Media, in New York; Communications for Change, in Chicago; Portable Channel, in Rochester; The Media Group, in Boston; and many others across the country. Some groups have specifically limited constituencies,

such as the Women's Video Collective in New York and Video Chinatown in San Francisco.

In Santa Cruz, California, a group called Johnny Videotape and Friends proposed to organize the local public-access channel along lines that are fairly typical. The proposal included a sample log of a week's programming, from which the following is an excerpt:

THURSDAY EVENING
6:00 WELFARE RIGHTS HOT LINE. Welfare recipients phone in for advice on problems they have dealing with the welfare bureaucracy.
7:00 DO IT NOW. Shows how group encounter works to help ex-drug users.
7:30 GOVERNMENT FEEDBACK. Santa Cruz Mayor (live). Citizens phone in to ask questions.
8:00 SANTA CRUZ GALLERY. Local artists display work.
8:30 RECYCLING. County Recycling Center gives household tips.
9:00 19TH CENTURY SANTA CRUZ. Senior citizen Bob Hilliard shares his experiences on local life at the turn of the century.

A similar project was envisioned in a study, cited by the Sloan Commission, for a community-controlled cable installation in Brooklyn's Bedford-Stuyvesant section. Some of the programming suggested is as follows:

JOB-A-RAMA. Job opportunities; instruction in job interview techniques and preparation of application; other employment services.
CHILDREN'S PLAYHOUSE. A light, educational background for preschool children.
AREA CENTER PARADE. Explanation, documentation, and advertisement of community center activities; transmission of special programs instituted by the various community centers.

STREET SCENE. A roving-reporter presentation of "what's going on in the community," as a means of building community identity.

THE CONSUMER. Bargain hunting, shopping techniques, money-saving hints.

KINGS COUNTY HOSPITAL. To create wider attention to endemic health problems and to assist in methods for their eradication.

These program designs are for the information and entertainment of a limited audience. They aim to establish contact between the individual and the huge institutions that surround him and control his life. Many of the projects quoted throughout this book are even more concrete and specific along these lines.

Public access on cable is a fact and, considering the amount of controversy and debate it has inspired, it is likely to grow in importance. However, there are many technical problems. Tapes vary enormously in quality and interest, a fact which does not encourage casual viewing. The signal stored on half-inch tape is not very strong in the first place, and some tapes are virtually undecipherable when they are broadcast without the aid of sophisticated equipment designed to strengthen the signal. Finally, the controversy surrounding public access originates primarily from those who are producing the tapes, for, at this point, very few people are watching. Many cannot afford to be hooked into the system; many others will not pass up Monday night football for "Job-A-Rama" or the PTA meeting. These people might very well be reached more successfully by other methods. Tapemakers should bear in mind that cable casting, at this point in history, may do more for the producer's ego than for the interest of the audience. George Stoney, director of the Alternate Media Center, mentions a tape that, although finally shown on cable, had several *more useful* showings before that: The tape, made by John Kraus and Jenny Goldberg, described the poor conditions in a New

York tenement and included interviews with tenants, graphic pictures of deteriorating walls, pipes, and so on. The tape was shown first to the tenants themselves, where it had the effect of pulling them together as a group; those who were picketing outside the building in favor of a rent strike could make their case known graphically to those inside who had not yet joined the group. It was then shown to the immediate community, to elicit support and sympathy for the rent strike. At the next stage, it was shown in court, where the judge ruled in the tenants' favor. A short time later it was shown to their state representative in Albany. His response was likewise recorded and then this tape was brought back and shown to the entire tenants' committee on the block. And so on. Eventually the tape was shown on cable, but by then it had already done its job, fulfilling the concrete communication needs of a relatively small group.

It is likely that, for the moment, more exploration of the direct uses of video—viewing centers, closed-circuit setups, perhaps a touring "videobus"—will help to define what this medium is really needed for, so that when cable systems grow in scope, public access will be a more coherent force in the community.

Legal Aspects

At the same time that communication among people becomes more and more open, the individual's right to privacy becomes inevitably more threatened; the technology used in communicating is much the same as that used in surveillance and spying. Occasionally people may find themselves plugged into a network against their will, and video enthusiasts must bear in mind that everyone has a right *not* to communicate if they so choose.

The laws are not entirely clear in this regard. Can a person in a public place be photographed without his permission? Does the consent to be inter-

viewed on videotape imply consent for all uses of the tape? Despite the inconvenience, it is probably best for the tapemaker to be overcareful in interpreting these questions. Those who use video for professional purposes—training, research, public relations—have a particular responsibility to respect the participants' privacy. This involves *obtaining the consent* of those involved in the tape, and specifically obtaining a written release or waiver of rights. Normally, the release would restrict the use of the tape, even if fairly broadly, such as "for educational purposes." (See sample form in appendix A.)

Videotapes can be copyrighted, but it is usually not worth the effort and expense for half-inch portapak tapes. If a tape will be loaned or rented to other groups or agencies, the tapemaker may wish to have a signed "User's Contract" (see appendix B) which will help to protect him and any individuals who took part in the tape.

Video experiments so far have generally been rooted in a respect and compassion for people—this is why they have happened. It is not only paranoia, however, that makes many people suspicious of every lens pointed in their direction and every cable introduced into their living room, and legal documents can only go a certain distance toward solving the problem. If the tapemaker is always consciously working on behalf of people, and with their cooperation, he will not only put people at ease but he will be exploiting the medium to the fullest, using it in the service of the community.

Downsville Community TV

There's a funny, funky video thing happening in
Downsville, New York, in the Catskills. At a pre-
scheduled time, on a given evening each week, a
green VW van pulls up to a telephone pole on a
country road and unhooks two cables which are
hanging there waiting to be plugged into a Sony 3600
or a portapak. With the flip of a few switches, the local
community cable cast begins. In their homes, all
the local folks are sitting eagerly by their TV sets,
waiting to see themselves, their friends and neighbors
on Channel 3. Usually there are some live announce-
ments, an invitation to come on down and be on
TV, and a description of the tapes to be played. . . .

As far as programming is concerned, possibilities
keep growing. We have shown only local tapes so far,
mainly because people are most excited about seeing
their own little town on TV—the local grocer making
sausage, a former school teacher caning chairs, the
cop talking about the nonexistence of crime in a
small town, a terra firma man talking about his Wallace
politics and how his life has changed since he came
to live in the country, some city kids turning people

on to video at a fire house bazaar, interviews with townspeople about a local controversy on whether to close an old covered bridge to cars, American Indians dancing at a nearby crafts fair as well as people demonstrating their crafts, an auction, a square dance, the Memorial Day parade (much requested, since everyone in town was there), and numerous events from the school. The school, by the way, is purchasing a portapak and a 3600 in September, so hopefully a lot of programming will be originating from the kids themselves.

Dean and Dudley Evenson
excerpted from
Radical Software, vol. II, no. 1, a publication of the Raindance Foundation, 51 Fifth Ave., New York, N.Y. 10003

I am watching my ten-month-old son who is sitting on the floor playing with a string of heavy beads. He studies them for a long time, fascinated. He twists the beads around on the string, puts one end in his mouth, then takes it out again and examines the different colors. He bangs the beads on the floor, over and over. He looks up to see if I enjoy the noise; we smile. He crawls away a few yards on the hard-wood floor, the beads in one hand, clopping on the floor: clum *clop,* clum *clop,* clum *clop,* clum *clop.* He stops next to a plastic toy mailbox, sits, chews the beads for a moment and then whacks them into the mailbox. A plastic drawer falls open. He tries bouncing the beads in the drawer, solemnly testing the sound of it. This goes on for a few minutes. Then he raises the beads over his head with both hands; it looks like a stretch, as he is holding up the beads. Then one hand lets go and the other flings the beads away. They roll across the wood floor. He pays no attention and goes on to something else.

I do not have that scene on tape. Instead I have
a few of the predictable birthdays, Christmases, and
family gatherings where the children sit frozen,
surrounded by adults who are willing to endure it
for the sake of posterity. I also have fourteen photo
albums featuring mainly instamatic glimpses of the
same big moments.

I think it's possible that posterity would be more

interested in a tape of my son playing with the beads for an unedited ten minutes, if one existed. That ten minutes was very full—not just full of activity, but full of the whole person who was playing on the floor. The snapshots and the birthday movies can help us to recall the way things were at special times, but this tape would have actually and mysteriously captured a piece of ordinary existence. Since there would be no jokes in it, no poses, and no structure, we would have to search it carefully for what it might reveal.

But I didn't make the tape of this ten minutes because I didn't think about it, and soon afterward my son was into trouble in the kitchen and I was chasing him. And it doesn't matter; that ten minutes was of course no more full than any other ten minutes (except that we become more guarded as we grow older). Someday, when it occurs to me, I will make a small tape of my son, or a few of them. It's always possible.

I have tried to show in this book how tape can have a role in solving big problems and in helping to bridge the big gulfs between people and groups. It can do these big things because it can also do little things—such as tell me something about my son and about myself. As the use of videotape continues to grow, what makes it grow will be its capacity to help people to shift their focus from the impersonal, the out of scale, the machinelike, the overcrowded, the mysterious, the hostile, and the frightening to something a good deal easier to take: themselves.

APPENDIX A

SAMPLE RELEASE

I UNDERSTAND THAT ANY VIDEOTAPE TAKEN OF ME ON THIS DATE _____
IS TAKEN ONLY FOR THE PURPOSE OF _____.

I HEREBY ASSIGN TO (PRODUCER) ALL RIGHTS IN AND TO SUCH VIDEOTAPE, AND I HEREBY AUTHORIZE SAID (PRODUCER) WITHOUT LIMITATION, TO REPRODUCE, COPY, SELL, EXHIBIT, PUBLISH, OR DISTRIBUTE ANY SUCH VIDEOTAPE IN THE FURTHERANCE OF THE ABOVE PURPOSE.

SIGNED: _____

WITNESS: _____

APPENDIX B

SAMPLE USER CONTRACT

I, THE UNDERSIGNED, AGREE TO RESTRICT THE USE OF THIS VIDEOTAPE TO (STATED PURPOSE) AND NOT TO PERMIT SHOWING OF THIS TAPE ON ANY PUBLIC COMMUNICATION CHANNEL, AND NOT TO DUPLICATE IT. THIS AGREEMENT WILL REMAIN IN EFFECT FOR ALL FUTURE USE OF THE VIDEOTAPE ORDERED BY OR SHIPPED TO ME.

SIGNATURE DATE

Resource Organizations

The following are organizations that function as video resources of one kind or another. Many are funded specifically to assist community groups and individuals to make tapes, to expand the public use of cable television, and to explore and extend the uses of video through research and experimentation.

The list is by no means comprehensive: video groups tend to spring up overnight and to disappear just as suddenly. Also, much of today's video activity emanates from the colleges and universities—so much so that, with a few exceptions, I have not attempted to include these resources. Anyone who wants to inquire about video, however, and who cannot locate a video organization in the neighborhood, is likely to find help at a local campus.

Many groups, wherever they are, are not in a position to deal with every inquisitive passerby, or are just not interested. The majority, however, are enthusiastically involved in the video movement and are willing to share information, to swap tapes, and generally to spread the word.

Alternate Media Center
144 Bleecker Street
New York, N.Y. 10012

April Video Cooperative
Box AK
Downsville, N.Y. 13755

Cable Information Service
475 Riverside Drive
New York, N.Y. 10027

Catalyst, Inc.
5279 Brookway
Columbia, Md. 21044

Center for Understanding Media
75 Horatio Street
New York, N.Y. 10014

Challenge for Change
National Film Board
Box 6100
Montreal 101, Quebec
Canada

Communications for Change
Community Programs, Inc.
111 East Wacker Drive
Chicago, Ill. 60601

Community Video Project
7 North Front Street
New Paltz, N.Y. 12561

Eyecon Systems
1314 Northeast 43rd
Seattle, Wash. 98105

Global Village
454 Broome Street
New York, N.Y. 10012

The Grassroots Network
Box 2006
Aspen, Colo. 81611

Johnny Videotape
695 30th Avenue
Santa Cruz, Calif. 95060

The Kitchen
59 Wooster Street
New York, N.Y. 10012

Media Access Center
Portola Institute
1115 Merrill Street
Menlo Park, Calif. 94025

The Media Project
Urban Planning Aid, Inc.
639 Massachusetts Avenue
Cambridge, Mass. 02139

National Center for Experiments
in Television
288 Seventh Street
San Francisco, Calif. 94103

New York Public Library
Office of Young Adult Services
8 East 40th Street
New York, N.Y. 10016

Open Channel Video
889 Tenth Avenue
New York, N.Y. 10036

People's Communication
Network
191 Claremont Avenue
New York, N.Y. 10027

Port Washington Public Library
Port Washington, N.Y.

Portable Channel
8 Prince Street
Rochester, N.Y. 14607

Raindance
Top Value Television
555 California
San Francisco, Calif. 94104

Survival Arts Media
595 Broadway
New York, N.Y. 10012

Urban Communications Teaching
& Research Center
Livingston College
Rutgers University
New Brunswick, N.J. 07103

Video Exchange Directory
358 Powell Street
Vancouver 4, British Columbia
Canada

Video Free America
442 Shotwell Street
San Francisco, Calif. 94110

The Video Group
304 West 90 Street
New York, N.Y. 10024

Videoball
Antioch College

Washington-Baltimore Campus
525 St. Paul Street
Baltimore, Md. 21202

Videofreex
Maple Tree Farm
Lanesville, N.Y. 12450

Wiegand, Ingrid & Bob
16 Greene Street
New York, N.Y. 10013

Women's Inter-Arts Center
549 West 52 Street
New York, N.Y. 10019

Selected Bibliography

Books

Alternate Media Center, *Catalog*. New York: AMC. Notes on their experience promoting the public use of cable TV in various communities. Issued annually.

Anderson, Chuck, *The Electric Journalist*. New York: Praeger Publishers, 1973. Introduction to video, oriented to high schools.

Berger, Milton M., ed., *Videotape Techniques in Psychiatric Training and Treatment*. New York: Brunner/Mazel, 1970. Articles on all aspects of video in psychiatry.

Center for Understanding Media, *Doing the Media, A Portfolio of Activities and Resources*. New York: Center for Understanding Media. 1972. Practical suggestions for using media in teaching young children.

CTL Electronics, Inc., *Video Tools*. New York: CTL Electronics. Review of equipment and techniques. Issued annually.

Fredericksen, H. Allan, *Community Access Video*. Santa Cruz: Johnny Videotape, 1972. Hints on using portapaks and cable TV.

Gordon, George N., *Classroom Television: New Frontiers in ITV*. New York: Hastings House, 1970. TV and video in education.

Mattingly, Grayson, and Smith, Welby, *Introducing the Single Camera VTR System*. Washington, D.C.: Smith-Mattingly Productions, Ltd. Basic steps with a single studio camera.

Media Horizons, *The Video Handbook*. New York: Media Horizons Inc., Mixed bag of articles, mostly about large studio techniques.

Millerson, Gerald, *The Technique of Television Production*. New York: Hastings House, 1970. Comprehensive description of all aspects of TV, although oriented toward British methods.

National Cable Television Association, *Cable Television and Education*. Washington, D.C.: NCTA, 1973. Useful pamphlet on the theory and practice of CATV in the schools.

National Center for Experiments in Television, *Reports*. San Francisco: National Center for Experiments in Television.

Phillips, Victor R., *The Video Tape Recorder in the Classroom*. Phillips Media Publications, P.O. Box 1339, Vancouver WA 98660, 1972. A rudimentary manual with many drawings and photographs.

Quick, John, and Wolff, Herbert, *Small-Studio Video Tape Production*. Reading, Mass: Addison-Wesley Publishing Co., 1972. Thorough guide for setting up a small TV studio.

Shamberg, Michael, and Raindance Corporation, *Guerilla Television*. New York: Holt, Rinehart and Winston, 1971. Introduction to radical uses of community video.

Sloane Commission on Cable Communications, *On the Cable: The Television of Abundance*. New York: McGraw-Hill, 1971. The commission's report.

Smallman, Kirk, *Creative Film-Making*. New York: Bantam Books (paperback), 1972. Basic theories and techniques of film, many of which apply also to video.

Smith, Ralph Lee, *The Wired Nation*. New York: Harper & Row (paperback), 1972. Pioneering study of cable TV.

Videofreex, *The Spaghetti City Video Manual*. New York: Praeger Publishers, 1973. A not too technical review of the use, repair and maintenance of video equipment.

Youngblood, Gene, *Expanded Cinema*. New York: E. P. Dutton, 1970. The video frontier: videotronics and videographic cinema.

Periodicals

Bulletin for Film & Video Information. 80 Wooster Street, New York, N.Y. 10012. Monthly. New trends, put out by the Anthology Film Archive.

Cable Information Newsletter. Room 852, 475 Riverside Drive, New York, N.Y. 10027. Monthly. Concerned with the community use of cable.

Educational and Industrial Television. C. S. Tepfer Publishing Co., 607 Main Street, Ridgefield, Conn. 06877. Monthly. Slick format, with articles by users and experts.

Filmmakers Newsletter. P.O. Box 46, New York, N.Y. 10012. Monthly. Lively film magazine with a regular video department.

Media and Methods. 134 North 13th Street, Philadelphia, Pa. 19107. Monthly, September-May. Concerned with the uses of media in education.

The Network Project Notebooks. 104 Earl Hall, Columbia University, New York, N.Y. 10027. Bimonthly. Investigations of various areas of telecommunications.

Radical Software. Editorial: Raindance Foundation, 51 Fifth Avenue, Suite 11D, New York, N.Y. 10003. Publishers: Gordon & Breach, Science Publishers, Inc., 1 Park Avenue, New York, N.Y. 10016. Nine issues per year. Combines technology and mysticism. The technology is helpful.

The Video Exchange Directory. 261 Powell Street, Vancouver, British Columbia, Canada V6A 1G3. Annual. Most complete list of video groups to date. Over four-hundred listings for Canada, United States, Japan, South America, and Europe. Subscription only available to those video groups or individuals listed in the directory.

The Video Publisher. Knowledge Industry Publications, Inc., Tiffany Towers, White Plains, N.Y. 10602. Semi-monthly. Newsletter for the cable and videocassette industry.

The Videocassette and CATV Newsletter. Martin Roberts and Associates, Inc., Box 5254 N, Beverly Hills, Calif. 90210. Monthly. Similar to previous listing.

The Videoplay Report. C. S. Tepfer Publishing Co., 607 Main Street, Ridgefield, Conn. 06877. Semi-monthly. Similar to previous listings, but the best of this group.

Vid News. Billboard Publications, Inc., 165 West 46 Street, New York, N.Y. 10036. Semi-monthly. Similar to previous listings.

Index